D1450072

Sascha Erni is a freelance photojournalist and reporter. Since 2004, he has contributed images and stories to many popular agencies, newspapers, and magazines around the world. He authored his first non-fiction book *Mac and iPad for Photographers* in 2014. In his spare time, he writes fiction and practices fine art photography. Erni is a member of the Phase One Ambassador Program, which keeps him on the cutting edge of Capture One development. Erni lives, photographs, and writes in Switzerland.

Sascha Erni

Capture One Pro 9

Mastering Raw Development, Image Processing, and Asset Management

rockynook

Sascha Erni, http://www.saschaerni.com

Project Editor: Jocelyn Howell
Copyeditor: Elizabeth Welch
Layout: Petra Strauch
Cover Design: Rebecca Cowlin
Printed in China

ISBN 978-1-937538-81-1

1st Edition 2016
© 2016 by Sascha Erni

Rocky Nook Inc.
802 East Cota St., 3rd Floor
Santa Barbara, CA 93103
www.rockynook.com

Library of Congress Control Number: 2015954471

Copyright © 2015 by dpunkt.verlag GmbH, Heidelberg, Germany.
Title of the German original: Praxis Capture One Pro 8
ISBN 978-3-86490-245-1
Translation Copyright © 2016 by Rocky Nook. All rights reserved.

All photographs and illustrations by the author.

Table of Contents

Preface and Introduction

Preface

The title of this book says it all. *Capture One Pro 9: Mastering Raw Development, Image Processing, and Asset Management* is based on my many years of practical experience as a photographer and imaging specialist and, most important, on five years of hands-on experience earning a living with Capture One.

Don't worry—I'm not going to list the program's features and explain them to death, and my book is neither an alternative to the user manual and online help provided by Phase One nor simply a collection of tutorials. And why is this so? Because Capture One is an evolving digital product with tools and functions that are constantly being refined, reevaluated and replaced.

With the release of version 8, Phase One switched to a "rolling release" development model. This means that significant changes took place during version 8's lifetime and more are sure to follow with version 9's point-releases, so a collection of step-by-step tutorials in book form would quickly become outdated. The web is a much better medium for regular updates on technicalities and details, and the Phase One blog (http://blog.phaseone.com) does a great job of keeping users up to speed. My approach with this book is to provide you with the necessary foundation for you to learn to "think Capture One," so to speak.

Who This Book Is For and Why You Should Read It

Capture One is an image-processing package that has developed over the course of many years, so it can take a while to come to grips with how it all fits together and learn to make the most of its fantastic features. It took me about a year to get up to speed; I know people who have been working with the program since version 4 who still have trouble with some of its basic concepts and occasionally end up frustrated because Capture One doesn't behave the way they expect.

And that's exactly where this book comes in. Within its pages, you will find a wealth of tips, examples, and explanations that will help you dramatically reduce your learning curve. I want you to *understand* Capture One, not just learn how to use it. This book is no substitute for learning, practice, or working on your own images, and even when I mention a specific tool or the position of a particular button, what I'm really talking about is the thought

processes behind them. How can you best approach the task at hand? How does tool "X" work and when is the best time to use it as part of your own personal workflow?

This book is also aimed at photographers who want to switch programs, and especially those on the lookout for an alternative to Apple's now defunct Aperture. If you belong to this group, you will already be familiar with concepts such as nondestructive processing and the creation of image copies. However, even though Capture One is broadly comparable to Aperture and offers robust import functionality for existing Aperture libraries, the two programs still work very differently. This book emphasizes these differences in many places and offers solutions to make the switch as painless as possible.

The concepts you'll encounter will help you get to know the program and speed up the process of delving into its inner workings. You won't have to guess how processes work, experiment with countless settings, or send endless support questions to get the most out of this somewhat stubborn software because I've spent the last five years doing that for you!

In short: This book isn't an instruction manual, but rather a teaching aid and a tool to help you use Capture One Pro 9, and future releases, effectively. I hope you will find it interesting and enlightening—please let me know if it is.

April 2015

Sascha Erni
Twitter: @nggalai

Acknowledgments

A big thank you goes to my U.S. editor, Ted Waitt, and everyone at Rocky Nook for their patience during the preparation of this book. Because of my day job as a journalist and photographer, the book was a long time in the making, and I'm sure other publishers wouldn't have been so flexible and understanding.

I would also like to thank Phase One, and especially Tobias Kreusler, Gitte Maj Nielsen, James Johnson, and David Grover. Their friendliness and our close cooperation allowed me to get the early look at the beta versions of Capture One 8 and 9, which that was essential in getting this book off the ground.

Last but not least, a huge thank you (and an apology) goes to everyone who had to live with me during the research and writing phases. You know who you are, even if you don't know how much you helped!

How the Book Is Structured

Side notes like this appear at regular intervals. They are designed to help you decide whether a section is of particular interest and quickly locate sections you want to refer back to.

Capture One Pro 9 consists of 15 chapters and an appendix. You can read it from end to end if you like, but it's also designed to let you dive in and get help where you need it most. Cross-references guide you to related sections that go into more detail on the topic being discussed.

To get you started and give you an idea of what's in store, here's a summary of the material addressed in the individual chapters.

Chapter 1: Software: How Does Capture One Work?

This chapter is all about the basics. How does Capture One work? What are the fundamental concepts on which it's based? What exactly *is* Capture One, and when are you better off using other programs like Photoshop or PhotoLine? What do you have to watch out for when using the various versions, and how is the user interface put together?

Chapter 2: Hardware

This chapter addresses the question of optimizing your hardware to get the most out of Capture One, from graphics cards to Wacom pen tablets. It also talks about using Capture One in a network and what to watch out for if you use it on multiple devices—for example, on your laptop when you're out and about as well as on your desktop computer at home.

Chapter 3: The Workflow Pipeline

Chapters 1 and 2 explain the terms you need to know and give you the knowledge you need to get started. Chapter 3 is where you really get going. The "workflow pipeline" is a concept that I'll use to guide you through the book and the software. Many of the chapters start with a flowchart that shows the stage in the process that you and your images have reached. This chapter explains how your images "flow" through a raw converter and how the various tools involved interact.

Chapter 4: The Library Tool Tab

Capture One uses tabs to group tools, and chapters 4 through 15 discuss the individual tools in each tab. This chapter explains the difference between a catalog and a session, and introduces the Filters tool and Smart Albums. It also tells you all you need to know about asset management in Capture One. In addition, this chapter includes tips for readers making the switch from Aperture or Adobe Lightroom.

Chapter 5: The Color Tool Tab

Capture One handles color differently than Aperture and Lightroom, and this is one of the reasons it is so popular among studio photographers. This chapter discusses the basic concepts the program uses when dealing with color and introduces the White Point, Color Editor, and Color Balance tools that play such an important role in the overall workflow. We'll also take

a look at the various histograms and what they mean, and we'll take an excursion into the world of black-and-white photography.

Chapter 6: The Exposure Tool Tab

Alongside the color question, the second major element of every raw converter is how it handles individual tonal values. This chapter explains how to correct exposure errors simply and effectively and how to use image flaws creatively. We'll look at the difference between Curves and Levels, try out the HDR tool, and, as a prelude to chapter 9, we'll take a first look at how to compose great-looking images.

Chapter 7: The Lens Correction Tab

This chapter is all about correcting lens errors such as barrel and pin-cushion distortion, chromatic aberrations, and purple fringing. You'll also learn how to use Lens Cast Calibration (LCC) profiles to eliminate the effects of a dusty sensor.

Chapter 8: The Composition Tool Tab

Ideally, you will always compose great images that you can use straight out of the camera. However, you'll often find that an adjustment or two is required—for example, when a wide-angle lens has produced too much distortion, a client needs a different aspect ratio, or the horizon isn't quite straight. Chapter 8 covers all this and more.

Chapter 9: The Details Tools Tab

"Correct" sharpening is a topic of hot debate among photographers, and no two people have quite the same opinion about it. We'll take a look at sharpening the Capture One way and explain how the Sharpening and Noise Reduction tools interact. You'll also learn what the Clarity and Structure sliders do and delve into the magic of the Film Grain tool, which can do far more than just create analog-style looks.

Chapter 10: The Local Adjustments Tool Tab

Many of Capture One's tools can be used "locally," in only parts of an image rather than the whole file. Like with Photoshop adjustments, this creates an additional layer on which the corresponding adjustment is made in real time. This chapter looks at the benefits and the limitations of local adjustments and explains why the Clone and Heal controls in the Local Repair tool will probably get you firing up Photoshop less often than you used to.

Chapter 11: The Adjustments Tool Tab

Although its name is similar to the Local Adjustments tool tab, Style and Preset Management might be more appropriate. This chapter discusses how to create and save styles and presets and explains how to copy adjustments to other images and apply complete looks to batches of photos.

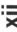

Chapter 12: The Metadata Tool Tab

Metadata plays a significant role in the digital age. It is hard to imagine life without tags that tell us where and when a photo was captured, what it shows, who is in it, and how highly it is rated. This chapter introduces the types of metadata used by Capture One and shows how to use the information how *you* want to. We'll discuss the potential pitfalls involved in swapping metadata between programs, and I'll give you tips on how to build up your own system of tags. The aim here is to use the Capture One Pro catalog to sort and order your image archives once and for all.

Chapter 13: The Output and Batch Tool Tabs

This chapter covers two tabs. The Output tool tab is used to create copies of images for sharing online or with other applications, while the Batch tool tab lists the copies you've made. Here, you'll learn how to work with multiple "output recipes" to create copies of different versions of an image. I'll also explain where to look for errors if your output doesn't end up looking the way you expect.

Chapter 14: Tethered Shooting

Capture One is designed from the ground up for use in Tethered Shooting mode, and this is the main reason the program exists in the first place. Catalogs, the Clone tool, and other details all came later. The best way to learn about tethered shooting is to plug in your camera and try it for yourself. This is why chapter 14 deals largely with the theory of preparing your camera and computer for a tethered session and leaves the practice to you. It also looks at saving and renaming image files and explains the role played by the Capture Pilot app for iPad and Android.

Chapter 15: Using Capture One with Third-Party Software

"No man is an island." Poet John Donne's assessment of the human condition is also true for most image-processing applications, which are of no use without additional database and digital asset management (DAM) software and often require the use of other programs or plug-ins. This chapter explores this aspect of the image creation process and explains how to reimport your images into the Capture One Library once you are done with your external processing steps.

Appendix

As mentioned in the preface, software evolves too fast for a book like this to be completely up to date, so in addition to a comprehensive index, the appendix includes a list of links to online material and suggestions for further reading to help you stay up to speed.

1 Software: How Does Capture One Work?

Capture One Pro 9 is the current version of a raw developer that has proved itself in photographic studios over the course of more than a decade. It started life as an accessory program for Phase One's medium-format digital backs and, over the years, has developed into a universal image-processing program for use with a wide range of cameras in all sorts of situations. However, Capture One still has its own particular focus and idiosyncrasies and isn't particularly intuitive to use. This chapter addresses the underlying concepts that are most likely to cause problems for Capture One beginners and those switching from other, similar programs. Section 1.1 begins with a quick history lesson for those of you who have so far only heard about Capture One. If you're already familiar with the program, you can move straight on to section 1.2, which is aimed at those who have an idea of what it's all about but have yet to make a purchase decision.

Capture One wasn't originally designed as an all-in-one software solution. In studio, media, and publishing environments, images are usually processed in Photoshop before they're handed over to some kind of layout software. Capture One was originally conceived to squeeze the best possible image quality out of Phase One's own cameras while making life as simple as possible for the photographer.

Capture One is not just another Lightroom or Aperture clone.

Today's Capture One Pro is different from the original and, although its major strengths lie in professional studio shooting environments, the inclusion of support for an ever-expanding range of cameras has seen its target audience grow and grow. The toolset has moved away from its original raw developer/studio workflow base to encompass an expanding range of tools that include creative sharpening, selective processing, and spot removal—all functions that are traditionally handled by Photoshop. Version 7 saw the introduction of catalog functionality that is still not perfect but nevertheless covered many photographers' DAM requirements. This only got better in versions 8 and 9.

It's important to keep the software's origins in mind, especially if you're used to the Lightroom/Aperture approach to image management and color profiles.

The software's name includes the word "capture," which clearly indicates the most important aspect of how it works. It's primarily designed for capturing photos that are immediately saved on a computer, so memory cards play a secondary, backup role in the Capture One workflow. The advantages of this approach are as follows:

Tethered photo capture and meticulous color management were long the cornerstones of the Capture One philosophy.

- The art director in a team doesn't have to wait until a memory card is full before development work on the raw files can begin. Every image is immediately available on the computer.
- If present at the shoot, the project leader or client can give immediate feedback on composition and lighting and doesn't have to wait until later when the model has probably already left the building.
- You no longer have to remove the memory card from the camera, insert it into a card reader, and import your images. This saves a lot of time in situations that produce large numbers of extremely large files.

The program's focus on image capture sessions resulted in concepts like using a session as a project container for storing folder locations (see section 4.1) and managing images and sidecar files outside of a database using the Enhanced Image Package (EIP) file format (see section 4.3). In other words, the program takes a highly file-centric approach. Unlike Aperture and Lightroom, which were both designed around the catalog as their central element, Capture One's catalog functionality was added later to the basic program framework.

The studio photography workflow requires strict adherence to the International Color Consortium/Image Color Management (Windows) (ICC/ICM) color management guidelines. If you spend your time photographing fashion and jewelry using a camera that cost a five-figure sum, you're probably producing work for magazines or advertising purposes. Capture One is designed with compatibility with various color models (RGB, CMYK, and so forth) in mind and has to be able to warn you at the raw development stage if your images exceed the color gamut of the planned output medium. It also has to deliver prepress-ready material without the use of third-party software. This approach is designed primarily with professional photographers in mind, but the benefits of a pro-grade workflow are nice to have for hobbyists and enthusiasts, too. Even if a pro workflow exceeds your initial needs, you'll find it makes life a lot easier the more your imaging requirements grow.

1.1 Basic Concepts and Features

1.1 The basic Capture One concept: raw image data development followed by nondestructive processing of the resulting images

Whatever you do with your images in Capture One, *your original files remain unchanged.* The program saves a log of all the adjustments you make and,

in order to view, share, or publish a "finished" image, you have to output it using a process akin to making a print from an analog negative (see chapter 13).

In Capture One, a "finished" image exists in the form of the original image file and its accompanying develop settings, either in the form of a sidecar file or as part of a catalog. If you decide at some point to switch from Capture One to another image-processing platform and you want to retain all the adjustments you've made to your images, you'll first have to make your develop settings a permanent part of the corresponding image files. If your computer should crash or be stolen, you'll have access to your backup image files but not to the adjustments you've made. Many photographers avoid such a situation by making a JPEG or 16-bit TIFF copy of each processed image as a regular part of their everyday processing workflow. The format you use will depend on the level of quality you require and the amount of available disk space.

Capture One is still "only" a raw developer at heart, although each version has seen the addition of tools and functions that used to be available only in programs like Photoshop. Capture One Pro can perform each of the following tasks at the raw development stage:

Nondestructive processing means that images are only transformed into finished, output-ready files when you need them.

- Correct lens and perspective errors
- Eliminate the effects of dust on the sensor and the rear element of your lens
- Suppress the effects of sensor noise and hot pixels
- Apply basic and creative sharpening
- Process color data for a range of color spaces and color models
- Convert to black and white and make creative color adjustments
- Remove red-eye and retouch skin tone
- Add watermarks to images for online publishing
- Make individual prints and contact sheets
- Manage assets

Today's Capture One is an all-in-one raw developer and image-processing package. The more processing steps you perform within Capture One, the less subsequent adjustments you'll have to make to your finished images.

...and much more. Performing all these tasks at a raw level also means that you can combine multiple adjustments in any order without affecting the quality of the resulting image. For example, you can begin by reducing noise and sharpening before you correct lens errors and adjust the white point,

or vice versa. Capture One applies adjustments directly to the original raw image data, which means that you can make selective changes to your adjustments later on, too.

A Sample Process

Let's imagine you want to create a black-and-white version of an image using the Nik/Google SilverEfex software. Begin by creating the black-and white image file in Capture One and hand over a TIFF copy to SilverEfex, where you mess around with the tone curve a little, add a vignette, and set a color filter. You're happy with the results and save it...

1.2 Oops!

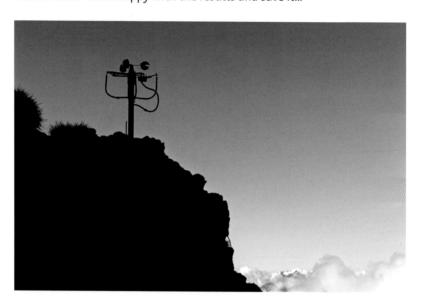

...only to discover online that you overlooked a blotch in the sky. You take a deep breath and remove the blotch in Capture One before starting over with your adjustments in SilverEfex. And then you realize that there are other specks you missed, or that you didn't quite correct perspective properly, or that you don't like the sepia tone you applied after all, and so on.

Performing all of these steps in Capture One saves you a lot of time and effort. All you have to do is correct each error individually—your previous steps and any you made after the one you're adjusting are preserved without affecting the quality of the finished image.

This is the main reason for performing as many of your adjustments as possible at the raw development stage. You can, of course, use Photoshop layers to achieve similar effects, but taking this approach often produces extremely large files and makes processing slower. Some steps—for example, noise reduction and lens error corrections—cannot be adjusted later in Photoshop. The moment you hand over a developed image to Photoshop, all the adjustments you've made so far become a permanent part of the image copy and can only be further adjusted if you're prepared to accept a visible drop in image quality. The only other alternative is to start over.

So which major processing steps *can't* be performed in Capture One yet? The list is actually quite short:

- Panorama stitching and other types of merge
- Complex retouching and the cloning of image data from other images
- Automatic synchronization of images published at online sharing sites such as flickr and 500px
- Sharing of images using online services such as Twitter and Facebook

Although it has some limitations that we'll look into in more detail in the next chapter, the scaled-down Capture One Express (for Sony) handles raw image data just like the full-fledged program. The original data remains unchanged and you have to create copies of your images to output them. The more steps you perform within Capture One, the fewer adjustments you'll have to make to your "finished" image.

1.2 Which Version Do I Need?

This section is for those of you who haven't yet decided which version of the program you need. The decision itself isn't too difficult to make, but once you understand *why* a particular version and licensing model is the best for your particular purposes, you'll significantly increase your chances of getting the very best out of the software.

1.2.1 A Question of Licensing

As of version 8, you can either purchase Capture One outright or take out a subscription. However, unlike the Adobe CC model, which provides a comprehensive cloud environment and online disk space, the Capture One subscription model affects only how you actually pay for the software. Therefore, the first question you have to ask yourself is whether you prefer to buy or "rent" your software. Both models have their pros and cons.

The Subscription Model

A subscription gives you the right to always use the latest version of Capture One Pro. You don't have to spend your entire life online to use this model—logging on once a month is sufficient to keep your subscription data up to date and synchronized with the Capture One servers.

Capture One isn't cheap, so a subscription will help you keep tabs on your expenses and spread the cost of using the software. The more licenses you require, the better value the subscription model offers. Purchasing 10 standard licenses costs almost twice as much as a one-year subscription for 10 users and has to be paid immediately, so a subscription model is especially practical for smaller studios on a limited budget.

A subscription helps you keep your expenses under control.

If you haven't decided whether Capture One is the right tool for you, you can try it for three or perhaps six months and, should you decide to use a different program after all, you can cancel your subscription at the end of any three-month period and save the difference in price between a full license and a few months' tryout.

A subscription ties you to a specific vendor and forces you to upgrade.

A subscription has downsides, too. It ties you to Phase One for its duration, and perhaps more important, Capture One catalogs and adjustments cannot be read by other image-processing programs. This means that if you cancel your subscription, you'll either have to reprocess your images or create copies for use with your new software. You'll also have to re-create your catalogs manually. The subscription servers don't allow you to keep an expired version of the software on your computer even if you only occasionally need to create an image copy. If, for example, you find that a successful sequence of images that you made using Capture One has gotten lost or broken, you'll have to take out a fresh three-month subscription in order to export your images along with the adjustments you made. The only alternative in this case is to reprocess all your images using your new software.

System requirements can also cause trouble. The Mac version of Capture One 9 requires OS X 10.10 or later, so users of OS X 10.9 or earlier simply cannot use it. Similarly, the PC version requires a 64-bit OS, so users sticking with 32-bit are out of luck. If future versions of the software are only compatible with certain versions of an operating system or require a specific minimum level of graphics power, you may find you have to update or even replace your computer to match, thus making it impossible to stick to a familiar running version.

Standard Full Licenses

Phase One is not planning to switch to a subscription-only licensing model, and standard licenses, too, offer certain advantages and disadvantages.

A single-user license is quite expensive.

As already mentioned, Capture One is not particularly cheap, and even an upgrade can cost more than a full license for a competitive product. Over the years, using this model can cost a significant amount of money, so it's worth taking a close look at your needs, especially if you use multiple licenses.

A full license makes you independent.

Purchasing a full license makes you independent of future developments. This means if you were happy with version 8, you don't have to upgrade to subsequent versions as they become available. If you find that version "X" no longer works with your computer or you want to use an older version to maintain your image archives, your "perpetual license" (as Phase One calls it) does the job. Freelancers and imaging studios often spend years optimizing their workflows and setting up hardware and software to suit their style of work and can't (or don't want to) update to the latest version.

IMPORTANT
Full and subscription licenses fulfill different purposes and neither model is "better" than the other. Rather than making a gut decision, take a careful look at your workflow, the hardware and software you use, and your available budget, and work out how much each model will cost over the next two or three years. Consider, too, how often you've upgraded in the past and whether you tend to skip some versions. Try to remain objective at this stage and only allow your instincts to take over once you've made that basic decision.

1.2.2 Which Version Is Right for Me?

With the introduction of Capture One 8, the question of which version to use became a lot simpler to answer, as there was only one choice for most users: Capture One Pro 8. All earlier versions were eligible for an upgrade to Capture One Pro 8 for the same price—i.e., the upgrade from Capture One Pro 4 to Pro 8 cost the same as the upgrade from Pro 7 to Pro 8. With Capture One Pro 9, though, the scope of eligible versions was reduced to versions 7 and 8—i.e., if you want to upgrade to version 9 now, you need to already own a version 7 or 8 license. If you are upgrading from an earlier version, such as Capture One Pro 6, you are required to buy a full license. Supposedly Phase One decided on the wide scope with the introduction of Capture One Pro 8 to get as many users as possible on the same page. With the release of version 9, it's as simple as that: two versions down? Upgrade possible. Older version? New license needed.

Capture One Pro and Capture One Express/ Pro for Sony—choosing the right version is simple.

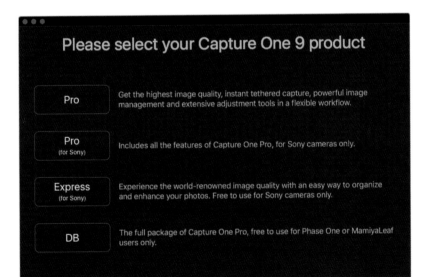

1.3 The first time you start Capture One you have to choose which version to activate. The download file is always the same, but different sets of functions are activated according to the version you select.

Users of Sony's a7 series cameras are a special case and have the option of using a cheaper Express version of the software that only supports a7 cameras. Look at it as if this version of the software was bundled with the camera you bought, but you need to download it. This version has no session mode and limited layer functionality. It doesn't support tethered shooting (see chapter 14), and the Lens Correction tab contains fewer options than the full Pro version. Sony users can also opt to use the full Pro version "for Sony," which, like the Express version, only supports Sony cameras and their proprietary file formats, and is a lot cheaper than the regular Pro version.

The Express version for Sony is similar to earlier Express versions and can be upgraded to the full Capture One Pro just like other Capture One 6 and 7 Express licenses.

For the sake of completeness, I also need to mention the DB and Cultural Heritage versions of Capture One 9. DB stands for Digital Back and is optimized for use with Phase One and Mamiya Leaf medium-format digital backs. This free version has functionality identical to that of the standard version of Capture One Pro but, like the Sony version, only supports the cameras it is delivered with.

The Cultural Heritage version is optimized for reproduction photography in museums and other archiving situations. It, too, has the same functionality as the regular Capture One but also offers extended support from Phase One and a range of support contracts that include additional hardware and software.

Neither of these special versions is available on the open market and won't be mentioned again in the course of the book.

1.3 An Overview of the Rendering Pipeline

In principle, Capture One works just like any other raw developer. It reads the raw image data, interprets it, and transforms it into an image that can be viewed by humans. Chapter 3 discusses in detail how your image files pass through the various modules that make up the Capture One "workflow pipeline," but for now we'll concentrate on a more fundamental question, namely:

How does Capture One know the color of a model's hair or the precise shade of green produced by the rising sun shining on a meadow?

For the purposes of this book we'll call the process of converting raw image data into a human-readable image "rendering."

This section introduces the "rendering pipeline" and will help you understand how Capture One works.

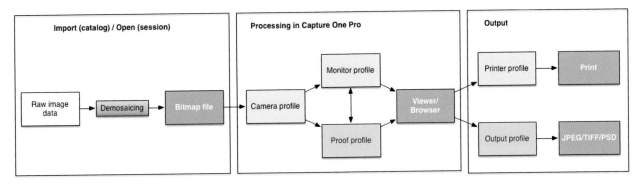

Your images pass through a system made up of a series of color definitions. To interpret the raw data captured by the camera and transform it into an image that makes sense to a human viewer, Capture One requires two types of profiles. On the one hand, it needs to know about the attributes of the hardware used in the image capture process (lens distortion, sensor characteristics, and so forth) and on the other, it needs to produce realistic colors that can, if necessary, be adjusted to suit the monitor or output medium you're using. The data for the former is found in *device profiles* and for the latter in standardized ICC *color profiles*.

The International Color Consortium (ICC) was formed in 1993 by Apple, Agfa, Adobe, Kodak, Microsoft, Silicon Graphics, Sun Microsystems, and Taligent with the aim of creating an open, system-independent standard for dealing with the digital reproduction of colors. In 2010, the standards created by the ICC became ISO standards. The ICC standard defines the format in which profiles are written but not which algorithms and methods are used to define the colors themselves.

ICC standards are governed technically by a color management module (CMM) that is part of your computer's operating system or your image-processing software. Windows and OS X both have their own system-wide CMM, whereas Adobe products have their own proprietary CMM and the Firefox browser uses open source color management modules. Capture One is something of a hybrid in this respect, using the color management system embedded in the OS as well as its own internal colorimetric methods.

Because every color management module is different, you may end up producing quite different results from computer to computer and program to program, and this is one reason Capture One renders colors differently from programs such as Adobe Camera Raw.

All the color profiles used by Capture One are ICC profiles. This makes images processed using Capture One ideal for use in magazine and poster printing environments that usually use ICC workflows as standard. In other words, from the moment you open an image in Capture One it's handled as part of a standardized technical environment. Capture One doesn't have to use multiple color models and doesn't have to convert tonal values or simulate output. Instead, it relies on standardized ICC profiles and renders tonal values using dedicated data at every stage of the development and editing process.

1.4 The rendering pipeline uses color profiles (shaded green) and device profiles (shaded gray) to link various processes.

Capture One's color management module and the entire rendering pipeline are optimized for use in studio and (offset) printing environments.

1.5 These Lightroom HSL sliders are sorely missed by many in Capture One.

The downside of this high level of consistency is that the Capture One rendering pipeline has to strictly adhere to the ICC standards and color models. Adobe Lightroom, for example, is built from the ground up to process color data captured by digital cameras, making it simple to create custom camera profiles and adjust images using global HSL (Hue, Saturation, and Lightness) sliders. In contrast, Capture One is designed as part of a chain of predefined processes that encompasses the work of photographers, graphic designers, and printers.

> The limitations caused by strict adherence to ICC standards are often either theoretical or simply affect old habits such as use of the HSL sliders in Adobe Camera Raw. You'll probably no longer notice the difference once you've become accustomed to the way Capture One works.
>
> You won't usually notice how Capture One processes color internally but, if you should have issues like the DNG-format special case discussed in section 1.4.2, remember that the cause is probably a system issue rather than a user error and can most likely be solved via a support question to Phase One. Section 1.4 takes a detailed look at ICC profiles and color management in general.

But let's get down to brass tacks and take a look at how Capture One actually works. The steps involved in the rendering pipeline are as follows:

1. Capture One loads the original raw image data and creates preview images (see section 1.7).
2. The program uses an appropriate camera profile to interpret the raw data and create previews in the Viewer (see section 1.5). Some cameras have a choice of profiles, and you can select one according to the situation or your personal taste.

1.6 The built-in color profiles for the Canon EOS-1Ds. It's up to you to decide which is best for the images you're processing.

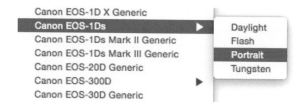

3. You can now process your images, tweak sliders, correct color casts, perform some basic sharpening, and so on. For every step you take, Capture One uses the profiles already used in the processing chain and applies your adjustments in real time.

4. If you want to save your images to JPEG or TIFF, Capture One uses the appropriate sRGB or CMYK Offset profiles.

1.7 sRGB or Adobe RGB? Or something else entirely? Use the Output tool tab to make your settings (see chapter 13).

5. When you're making prints, you can leave color management for your particular paper to the printer driver, select a preset profile from your paper's manufacturer, or create your own custom profile for your particular combination of paper and printer.

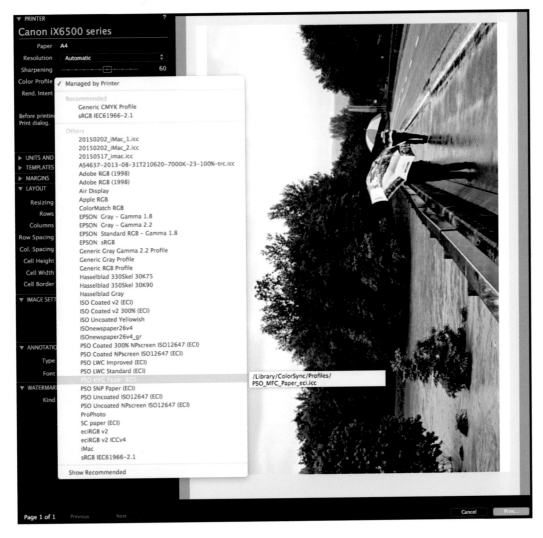

1.8 If you already have an appropriate profile for your combination of printer and paper, you can select it in the Printer dialog. If you don't have an appropriate profile, it's better to leave color management to the printer driver.

You can create your own color and device profiles or adjust existing profiles to suit your particular needs. The amount of effort involved ranges from "huge" (in the case of camera profiles) through "justifiable" (for printer profiles) to "child's play" (monitor profiles). However you approach profile creation, *the chain must not be broken!* And the individual links in the chain have to be sufficiently robust if you want to achieve great results. Think carefully before adjusting profiles—if everything works out as planned, you'll get perfect results, but you might just end up producing garbage instead.

The concept of the "rendering pipeline" will accompany you throughout the book, approached from varying points of view that suit the topics at hand. I call the combination of processing steps, program tools, and rendering pipeline the "workflow pipeline," and chapter 3 is dedicated to explaining this term in detail. A complete diagram illustrating all the intersections and substeps in the pipeline is included in the appendix.

1.4 Color Management and ICC/ICM Profiles

As mentioned, Capture One is based on ICC standards. This means that the entire rendering pipeline is optimized for the ICC-based color spaces and that ICC/ICM color profiles play an important role in the Capture One workflow. This section goes into more detail on aspects touched on in general in the previous section.

ICC profiles are embedded at various stages in the Capture One workflow, including file import, image processing, camera profiling, and output. For this model to work properly, the profile chain must not be broken. So what does this mean in practical terms?

Color profiles provide a mathematical basis for the precise reproduction of colors. They describe devices (cameras, scanners, monitors, and printers) and color spaces (such a sRGB and Adobe RGB). Where these profiles come from and where they're stored shouldn't bother you in the course of your everyday workflow, as Capture One and your operating system provide all the profiles required for glitch-free image processing.

Capture One uses ICC profiles to process color data, describe camera attributes, and prepare images for display and printing. Depending on the operating system you use, the corresponding files have .ICC or .ICM filename extensions. The two file types are interchangeable.

1.9 The color profiles involved in the rendering pipeline described in section 1.3

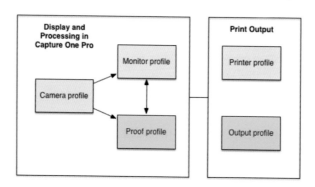

When interpreting colors, Capture One concentrates more on the final effect than on precise colorimetric results. The aim of the process is to produce images that are nice to look at, not ones that contain hues precisely calculated to several decimal places. Human perception is very different from that of machines, and it can be quite tricky to find the right compromise between images you like and ones that are empirically "correct." Don't worry if the colors in your test images turn out different in Lightroom or Aperture—that's all part of what Capture One is about.

1.4.1 Device Profiles and What You Can Do with Them

ICC/ICM device profiles are the most relevant in the world of photography. They describe the color sensitivity of your camera and how your printer and monitor reproduce colors. They are the only part of the profile chain that you should consider altering—camera profiles are too complex to be worth the effort.

ICC isn't new and its tenets are deeply rooted in the history of imaging and printing. Unlike Adobe, which took a completely new approach when creating Lightroom and Adobe Camera Raw, Capture One is firmly based on ICC industry standards. If you want to create your own (clean) camera profiles, go ahead, but please note that doing so isn't just a case of photographing a ColorChecker the way you can for Adobe products. Creating camera profiles for Capture One involves coming to grips with the finer points of color profiling and a sizable investment in the necessary hardware and software. However you approach it, camera profiling is beyond the scope of this book.

The effort involved in producing camera profiles better than the ones provided with Capture One is usually much greater than the potential benefits.

With Capture One, it's possible to use custom camera profiles in certain situations, although doing so is anything but trivial. Phase One continually invests a *lot* of time and specialist know-how in creating camera profiles for Capture One, and my advice is to go ahead and use the results of this investment. Color reproduction is one of the fundamental reasons for choosing one raw developer over another. If you don't like the colors Capture One produces, you're probably better off trying out the Adobe competition.

Things look very different at the other end of the profile chain. Even if you're only moderately interested in producing balanced colors, always profile your printer and your monitor. This is quick and easy to do and doesn't cost much. See chapter 2 for more details and the appendix for a selection of resources on the subject.

Appropriate monitor and printer profiles are not just nice to have, they are essential.

1.10 You can only correctly evaluate the colors in your images if you use a monitor and a printer that are profiled to match the lighting conditions where you work.

1.4.2 The Problem with DNGs

Adobe designed DNG as an open, standardized archiving format, or "digital negative." For most raw developers, DNG is akin to a standard, and if the software can read one DNG file it can usually read them all, including converted files like the ones produced by Lightroom when you use its Import DNG function. In this respect, Capture One is an exception and often has trouble handling raw image data that has been converted to DNG after capture.

Capture One requires the use of corresponding camera profiles if you want to use it to process DNG files. If you don't take this step, the software will apply a standard DNG color profile and color errors will result.

What Phase One calls a "calibrated DNG" is a DNG file as it comes out of the camera. If the file was produced by a camera that Capture One supports, it comes with an appropriate ICC profile built in. Capture One handles such DNG files (for example, from Leica and Pentax cameras) like any other raw file, be it an Olympus ORF or Nikon NEF.

And this is where the trouble starts. ORF and NEF files can be converted to DNG, but Capture One has issues handling the results.

1.11 An Olympus raw file converted to DNG (right) shown with a copy of the same file made in Lightroom

When opening converted DNGs, instead of using the appropriate camera profile, Capture One uses the standard DNG Neutral ICC profile. Even if the file was converted losslessly, the camera profile Capture One uses doesn't suit the converted file—color mapping is off-kilter and the ICC white point for interpolating other colors contradicts the one stored in the converted

file, to name just two of the known issues. As a result, the entire rendering pipeline is disturbed.

> Put simply, Capture One only supports "pure" DNG formats for which Phase One has analyzed and produced appropriate ICC profiles, or converted DNGs in which the original raw file (.NEF, .ORF, etc.) was embedded during conversion—that is, if Capture One supports the original raw file. For technical reasons, the camera profiles provided with the software don't work with the image data stored in generically converted DNGs. Phase One provides ICC color profiles for every camera that uses DNG as its native file format, but in all other cases, you have to either stick to using your camera's native file format, embed the original raw file during DNG conversion, or simply put up with the inconsistencies produced by the DNG Neutral profile.

This is a serious blow to Lightroom users who have converted their entire image archives to DNG without embedding the original raw files because they cannot produce usable results when developing their images in Capture One. Until Phase One changes its mind and provides a better solution, you have to stick to the following rules when processing DNG files in Capture One:

◉ If you're using Capture One as a second raw converter and you wish to save your images to DNG, embed the original raw files in your DNGs. To do this, check the Embed Original Raw File option in the Preferences dialog in the Adobe DNG Converter.

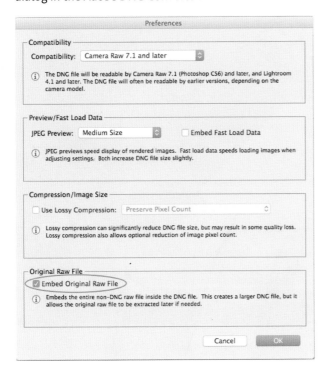

1.12 Checking the Embed Original Raw File option in Adobe's DNG Converter produces enormous files but puts you on the safe side when it comes to ensuring that you can process your DNGs in the future—for example, if you decide to make Capture One your primary raw converter.

1.13 The Capture One interface is highly configurable.

◉ As an alternative, you can create a backup copy of your original raw file before conversion—a process that's easily automated during image import from a memory card.

◉ If you've already made the switch to Capture One and have to deal with DNG files that do not have embedded originals, you have to either create a new custom ICC camera profile for your converted DNGs or tweak the provided DNG Neutral profile using the Color Editor until the color shifts reach a tolerable level (see section 5.6 for more details).

1.5 All about Panels, Tabs, and the Capture One Interface in General

Capture One can be freely configured to suit your own personal style of work. If you like a module-based approach like Lightroom, you can use the tool tabs provided with the program or create your own custom tabs with tools grouped to suit your needs. If you prefer to work with floating panels like in Photoshop, Capture One supports this, too. ☐ 1.13

To make sure you don't get lost along the way, the following sections introduce the main elements of the user interface and some of the terms that we'll be using frequently in this book. ☐ 1.14

1. **The Toolbar (outlined in white):** This contains tools that are often applied globally, such as the print tool; the tool for deleting files from the catalog; exposure warnings; the Focus Mask; and the Select, Pan, and Loupe tools. In tethered mode (see chapter 14), the Toolbar also shows the connected camera's battery status.
2. **Tool tabs (outlined in yellow):** Capture One's default settings group tools in preset tabs according to types of tasks, such as Exposure, Color, Lens, and Details. Although you can customize the existing tabs and create your own to suit your personal style, this book sticks to the standard groupings. The Quick Tool tab features a selection of key tools to help you achieve a faster workflow.
3. **Individual tools (outlined in green):** Each tool has its own panel, which you can float anywhere on the desktop or dock to the right or left of the main window.
4. **The Browser (outlined in blue):** This shows all the currently selected images in a folder, Album, Smart Album, project, group, or catalog. The Browser can be docked to the right or left of the main window or beneath it, or you can display it to fill the screen—for example, on a second monitor. If you have limited desktop real estate, you can hide the Browser until you need it.

5. **The Viewer (outlined in orange):** This is where you see the effects of your adjustments. It can also be used to display multiple versions of a single image. The Viewer can be hidden, too, which can be useful if you want to concentrate on organizing your images in the catalog and have limited space on your monitor.

1.14 The major elements of the Capture One interface

Because Capture One is so highly configurable, beginners often lose their way and can't find the tool they're looking for. To make getting started simpler, the program provides a selection of predefined workspaces located in the Window > Workspace menu. Take the time to click through them. If you find one that suits you, you can fine-tune it to suit your needs and save it using the Window > Workspace > Save Workspace command.

Workspaces give advanced users the option of creating custom workspaces for specific tasks. This way, you can define workspaces for organizing and key-wording, pure retouching work, or whatever. You can then switch workspaces with a single click.

1.5.1 The Toolbar

The Toolbar contains basic functions like image import, undo/redo, and image delete. You can customize it using the View > Customize Toolbar command and hide it using View > Hide Toolbar. Experienced users often prefer to use keyboard shortcuts, and once you're up to speed, you'll probably rarely use the Toolbar buttons.

The Toolbar contains the most important tools that you need all the time. All the tools located here also have their own keyboard shortcuts.

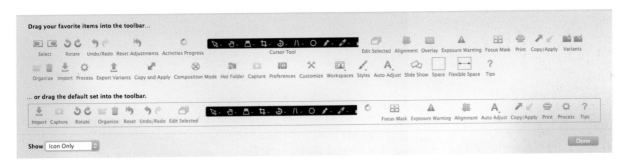

The most important elements of the Toolbar are the Cursor Tools. These are used to alter how the cursor functions, for example, transforming it into an eyedropper (the Pick White Balance tool) or a loupe. All the Cursor Tools except Spot Removal offer a range of options that you can access using a click-and-hold or a keyboard shortcut.

1.15 The Toolbar can be easily customized and hidden.

Pick White Balance (w)
Pick White Balance on Selected Layer
Pick Skin Tone (s)
✓ Pick Skin Tone on Selected Layer
Pick Shadow Level (l)
Pick Highlight Level (l)
Pick Curve Point (u)
Pick Color Correction
Pick Color Correction on Selected Layer
Pick Basic Color Correction
Pick Skin Color Correction
Pick Skin Color Correction on Selected Layer
Add Color Readout
Delete Color Readout

✓ Always Show Color Readouts

1.16 Nearly all Cursor Tools offer a range of options like those for the Pick White Balance eyedropper shown here. The corresponding keyboard shortcuts—such as W for white balance or L for shadow level—are shown in brackets after each option.

The Cursor Tools can also be accessed via their corresponding tool tabs. For example, the Pick White Balance tool can also be accessed via the White Balance section of the Color tool tab and the shadow level in the Exposure tool tab. It is a good idea to get familiar with the Cursor tools, but don't be put off by the wide range of options they offer—each tool is automatically offered at the appropriate stages in the workflow. The Cursor Tool section of the toolbar is designed to give you quick access to these tools when you need them, even if the corresponding tool panel is hidden. This is just one of the many different approaches to using Capture One's tools and is by no means obligatory.

1.5.2 Floating Tool Panels or Tool Tabs?

Tools can be floated freely on the desktop or docked to the main window, or you can do both.

As with most aspects of the Capture One workflow, it is up to you how you organize the look and feel of your tools. If you're familiar with Aperture, you'll probably prefer to float the tool panels on the desktop, whereas Lightroom users will be more accustomed to working with tool tabs. Capture One offers both approaches and you can combine them if you wish.

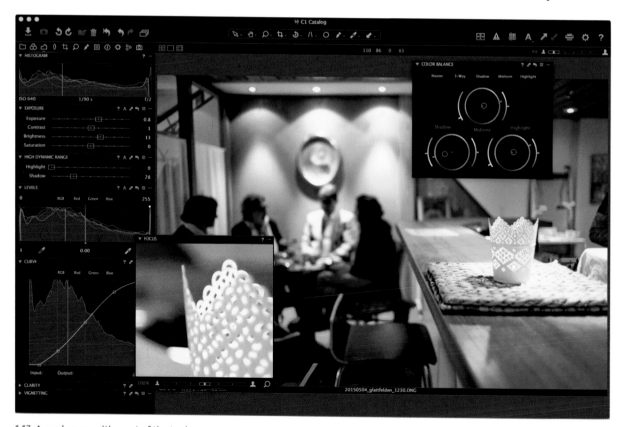

1.17 A workspace with most of the tools arranged in tabs and the more important ones floated on the desktop. You can save any arrangement using the Workspace > Save Workspace command in the Window menu.

Capture One's tool panels consist of a title bar with the tool's name and any menus and options it offers. The rest of each panel is taken up with the tool's sliders, buttons, curves, and so forth.

▼ HDR ? A ⤢ ↰ ≡ ⋯

The tool options contained in each tool panel's title bar are as follows (from left to right):

1.18 All tool panels have the same basic structure whether you float them or use them in tabs. The right-hand end of the title bar contains the tool's options and menus, and mouseover tooltips explain each button's functionality.

- Click the triangular icon at the left-hand end to show or hide the rest of the tool panel.
- Click the question mark to open a tool's online help page.
- If the tool has an auto option, an uppercase A will be shown in the title bar and clicking it applies the tool automatically.
- The double-arrow copies the current settings to the Adjustments Clipboard for application to other images.
- Click the back arrow to reset adjustments made to all selected variants. Option/Alt-clicking the button temporarily resets your adjustments as long as you keep the mouse button pressed, and is a great way to compare your changes with the original image.
- The icon with three parallel lines is for creating and applying presets. The Stack Presets option enables you to simultaneously apply multiple presets.
- The icon with three dots reveals an action menu for applying or resetting camera-specific presets (see section 1.6), adjusting the size of the panel, and removing the tool from the current tab (or from the desktop if you're using a floating tool panel).

> Each tool offers various options according to its function. For example, the histogram can only display curves but doesn't allow you to alter any settings, so it has no "copy settings" option. In contrast, the White Point adjustment has an auto option and thus has an A icon in its title bar.

You can hide tools using the Hide Tools command in the View menu. The Tools Auto Mode command automatically hides any active tools until you move the cursor to the edge of the Browser or Viewer window. This is a useful option if you have limited space on your desktop.

QUICK TIP
As of version 8.1, most tools have their own context menus. For example, right-clicking the Viewer displays the settings for the active tool in a floating window at the current cursor position. This means you can make adjustments even when a tool is hidden. This gives you maximum desktop real estate for making adjustments and, once you have memorized the appropriate keyboard shortcuts, makes working with Capture One really fast.

1.19 The white balance context menu. Context menus save a lot of mouse travel and enable you to hide tools and maximize your available desktop space.

The Browser and the Viewer can be adjusted to suit your style.

1.5.3 Browser and Viewer

Although they offer only a few options, the Viewer and Browser displays can be adjusted as well.

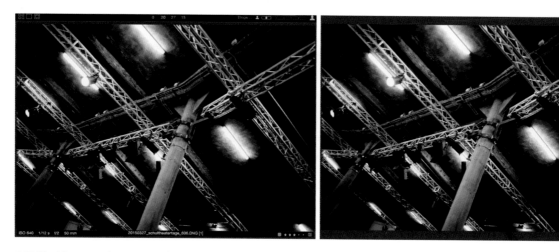

1.20 The Viewer can be set up to show or hide image information as required.

The Viewer settings are located in the View menu:

- Viewer Mode offers the options Primary View (that is, the current image) and Multi View (all selected images in a tiled view). Show/Hide Proof Margin shows or hides the entire printable area. You can also access these commands via the three icons in the Viewer Toolbar, which you can hide if you prefer a clean Viewer interface.
- Show/Hide Viewer Labels shows or hides the info bar beneath the current image. The default setting shows the filename, the ISO setting, the exposure time, and the image rating. Even if you hide them in the Viewer, this data is still available in the Metadata tool tab.

View options that have a more significant effect on the Viewer display, such as Focus Mask and Proof Profile, are addressed in detail in section 1.8.

Most of the time, you'll probably use the Browser in filmstrip mode, placed either to one side or below the Viewer window with one or two rows of images. Like with the Viewer, the Browser commands are located in the View menu.

> **QUICK TIP**
> To place the Browser on the left-hand side of the main window, navigate to the View menu and select the Place Tools Right command. To place it beneath the window, use the Place Browser Below command.

The Browser's display options are probably more interesting than its location options. Previews are a must, but do you want to show the contents of the current album as a list or as thumbnails? If you prefer a tiled view, how many rows do you want? ☐ 1.22

1.21 The Browser can be set up to show as much detail as you like, arranged the way you prefer.

1.22 The Browser uses the available space according to the mode you have set. You can adjust the view using the three icons at top left of the Browser window (if it is placed below the Viewer) or using the "eye" icon if it is placed to the left or right. This is also where you set the order in which your images are displayed.

Try out different Viewer and Browser settings until you find the combination of data and positions that suits you best. It is up to you to decide how much data you display and where. For example, ratings displayed in the Browser and the Viewer can be annoying.

The previews in the Browser provide information about the state of an image. A gearwheel icon at the bottom right indicates that an image has already been output, whereas a stack icon indicates that it has already been processed. This gives you a quick overview of your work while you are scrolling through the Browser view. The Browser defaults use Edit mode and show the filename, color tags, and ratings.

Edit mode is set in the Browser Labels submenu in the View menu and enables you to alter ratings, color tags, and filenames in the Browser. If you switch the view to Status mode, you can no longer alter the displayed data, which helps avoid adding unwanted ratings or tags when you're clicking through large numbers of files.

1.23 If you select the View > Hide Viewer command, the Browser is automatically enlarged to fill the available space. This way, you can use the entire desktop for admin tasks that don't require a Viewer window. To avoid setting unwanted tags and ratings while you browse, select Status mode in the View > Browser Labels menu.

1.5.4 Catalog and Session Templates

Everyone has his or her own personal approach to work. Some people have a highly organized system for handling incoming mail, whereas others simply throw everything in a shoebox. Some think in projects and create new folders and database entries for each new job; others don't.

1.24 A highly organized system or a single folder called "documents"—which type of user are you?

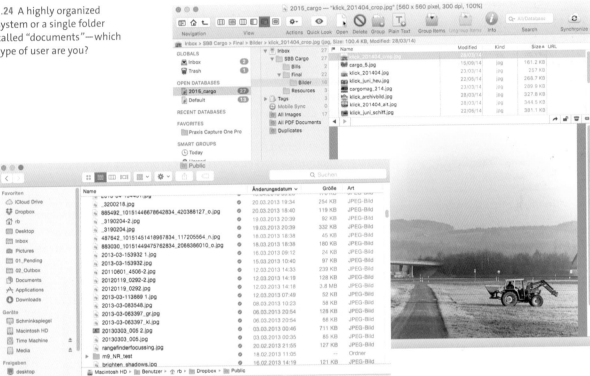

If you prefer to treat each new job as a separate project, you are sure to appreciate the Templates functionality.

To save a project as a template, use the File > Save as Template command. This opens your operating system's file management dialog, where you can give your template a meaningful name and save it. You can now replicate the environment you have saved for future projects—all you have to do is select the appropriate template from the drop-down list that appears when you select the New Session/New Catalog commands. ☐ 1.25

Catalog and Session templates enable you to save the structure and working environment for each project separately.

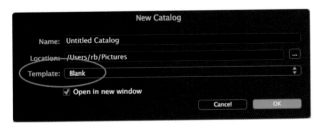

1.25 The template drop-down list in the New Catalog dialog is easy to overlook.

Just like the way you organize your data, it is up to you to decide whether you need multiple catalogs or sessions. Phase One recommends that you use just one main catalog and multiple sessions to organize individual projects or tethered shooting sessions. We'll go into detail on the advantages and disadvantages of catalogs and sessions in section 4.1.

1.6 Default Settings for Cameras

You can save default settings that are automatically applied when you open images from recognized cameras.

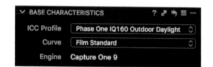

1.26 You can select the camera profile and the curve you want to use in the Base Characteristics section of the Color tool tab.

Capture One provides default settings for all the cameras it supports. These are displayed in the Base Characteristics section of the Color tool tab. ☐ 1.26

But what can you do if a particular camera always underexposes and requires you to apply an adjustment to all the images it captures? Or if you want to use a different ICC camera profile than the one Capture One recommends? If you use a pocket camera that produces a fair amount of image noise for your street photography but a high-end full-frame model to shoot landscapes, the denoising settings you use for each will be very different. And what if the sensor in an older camera always produces the same spots and dead pixels that have to be removed at the processing stage?

Many tool settings can be saved for use with a specific camera using the Save as Defaults for... command in the tool's action menu (the one with the three dots at the top right in the tool panel).

1.27 Use the action menu to save tool settings for a specific camera or reset them to the program's default values.

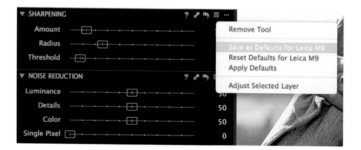

If you alter the default settings for a specific camera, the Reset Defaults command resets to your selected settings rather than "back to zero." For example, if you set default exposure compensation of −1.3 stops for one of your cameras, using the Reset command in the Exposure tool will set compensation to −1.3, not 0.

Although the defaults discussed here are camera specific, the presets described in section 1.5.2 are applied to a specific image or images, regardless of which camera they were captured with. In other words, use defaults to correct known camera issues but not for creative image processing. Most creative adjustment decisions are made independent of the camera used to capture the image.

1.7 Program Preferences

As well as setting up the interface to suit your needs, it is essential for you to familiarize yourself with Capture One's preferences settings. The Preferences dialog is located under Capture One > Preferences on a Mac and Edit > Preferences in Windows.

The Preferences dialog is where you can make global settings to suit the way you work. This dialog contains the following tabs:

- **General:** These settings govern how you zoom when using the Viewer, whether sessions and catalogs are opened in new windows, whether hardware acceleration is used, and so forth.
- **Appearance:** Sets the color scheme for the Viewer, the Browser, and local adjustment indicators.
- **Image:** Sets the preview size, enables or disables processing for various image formats, and determines how metadata is synchronized.
- **Capture:** These are the tethered shooting options.
- **Color:** Sets the desired rendering intent.
- **Exposure:** Determines when and how exposure warnings are used.
- **Crop:** These settings determine the look and feel of the Crop tool and the grid it uses.
- **Focus:** These settings determine the threshold value, opacity, and color for the Focus Mask.
- **Warnings:** Which situations require pop-up warnings?
- **Update:** Specifies how often you want the software to look for updates and how should it behave when an update is available.

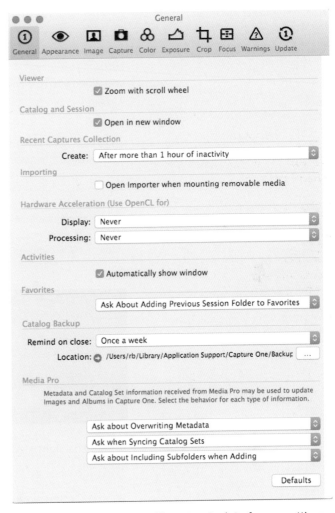

1.28 Capture One's Preferences settings are organized in themed tabs.

Most of these are self-explanatory, but we'll be addressing some of them in more detail later in this book (backups in section 4.10, and the Focus Mask in section 1.8). The following sections deal directly with preview sizes and metadata synchronization.

The best size for your preview images depends on the size of your image files and the resolution of your monitor.

1.7.1 Preview Image Size

The size you select for your previews influences the overall size of your Capture One installation. As mentioned in section 1.3, when displaying and processing images, Capture One usually uses proxies rather than directly accessing your original image files, and preview images are proxies. They are automatically kept up to date when you import images (in Catalog mode) and when you're navigating through your files and processing them during a session.

Capture One *never* uses the JPEG previews embedded in raw image files or JPEGs that come straight out of the camera. Instead, it creates its own new preview when you import new images or navigate existing ones. This means that styles you apply at the shooting stage (black and white, for example) are not visible in the Capture One raw view. It also means that it can take some time to open a folder that contains a large number of new images. Don't interrupt the creation of new preview images—if you do, you'll have to wait just as long the next time you start Capture One.

1.29 The preview embedded in the raw file (left) contains a style that Capture One ignores when it produces its own preview (right).

To find the right size for your preview images, you have to answer two questions:

- Do you often work on offline images?
- Do you use a high-dpi 4K/5K or MacBook Retina monitor?

Simply selecting the largest possible preview size costs time and processing power during image import and when you open collections. If you have a 1920 x 1080-dot monitor, this is simply an unnecessary waste.

If you *don't* often work with offline images, the size you select will depend on the resolution of your main monitor, not on the resolution of your source images. Capture One generates a 100 percent view when it needs to, thus ensuring that critical details are displayed with sufficient accuracy. In the smaller views created by the Browser or the Viewer, Capture One usually displays preview images. Always use a preview size that suits your setup and doesn't waste too much disk space.

Using previews that are two sizes smaller than maximum makes sense if you're working with the Browser, tools, and Viewer on a single monitor, whereas larger previews make life easier if you're using a dual monitor setup or working with the tools hidden. If you work with your images displayed in full-screen mode on a second monitor, you can set the preview size to match your monitor's resolution.

In offline mode, Capture One doesn't have access to your original images and always uses its internal previews. In this case, you should always select the maximum preview size; this enables you to produce large copies of your images regardless of whether the disk that contains the originals is online, or if you have accidentally left your external disk in the studio.

If you often work in offline mode, set the largest preview size that matches the resolution of your source images.

Catalogs and sessions can quickly get quite large if you're working with large previews. Solid-state drives (SSDs) require some free disk space to work at maximum speed, so it pays to keep 10–15 percent of your disk free. If you start running out of space, you can either reduce the size of your previews or save parts of your catalog/session to a separate disk.

1.7.2 All About XMP Synchronization

When selecting your options in the Metadata section of the Image tab in the Preferences dialog, you need to consider the following:

- Does third-party software (another database, for example) require access to the metadata stored with your raw files?
- Do you want to limit third-party software access to the metadata in image copies?
- How do you want Capture One to react if third-party software such as Media Pro alters metadata?

Metadata

Auto Sync Sidecar XMP: None
☑ Prefer Embedded XMP over Embedded IPTC
☑ Prefer Sidecar XMP over Embedded Metadata

Defaults

1.30 The Metadata options you select have significant consequences.

If you manage your images in a Capture One catalog and develop them exclusively in Capture One, you don't have to synchronize your metadata (that

is, you can select the None option in the Auto Sync Sidecar XMP drop-down list). In this case, Capture One manages keywords, color tags, descriptions, albums, and so on exclusively in the current catalog or session and doesn't hand over metadata to the filesystem that contains the original files.

Only use the Full Sync option in exceptional circumstances.

Thing are more complicated if you use a third-party solution to manage your image files. Full Sync sounds good, but isn't necessarily the best option in a number of situations. With this option selected, Capture One always loads the metadata from the original files (or their XMP sidecar files) and also writes any changes you make to metadata in real time. This slows down processing, especially if you're using a slow or full disk. More important, it can also cause sync conflicts between Capture One and your DAM system, either because the network connection is down, someone else is keywording images while you work, or simply because there's a full moon!

> QUICK TIP
> Only use the Full Sync option if you usually work alone and your system has a fast main disk. If either of these criteria isn't met, it is better to sync meta-data as required by right-clicking a selected image—for example, if you have finished a processing session and wish to continue organizing your archives.

If you use a third-party DAM system, the best option is Load. Choosing Load forces you to perform all metadata management within your DAM environment. Ignoring Capture One's metadata tools this way ensures that all metadata is written in a consistent format without the risk of conflicts, and also means that Capture One always loads the newest available metadata and embeds it in any images that you output.

> Regardless of which metadata options you select, Capture One never alters your original files or the metadata they contain. However, if you select Full Sync it will write changes to existing XMP sidecar files and create new XMP sidecars for DNG files, even though it could theoretically write data to the existing XMP area of the DNG. If your system includes third-party applications, make doubly sure that your backups include XMP sidecar files, especially if you're working with DNG files.

1.8 Global Tools

In addition to the Cursor tools mentioned earlier, Capture One has a set of global tools that you can apply anywhere at any time. Some of these are Cursor tools, whereas others are functions that can be accessed via the program's menus. The following sections address the Loupe, the Focus Mask, the Copy Adjustments/Apply Adjustments function, and the Exposure Warning tool.

1.8.1 The Loupe
One of the tools that made Aperture famous was its free-floating loupe tool that made it unnecessary to continually zoom in and out to check the effect of an adjustment. Although it is implemented as a Cursor tool, Capture One Pro's Loupe tool has the same functionality.

The Loupe has two modes:

You can use the Loupe in the Viewer and the Browser/Filmstrip.

- Floating: You click the tool's button and then click in the Viewer or Browser image you wish to inspect.
- Zoom In/Out: In this mode, clicking within the image zooms in or, with the Option/Alt key pressed, zooms out.

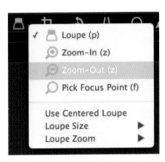

QUICK TIP
The second mode listed is already implemented via the scroll wheel, so you're unlikely to use it much. However, if you use a graphics tablet without a scroll wheel, you can use the Z shortcut to change the Viewer magnification without having to move your pen to the Viewer toolbar and back.

1.31 You can access the Loupe by either clicking on its icon in the toolbar or using the P keyboard shortcut.

The floating loupe is great for checking focus and overall sharpness and is one of the reasons that most raw developers now include the same functionality. Unfortunately, the Capture One version cannot be used while other tools are active. This is because it is a tool in its own right and only functions for as long as you keep the mouse button pressed.

1.8.2 Copy and Apply Adjustments
The Copy Adjustments/Apply Adjustments function appears at first glance to be a Cursor tool, although it is actually available everywhere within the program and is one of the cornerstones of the Capture One system. Note that even if you have clicked the "Edit selected variants" button, you're still only working on the currently active image. In many (but not all) cases, Capture One applies your adjustments to the other selected images in the background.

One of the central elements of the Capture One philosophy is its ability to copy adjustments and apply them to other images.

1.32 The Stack icon toggles between editing the primary image and all selected variants. The primary image is indicated in the Browser by a thick white border.

Capture One differentiates between primary and other active images to enable you to compare versions (see chapter 3) and to select a "master" image from which to copy your adjustments. Legacy versions of the software were only capable of processing a single, "primary" image.

Batch Processing with a Master Image
If you've captured a sequence of images that you wish to process using adjustments you've made to the best image of the set (that is, the "master"), proceed as follows:

1. Click the "Toggle primary / selected variants" button in the toolbar. It will turn orange.
2. In the Browser, select the images you wish to process. To select all images, click the first one, press the Shift key, and then click the last image in the sequence. To select individual images, press the Cmd key (Mac) or the Ctrl key (Windows) and click each image separately.
3. Now click the image you want to use as the master. It will be highlighted with a thick white border and the other images will remain selected.

1.33 The entire sequence is selected and the master highlighted.

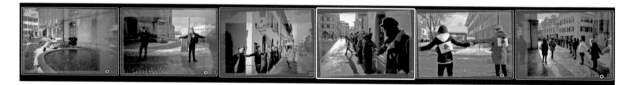

4. Process the master image as required. When you use presets or automatic corrections on the master image, Capture One will update all the selected images to reflect your adjustments in real time.
5. That's it! You have processed the entire sequence in one go. To deselect your sequence, click an image that wasn't selected during the previous steps.

As I said, this technique works with many of Capture One's tools, but not all of them. The scope of supported tools changes with every point-release of Capture One Pro, but it's growing. To be on the safe side—to make sure all of your edits make it through to all variants—use the Copy/Apply tool as outlined below.

It is really simple to apply adjustments you have made to other images. All you have to do is copy the adjustments from an image and click on an image in the Browser using the Apply tool.

1. Right-click an image whose adjustments you wish to copy and select the Copy Adjustments option from the context menu.
2. Switch to the Apply tool either by clicking it in the toolbar or using the A shortcut. The cursor will then turn into a broad arrow.
3. Click all the images in the Browser that you wish to apply the adjustments to.

1.34 The Copy/Apply tool does just what it says, enabling you to copy adjustments you have made and apply them to other images.

1.35 Here, we have copied the monochrome adjustment from the primary image in order to apply it to other images in the Browser.

> **QUICK TIP**
> The Apply tool applies the adjustments that are currently located on the Capture One Adjustments Clipboard. This does not necessarily include all the adjustments you have made to an image. As described in section 1.5.2, you can use the double-arrow button in a tool's panel to select individual adjustments. If you want to copy settings from multiple tools to the clipboard, select them in the Adjustments tool tab and apply them using the Apply tool. For more details, see chapter 11.

1.8.3 The Focus Mask

The Focus Mask is primarily a studio tool but can be useful in other situations.

The Focus Mask is designed to help you quickly find the photos in a series in which the desired elements (a portrait subject's eyes, for example) are in focus. The tool is often but not always effective. Used with the right settings, it can definitely save you a lot of time. This section explains how.

1.36 Does lots of green mean plenty of in-focus detail? Not necessarily...

But what is the Focus Mask anyway? In principle, it works like the focus peaking feature found in many cameras, analyzing local contrast in the images displayed in the Browser. If the tool's algorithm finds high levels of contrast, it assumes that the image is in focus and highlights the in-focus areas in green. You can alter the degree of precision the Focus Mask works with by using the settings in the Focus tab in the Preferences dialog. ☐ 1.37

The Opacity and Color settings determine how the mask is displayed and are easy to set, but it is trickier to find the right setting for the Threshold slider. It offers values from 200 to 500 and the higher the number, the greater the contrast between details has to be before the tool assumes that the image is in focus. In theory, lower values ignore image areas that aren't perfectly sharp.

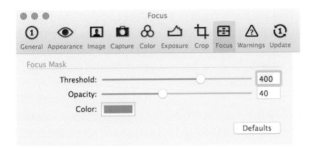

1.37 Although their scope is limited, it is worth taking a look at the options available for tweaking the Focus Mask.

In practice, the optimum setting depends on which camera you use and how it is set up. The larger the pixels in your camera's sensor and the closer the ISO value to its default setting, the lower you need to set the Threshold value. Conversely, the smaller the pixels and the noisier the image, the higher you need to set Threshold. Phase One recommends using a value of 250 with its medium-format IQ cameras, which have extremely large pixels. A 24-megapixel full-frame camera with a sensor half the size of those in the IQ cameras requires a much higher value if you want to produce usable results.

1.38 These two images show the effect of applying different Threshold values in the Focus Mask—on the left, using the default value for medium-format cameras and on the right, our tweaked value of 400.

QUICK TIP

The best way to find the optimum Threshold value is to experiment. Select an image with an obvious plane of focus and plenty of out-of-focus details, such as one captured at maximum aperture. Activate the Focus Mask using the toolbar button or via the View > Show Focus Mask command. Adjust the Threshold slider until only the details you know to be sharp are highlighted. Do the same for all your cameras and all the ISO values you use regularly and note the results. Remember, though, the values you end up with are approximations and the Focus Mask is rarely precise.

The tool is rarely precise and you have to find the right Threshold value for every combination of camera and ISO value you used to capture your images. So why bother using it at all? The answer is simple: using it is still the fastest way to find the best images in a batch.

Using the Focus Mask together with the Loupe makes it much easier to find the key images in a sequence.

It is always hard to find the key images in a sequence of shots of moving subjects such as models, athletes, or cars. Focusing perfectly on a player's facial expression or a motocross bike's wheel can depend on just a couple of millimeters of movement, and combining the Loupe with the Focus Mask is a great way to find the images that worked:

1. Hide the Viewer to make the Browser display as large as possible. Use the View > Hide Viewer command or the Cmd/Ctrl+Option/Alt+V shortcut.
2. Activate the Focus Mask and set the Threshold value that you have calculated for the camera and ISO value you used. The previews in the Browser will now be highlighted accordingly.
3. Activate the Loupe Cursor Tool (shortcut P) and click the images in which the Focus Mask appears to be correct. The Loupe displays the 100 percent view of the appropriate details without the highlight color, enabling you to see at a glance if the selected detail is in sharp focus.
4. Color tag or rate the best images in your sequence.

1.39 Using the Focus Mask and the Loupe is much quicker than in zooming in individually on hundreds of images.

1.8.4 Exposure Warnings

Capture One's exposure warnings work the same way as the ones built into your camera, highlighting under- or overexposed image areas. The difference is that you can precisely set the Threshold value at which the tool kicks in.

Like the Focus Mask, the Exposure Warning feature is designed help you form a quick impression, this time of the state of the image you're working on.

1.40 Almost the same: exposure warnings on a Leica M9 and the Capture One version in red and blue

The Exposure Warning tool is dynamic and analyzes the current state of your processed image rather than the original, static raw image data. This makes it much easier to effectively apply an exposure correction (see section 6.1) or a Highlight adjustment in the High Dynamic Range tool (see section 6.2). All you have to do is adjust the sliders until the image areas you wish to recover no longer display a warning highlight.

Like with the Focus Mask, the effectiveness of the exposure warnings depends on selecting the right Threshold value. ▢ 1.41

Exposure and shadow warning values range from 0 to 255—the entire 8-bit luminance range. The warning highlight kicks in when highlights threaten to burn out, and if activated, shadow warnings indicate when shadow detail begins to disappear.

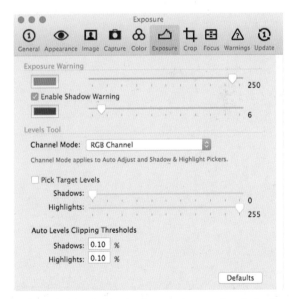

1.41 Set the Threshold value for exposure warnings in the Exposure tab in the Preferences dialog. Shadow warnings are deactivated by default.

QUICK TIP

The best settings for the exposure warnings depend on the camera you use and how it is set up as well as on your personal preferences. Use a high-key image with plenty of highlight detail to determine the best Exposure value and one with slight shadow detail to find the optimum Shadow Warning value. If you use multiple cameras with different dynamic ranges, note the values you assign for each. If your cameras have similar dynamic ranges, you can use the same values for all of them.

2 Hardware

Capture One requires a computer with plenty of processing power to run. This chapter addresses choosing Mac or PC, selecting the best type of graphics card to use, using the software on multiple computers, and using accessories such as a graphics tablet or a colorimeter.

Technology changes rapidly. Just a short time ago, only the rich could afford high-dpi (4K or 5K) monitors, whereas they are now virtually standard in new computers. The following sections don't contain hardware recommendations but instead explain what you need to work effectively with Capture One and when it makes sense to invest in a hardware upgrade.

2.1 The Oldest Question in the Book: Mac or PC?

Until recently, it was assumed that most "serious" photographers and graphic artists use Mac computers. Apple's reputation for efficiency and effectiveness in creative spheres is still very good, but Windows systems have begun to catch up and, in some cases, overtake Macs:

Capture One offers the same functionality for Mac and PC users; only a few minor details differ between the two versions.

- Windows has supported 10 bpc (bits per channel) color for several years. This means that if you use a suitable graphics card and monitor, you can reproduce 1,024 tones per color channel, which in turn gives you more than a billion colors to play with. The current Mac Pro is still limited to 8 bpc (256 tones per channel and a total of 1.6 million colors). This gives you plenty of scope but is simply not as good as Windows if you depend on extremely precise color rendition. There are hints with the latest generation iMacs that Apple will finally hop on the 10 bpc bandwagon, but how well it will work out is still open to debate.
- Windows computers are a lot easier to upgrade. Graphics cards and CPUs can be swapped out in minutes, whereas Apple now solders more and more components permanently to the motherboard, and some models don't even allow you to swap out their RAM. If your new camera produces images that are four times larger than those produced by your old one, you might just end up having to buy a new Mac.
- Comparing computing power alone, Windows computers are cheaper than Macs and save you money that you can sensibly invest in better lenses or a second camera body.

The major advantage of a Mac is that the system comes preconfigured and you don't have to make any effort deciding which components to use. In the Windows camp, even if you buy a preconfigured workstation from HP or Dell, you still have to regularly update your drivers and test which version works best with your software. With Mac systems, all necessary upgrades are included in regular, all-in-one system updates.

Put simply, you have to choose between greater flexibility but more effort (Windows) and simplicity with less flexibility (Mac). So what does all this mean for Capture One users?

2.1 The Mac and PC versions of Capture One are virtually identical, both visually and technically.

The Mac and PC versions of Capture One offer pretty much the same functionality and virtually the same handling. The only real exception is that you can operate the Mac version using AppleScript, whereas scripts are not available for the PC version. You can, however, control the PC version using third-party macros (see section 15.3). The other differences are extremely minor and extend to a couple of variations in keyboard shortcuts and the workspace presets included with the program (see section 1.5).

> **QUICK TIP**
>
> Most of you will already have a PC or a Mac. However, if you're about to decide which "ecosystem" to buy into, you need to consider what you'll be doing with your computer other than using Capture One, and you should also look into the other software you'll need. Even if Capture One works the same in both environments, things probably look very different when it comes to running accounting or word processing software. The only factor that speaks specifically for choosing OS X is the AppleScript option—if you need to automate your Capture One workflow, go for a Mac.

2.2 Choosing the Right Hardware

"More is better" is a simple maxim that certainly applies when it comes to selecting hardware to use with Capture One. Today's cameras produce images with 40 or 80 megapixels—and more—that your computer has to juggle in its RAM and that Capture One has to handle. If you then incorporate your processed image in a photomontage or print it at poster size, it quickly becomes clear that you need *plenty of RAM* to keep things running smoothly. Capture One is a 64-bit application and generally uses as much RAM as it can. Don't skimp on RAM—8 GB is the minimum requirement and 12 GB is better.

The more memory the better—you need at least 8 GB to make working with Capture One a smooth and pleasant experience.

The same applies to hard disk space. Large image files from a medium-format camera have to be copied, moved, read, and written, so the faster your main disk the better. If you're about to upgrade your computer, investing in an SSD will benefit you more than purchasing a new CPU. The (networked) FireWire or USB disks you use for your archives don't have to be as fast but require plenty of space. If you shoot tethered, your main disk works like an extended memory card, so the faster your disk and the connection between your computer and the camera, the better the system can keep up with the large amounts of data that flow from the camera during a session (see chapter 14).

You need plenty of fast disk space when working with Capture One, especially in tethered shooting situations.

Capture One is a *multithreaded* application. This means it can run multiple parallel tasks on multiple processors. Since the release of version 7, these can be CPU cores or graphics processors.

To display adjustments in real time and quickly create copies of finished images, Capture One uses OpenCL to farm out some of its processes to your computer's graphics processor. If Capture One supports your particular graphics unit, you'll notice an obvious increase in performance, with immediate zooming in and out even with very large files and super-fast output of finished images. If your work demands that you produce hundreds of images per session, using fast hardware will save you hours of waiting in the course of your daily photo workflow.

The CPU and graphics card work in tandem, so Capture One benefits from a powerful graphics processor—provided, of course, that it is properly supported by the system.

2.2 You can select OpenCL for display and processing in the Preferences dialog's General tab. If an option causes processing errors, simply uncheck it.

The CPU is nevertheless an important factor. Currently, not all of Capture One's tools can be farmed out to the graphics processor and you'll probably want to use your computer to do other things, too. In other words, it is not only the graphics processor itself but also the balance between CPU and graphics power that is crucial.

> **IMPORTANT**
>
> OpenCL stands for the Open Computing Language designed for distributing tasks between CPUs, graphics cards, signal processors, and the like. When you start it, Capture One creates an OpenCL kernel that depends on smooth cooperation between the program and your graphics driver software. Sometimes, system or program updates break the setup, causing display errors or producing image copies with unwanted stripes or other glitches. Incompatible drivers can even cause Capture One to crash. Test output with activated OpenCL before you use it to process batches of images. If you aren't sure about the quality of the results, it's better to switch off OpenCL support and wait a little longer than it is to risk producing a whole series of flawed images.

A list of the graphics cards that Capture One supports with OpenCL is available in article 1720 in the knowledge base at www.phaseone.com/support. The following criteria have to be met for OpenCL to work properly:

- Your graphics card has to have at least 1 GB of video memory. If it has less, Capture One won't activate OpenCL, even if it supports the graphics processor in question.
- The larger your image files, the more video memory you'll need to process them using OpenCL.
- Outputting your images requires more video memory than processing. If your image output shows errors, use only OpenCL display support.

If you discover display errors within Capture One, processing with OpenCL probably won't work properly either.

Do some tests. Output a selection of your images with OpenCL activated, then deactivate it, restart Capture One, output the same images again, and compare the amount of time it takes. This way, you can check directly whether using OpenCL speeds up your workflow. If not, you can save yourself the hassle of the potential problems listed here and leave OpenCL support deactivated.

> **QUICK TIP**
>
> Obviously, Capture One benefits from being run on a fast computer, although all the components of a system have to be well tuned to provide the best results. You need a fast hard disk to review your images, plenty of RAM to display large files, a fast CPU for smooth output and, ideally, a fully supported graphics card. Don't make the mistake of investing too much in one part of your system. Invest wisely and don't forget to consider the other things you want to do with your computer—if your other work involves a lot of processing but not much graphics power, you're better off investing in a faster CPU than a high-end graphics card.

2.3 Using Capture One with Multiple Computers or on a Network

Many of today's photographers use more than one computer: a notebook for work on the road or tethered sessions and one or two workstations for work at home or in the studio. Capture One's licensing terms allow the use of the software on multiple computers in various ways.

As mentioned in section 1.2.1, nonsubscription licenses are available in single- and multiuser packs. A single-user license is for you alone, and you are allowed to install the software on two computers simultaneously. However, as soon as multiple users come into play, you have to purchase a multiuser license, which then determines the number of computers you can use the software on, rather than the number of people who can use it—in other words, it doesn't matter who is actually using the computer.

Once you have purchased a license, Capture One has to be activated online. Phase One's servers then compare the number of active users with the license you have purchased. If you have a single-user license, you can use it on only two computers. If you have three or more computers, you either have to deactivate the software on one machine before activating it on another, or purchase an additional license via the Capture One > License command.

2.3 The License dialog shows when and how often you have activated Capture One and tells you how many activations you have left. Always deactivate unused licenses before you uninstall the software.

Capture One works seamlessly in networks and with multiple simultaneous users.

Aside from the licensing stipulations, you're sure to be asking yourself *how* you can use Capture One on multiple computers. You have three options:

1. Each machine has its own catalogs and sessions, and you copy or move individual images between installations.
2. You keep a single set of catalogs and sessions and move them between machines as necessary.
3. You use a single set of networked catalogs and sessions and access the same ones from each machine.

Option #1 is useful if you use different computers for different types of work—for example, if you manage your archives on your workstation at home but use your notebook for individual jobs. Once a job is finished, you copy your images and adjustments to your main computer and continue working there. If you're working in Session mode, you can either copy the entire session (see section 4.1.2) or bundle your original raw image files with your adjustments in an EIP file, which you can then import into your main catalog (see section 4.3).

Option #2 is trickier to implement but can be useful if, for example, you have two homes or studios and wish to have access to your entire archive at both. If you decide to take this approach, use fast portable storage such as a USB 3.0 external disk. You can then open catalogs and sessions by double-clicking or dragging-and-dropping them.

Option #3 is ideal for agencies. Since version 7, Capture One has been fully network capable. Sessions consist of simple folders of images and adjustment data (see section 4.2) and are well suited to being centrally managed. Catalogs, too, are multiuser compatible and work fine when saved on a network. If necessary, you can use the File > Lock Catalog command to ensure that no one else attempts to change its contents while you work. In both cases, all settings, adjustments, variants, and so forth are saved in the corresponding session or catalog. In a network environment, your local installation works as a "client" and the network-based catalog or session as the "server." For this approach to work, you need constant access to the network—your original files, your previews, and your adjustments are no longer stored locally. If you're using a notebook—for example, on-site with a client—you need to add the appropriate images to the network catalog when you're done, as described in option #1.

2.4 Graphics Tablets and Other Input Devices

2.4 Capture One has excellent support for graphics tablets but works fine with other types of input devices as well.

Most people who work with computers do so with one hand on the mouse and the other on the keyboard. This approach works well with Capture One, and its mostly single-key shortcuts mean you don't have to perform complex finger gymnastics to access specific tools and functions. Since the release of version 8.1, you can make adjustments to most tool settings via the context menu accessed by right-clicking in the Viewer—that is, you don't have to constantly trail back and forth between the tool panels and the Viewer with your mouse. Whether you use a mouse or a trackball is up to you.

Even local adjustments (see chapter 10) are quite easy to perform using a mouse and a keyboard. Many graphic artists and illustrators don't use graphics tablets simply because they are used to working with traditional input methods, whereas others—often for health reasons—prefer pen-based input. If you do decide to use a graphics tablet for whatever reason, rest assured that Capture One is well set up for use with this type of input device.

How you set up your graphics tablet depends on your personal preferences and the functionality the tablet offers. Some are quite simple, whereas others have sets of freely programmable buttons or parts of the active area that you can reserve for use with macros or selected program functions. Some people prefer to use the pen button like a right-click; others use it in place of a scroll wheel. The following tips will help you get the best out of Capture One when you use it with a graphics tablet.

2.5 The brushes used to make local adjustments can be set up to react to pen pressure.

◉ Capture One's default settings use the scroll wheel to zoom the Viewer. If you want to control the software using a pen only, deactivate this feature in the General tab of the Preferences dialog. This prevents unwanted scrolling if you accidentally trigger a scroll function in the tablet's driver. The best way to control scrolls is by using keyboard shortcuts or the zoom slider in the Viewer window.

◉ If you usually use a mouse but prefer to use a pen when refining masks, enlarge the active area to match the surface area of the Viewer. You can then work more accurately and still control the tools you use with shortcuts or context menus.

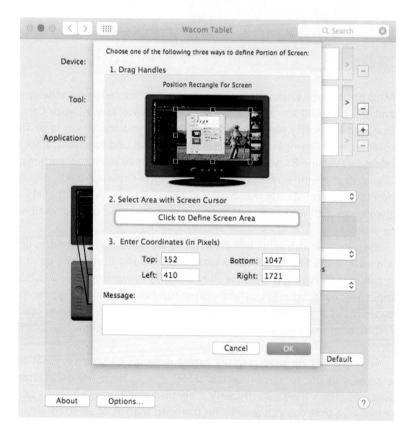

◉ Assign functions to your tablet's custom buttons that suit the way you work with Capture One. For example, if you often use context menus, it makes sense to assign a right-click to one of the custom buttons. Or perhaps assign to a free button one of the Cursor tools you most often use.

It's up to you to decide which functions to assign to your tablet's buttons. Capture One's ability to assign keyboard shortcuts to menu commands enables you to perform virtually all of your everyday workflow using a graphics tablet.

2.6 Used with the customization functions in your graphics tablet's driver, the Edit Keyboard Shortcuts dialog enables you to set up Capture One so that you can control it almost entirely using the pen, context menus, and the tablet's function buttons.

QUICK TIP
It's all in the mix. Even if you can control Capture One using a graphics tablet, some functions—entering keywords or altering metadata, for example—are simply easier to perform on a keyboard. Some functions are also better suited to use with a mouse than a pen. Don't cramp your style by trying to use just one input device all the time. Instead, use the device that's best suited to the task at hand.

2.7 The View menu includes the command for selecting your desired proof profile. The program makes suggestions, but you can also set it up to display all the profiles currently installed on your computer.

2.8 In the Capture One profile chain, the proof profile comes into play right before the monitor profile.

2.5 ICC Profiles: The Importance of Profiling Your Monitor

In section 1.4, we discussed how Capture One deals with various types of color profiles. However, your monitor plays an extremely important role in helping you assess your work for output on other devices and in other media.

"Soft proofing" is a term that comes from the printing industry and means using a precisely calibrated monitor to check how the colors in a document will look in print. Offset printing techniques are cheap when it comes to producing bulk print runs, but creating a single test print is comparatively expensive. Colors have to be mixed, printing machines fine-tuned, rolls of paper mounted, and so forth, so it makes sense to use digital tools to minimize the amount of resources used when proofing. Capture One's proof profiles fulfill the same task by simulating various types of output on your monitor before you go ahead with a print or send your work to the layout department—a layout department that doesn't want to have to send your work back because shadow detail is swamped.

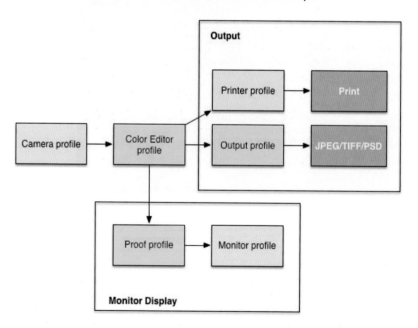

The diagram shows that Capture One always uses the monitor profile to create the colors displayed in the Viewer and the Browser, even if you select View > Proof Profile > No profile. It also illustrates the importance of matching preceding and subsequent profiles in order to avoid color reproduction or rounding errors. There is little you can do to optimize the camera profile (see section 5.1), but it is simply negligent if you don't take the trouble to optimize your monitor profile.

ICC monitor profiles are available in various versions. Not all manufacturers adhere strictly to the same standards for profile creation, and some programs support different types of profiles anyway. Some manufacturers have gained a reputation for providing "broken" profiles that programs such as Lightroom or Capture One cannot read.

This means that the program ends up displaying images without involving the monitor profile at all, producing significant color casts on the monitor that don't actually exist in the image file. You will probably then attempt to "correct" the colors, but that leads to overcompensation because correct colors are simply being incorrectly displayed. The result of all this confusion is that the finished image looks totally different than how you originally intended, regardless of which application you use to view it. Things get even more complicated if you have prints made by an online service or specialist lab—that's when the whole exercise gets expensive, probably costing more than a dedicated monitor-profiling device.

2.9 The profile provided with this monitor obviously has issues. The left-hand version was displayed with the profile activated, the right-hand one without.

> **QUICK TIP**
>
> Colorimeters are quite cheap and enable you to analyze your monitor and create your own custom ICC profile. Such profiles are usually more accurate than those provided by monitor manufacturers. If you have some money to burn, I definitely recommend purchasing a colorimeter over a new camera bag. Datacolor and X-Rite offer a range of devices to suit every budget.
>
> The fact that you profile your monitor at all is much more important than *how* you profile it. The profile describes your monitor in a way that enables Capture One and other image-processing programs to produce predictable results, whether digitally or in print.

3 The Workflow Pipeline

In the course of this book, I use the term "workflow pipeline" to describe the sequence of modules, tools, and processing steps that your images pass through within Capture One. You'll come across this term regularly in many of the following chapters.

Capture One enables you to work as you like, but using a structured sequence of processing steps still saves a lot of time.

Section 1.3 introduced the Capture One rendering pipeline and describes how the software links the color and device profiles involved in the raw development process to produce human-readable images from raw image data. The workflow pipeline is based on the same principle and describes how raw image data is altered by the tools you use and the processing steps you apply.

The same way your images are passed along a chain of color profiles, Capture One puts them through a sequence of tools and tasks, from the initial import (or opening) step, all the way through to printing and archiving the results.

As you saw in chapter 1, Capture One Pro is highly configurable and can be set up to suit your individual needs and preferences. It doesn't matter whether you work with panels or tabs, or a combination of both. The order in which you process your sessions or organize your catalogs is also irrelevant—you can add keywords before or after basic processing and batch-convert the results to black and white, or convert your images first and keyword them later as you wish. In theory, none of this makes a difference in how you work with Capture One.

However, practical experience has shown that the sequence you adopt can make working with Capture One more, but also less, practical. As mentioned in chapter 2, the hardware you use plays a role too. For example, if you do not make use of OpenCL hardware acceleration (see section 2.2), the Film Grain tool uses a lot of processing power and will slow you down unnecessarily if you apply it as the first step in the chain.

You need to question your general methodology, too. For example, it makes no sense to add multiple keywords to an entire sequence of images (see chapter 12) if you end up removing half of them from your catalog later on. If you aim to produce a sequence of monochrome images, you don't need to correct the white point (see section 5.3), but you do need to take a close look at the histograms (see section 5.2). The list of such considerations could be extended indefinitely.

In short: Even if Capture One allows you to work as you wish, or perhaps the way you are used to working in Aperture or Lightroom, you'll benefit from taking a close look at the sequence of steps you apply. This is where the "workflow pipeline" concept comes in.

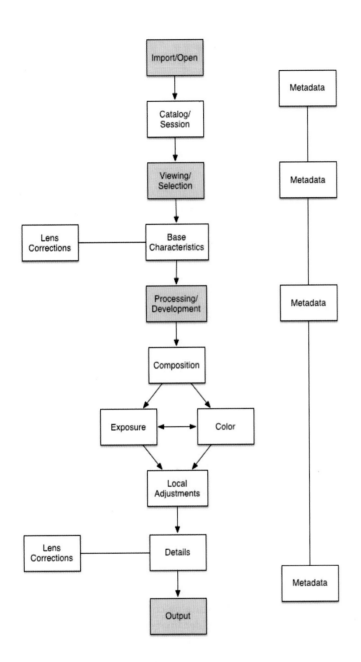

3.1 An overview of the workflow pipeline. Processing steps and other tasks have white backgrounds; the specific tools and tabs involved are colored orange. Lens corrections occur twice because the tools involved cover two different types of task.

There is no "correct" sequence for applying processing steps in Capture One, and no particular workflow is set in stone. You have to decide in each new situation how to approach the job at hand. The workflow pipeline is there to help you organize your work simply and systematically. You may find that you can use the same sequence for all the jobs you do. But if you find yourself in an unusual situation, understanding the individual elements that make up the pipeline will definitely help you optimize your workflow.

4 The Library Tool Tab

Capture One Pro lets you decide how to manage your image archives: within Capture One or using a separate database—or perhaps using a traditional folder structure. This chapter introduces the options available in the Library tool tab and looks at various ways of managing the mass of data that a modern digital photo workflow produces.

4.1 Catalog, Session, or Both?

Catalogs and *sessions* are the primary methods of file organization offered by Capture One. You can combine the two within certain limits, but it usually makes more sense to use one or the other.

> **IMPORTANT**
>
> Whether you use catalogs or sessions is a matter of personal preference. If you already use a media database or a dedicated DAM system such as Media Pro, there is no real point in using a catalog, and opening a session is definitely the right approach. If you prefer to organize your images within a traditional folder tree, sessions are the answer. In other situations, it is up to you to decide whether you're comfortable using catalogs. Give yourself time and experiment with catalogs and sessions before you decide which to use. You can swap from one to the other later if you need to.

4.1.1 Catalogs

Catalogs manage your image files, develop settings, and metadata.

Technically speaking, a Capture One catalog combines a database and, if required, your image files in a single folder. Images have to be imported into the catalog before you can process them. The program then "knows" the location of each imported image and automatically manages them within your filesystem.

In other programs, catalog-style structures are often called the "library" or "media library," and the terms are quite apt. Just as books in a library are indexed and cross-referenced, a Capture One catalog manages your images automatically according to where they're physically located. Only the program is allowed to alter the location of an image, just as librarians are the only people allowed to reorganize the locations of books.

If you work with catalogs, major processes such as keywording, adjustments, handover of images to third-party software, and image export *always* take place within Capture One, never within the filesystem or managed by third-party software. There are no exceptions to this rule—in catalog mode, Capture One is the interface to your entire photo workflow.

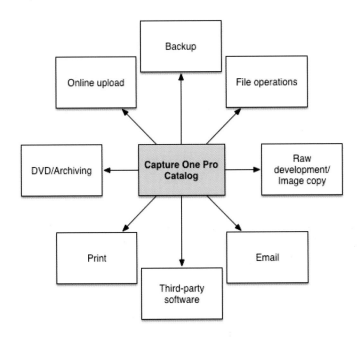

4.1 *Catalog mode is the cornerstone of the Capture One workflow.*

The catalog database contains all of your adjustment settings and metadata such as ratings, color tags, keywords, and keyword libraries. Using collections and albums (see section 4.5) or filters (see section 4.6) enables you to keep control of your archives. The actual physical location of your image files is irrelevant, and Capture One automatically keeps track of where they are.

> If you are not used to using a database to manage your images, you may be reluctant to allow the computer to decide where to store your files. Remember, though, that Capture One never alters your original files, and in an emergency, you can always find your originals using the search functionality built into your computer's operating system, even if you have handed over the day-to-day organization of your photos to the catalog.

You can save your original raw files as part of the catalog or elsewhere within your system. If you use the catalog, it becomes a single, central container for all aspects of your photo workflow. If you don't, the catalog contains links to your image files, which remain stored elsewhere. Both approaches have advantages and disadvantages.

4.2 *The PC catalog folder (left) and the Mac catalog package (right) contain all data relevant to your image archive. You can show the contents of the Mac package by right-clicking the folder and selecting the Show Package Contents option.*

If you save your images within the catalog, your develop settings, color and lens profiles, raw originals, and the logical structure of your albums are stored together in one place. This makes backups simple and keeps your filesystem tidy. The downside of keeping everything in one place is that the catalog folder quickly gets quite large, which can be a problem for notebook computers with low-capacity disks.

If you use linked image files in your catalog, you can store your original files on a network or external USB/FireWire drive. This limits the size of the catalog folder on your main disk and your storage disk doesn't have to be as fast (or expensive) as your main disk.

> **QUICK TIP**
>
> Whether you store your originals within the catalog or elsewhere, it is essential to give your files meaningful names and organize them in sensibly named folders. This way, you can easily find individual images and folders if you switch databases or go back to using a simple filesystem at a later date. You can do a lot toward keeping your images organized during import. See section 4.4 for details on import strategies.

Capture One can simultaneously manage multiple catalogs, and you can drag and drop files from one catalog to another. This means you can, for example, create a separate catalog for each of your clients and avoid the potential risk of sending someone the wrong file. You can also use catalogs to organize multiple long-term projects or themes—for example, you could manage your street photos in one catalog and your landscapes in another. Multiple catalogs mean less complex metadata and make it simpler to maintain clear and meaningful keyword lists for each. See chapter 12 for more on metadata and keywording.

4.3 *The Library module lists all the available catalogs in a drop-down list.*

4.1.2 Sessions

Using sessions is the most common approach to working with Capture One Pro. As explained in chapter 1, sessions owe their existence to Capture One's roots in studio photography. Unlike catalogs, sessions do *not* contain the images themselves and instead provide a standardized working environment that operates at a filesystem level. Opening a new session creates a new session folder with predefined subfolders.

A session contains a set of predefined folders created separately for each new project.

4.4 Sessions always have the same basic structure. The subfolders have nothing to do with data management and are designed solely to provide a standardized working environment.

The Capture folder contains images captured during tethered shooting sessions (see chapter 14 for more details). The Output folder contains your processed images, and the Selects folder contains images chosen using the Move to Selects Folder command (usually the key images in a sequence). Trash is self-explanatory.

Because sessions always have the same structure, it is simple to write automation scripts and set data paths in third-party programs.

You don't have to import images if you work in sessions, and you can open an image simply by right-clicking it or dragging and dropping it into the session window. The file in its original location remains unaltered. Finished images that are ready for output are always stored in the current session's Output folder.

Sessions are also useful in multiuser situations. Imagine a typical studio situation in which the photographer has captured images in the Capture folder on a computer and another member of the team views them and moves potential key images to the Selects folder. The same folder is selected in the Capture Pilot iPad app (see section 14.7) to allow the client, who is present at the shoot, to check work in progress and provide feedback. The client rates his or her favorites on the iPad while a media designer in another room accesses the Selects folder via the network and begins developing the client's favorites. The designer then saves the processed images in the Output folder, where the layout team picks them up and begins to prepare them for printing.

You can perform the same workflow using catalogs, but sessions are a proven and robust tool with a relatively low network overhead.

> **QUICK TIP**
> Team scenarios are, of course, irrelevant for freelancers working alone, although you can use the same principles within the bounds of your existing software infrastructure. If you add the Selects and Output folders to your database (such as Media Pro or Lightroom) as monitored folders, your key image files and processed copies will be automatically copied to your master archive without having to import them or move them manually.

4.5 You can have your image database monitor the standardized session folders so your key images and processed copies will automatically find their way into your master archive.

4.2 Default Folders and Folder Structures

At a first glance, the title of this section appears to contradict some of the ideas introduced at the beginning of the chapter—at least when it comes to using catalogs rather than sessions. Don't you want to avoid working with folder trees?

The truth is you want to reduce the amount of work you have to do within your folder structure, but you can't avoid the fact that catalogs require predefined folders to work in the first place. However, the folder structure is hidden to keep things simple for the user. If you've decided to use catalogs and want to know what Capture One does with your images while you work, read on.

4.2.1 Catalog Folders

As noted in the previous chapter, a catalog can contain a variety of things. Whether you store your image files within the catalog or elsewhere, the catalog itself will always contain the following subfolders and files:

A catalog isn't a self-contained database, but rather a folder stored within your computer's filesystem. It needs to be located on your fastest disk.

4.6 The structure of a default catalog folder

[catalog-name].cocatalogdb: This file is the core component of your catalog. It consists of an SQLite database that contains all metadata such as keywords, exchangeable image file format (EXIF) metadata from the original files, collections, albums, develop settings, and so on, and also records where your original raw files are stored.

The catalog folder appears on a Mac as a package file. To view its contents, right-click it and select the View Package Contents command from the context menu.

> **IMPORTANT**
> This file is the most important component of the catalog, and Capture One backs it up regularly. Backups are made when a catalog is closed, and you can select an appropriate interval in the General tab in the Preferences dialog. You can choose every time you close the catalog, once a day, once a week, once a month, or never. The last option leaves it to you to make manual backups whenever you see fit.

4.7 You can select how often the database is backed up in the Preferences dialog. If you only work with Capture One occasionally, select Always. This way, the program creates a fresh backup without you having to think about it, even if you haven't used the program for several weeks.

Cache: This folder contains two subfolders of thumbnails and previews that help accelerate processing in Capture One.

The thumbnails are actually highly compressed JPEGs stored in the proprietary COT file format. These are the images you see in the Browser and the Filmstrip. They are automatically kept up to date.

Each preview consists of COF and COP files that are combined to create a preview of the size you selected in the program preferences (see section 1.7). Using twin formats for image and subsidiary data helps increase overall performance.

Originals: This is where your original raw files are kept if you import them directly into the catalog. They are organized chronologically in subfolders according to the capture date (Year > Month > Day > Import action).

Writelock: This file does what its name says. The file is created when a catalog is opened and prevents other users from altering it while you work. This ensures that no conflicts occur when you apply keywords or ratings.

4.2.2 Session Folders

Alongside the Capture, Output, Selects, and Trash folders, a session also contains one other important file.

[session-name].cosessiondb: This file does almost the same job as the [catalog-name].cocatalogdb file mentioned earlier. It, too, is a SQLite database but contains less data than its catalog equivalent. Apart from the Session Keyword Library, it also contains all the collections and albums you create during a session and records which images belong in each.

In addition to these subfolders and the database file, the folder usually contains the images for which you opened the session, whether you're shooting tethered or working on images saved on a memory card. That's the great thing about sessions: all the data required by a project (that is, a session) is stored in one place. Everyone regularly backs up the original image files, but many users forget to back up their control files.

Sessions consist of a simple, easy-to-view folder structure combined with a database file. Always store session folders on your fastest disk.

4.8 *Every session has the same folder structure. The Phase.cosessiondb file (see the illustration) isn't actually necessary to run a session and is used to manage additional low-priority organizational tasks.*

The Cache folder has the same contents as its catalog-based counterpart. The Settings folder is more important because it contains all of your develop settings and metadata.

This means that for a full backup, you have to back up the entire CaptureOne folder as well as your image files. Capture One can only reconstruct the work you have done and create correctly processed copies if this folder is stored in the same (relative) place as your original image files. This prevents a lot of potential glitches.

In Session mode, Capture One saves metadata and develop settings individually for each image rather than in a central database.

> **IMPORTANT**
>
> If you open images that are stored outside of the session folder, a CaptureOne folder will be created in the folder in which the images are stored. If the changes you make to these images are important, don't forget to make a backup of the new CaptureOne folder and the settings it contains when you archive the images or add them to your media database.

4.3 The EIP File Format

It has been several years since Phase One introduced the proprietary EIP (Enhanced Image Package) file format. The format is designed to bundle your original image files with the various settings, ICC and LCC profiles, and metadata files that the program creates and uses while you work. EIP packages make it simple to hand over processed images from one Capture One workstation to another.

EIP is useful if you're shooting tethered while others members of the team process and keyword the resulting images on separate computers. EIP is also great for freelancers working alone with multiple computers—for example, on a notebook on the road and a workstation in the studio (see section 2.3, scenario #1).

The EIP file format bundles all the required files in a single container.

EIP is a proprietary file format that is currently only supported by Phase One software. Unlike images created by Lightroom's Import DNG function, EIP is a losslessly compressed container that contains the original image file and the corresponding control files. A packed EIP file can be unpacked at any time.

In Session mode, you can create EIP files upon import or convert already imported files to EIP and keep them as part of the session. In Catalog mode, you can read EIP files or export selected images to EIP, but you can't replace your files with EIP versions inside the catalog.

In Catalog mode, the catalog manages develop settings and metadata centrally, so you should access your images outside of the catalog only in an emergency. Using Catalog mode makes storing your images in EIP containers an unnecessary step that could cause unwanted complications:

- What happens if you add later changes to metadata or image settings to a packed image? Can you use an additional EIP sidecar file? Or write the changes directly to the packed settings file? If this occurs, which data has priority? The catalog data, the data embedded in the EIP file, or some other sidecar file?
- There is no point in altering and managing data in multiple locations; this only makes the system more susceptible to errors and potential conflicts.
- Can you use the ICC and LCC profiles embedded in an EIP file with other images and, if so, how can you access and manage them in the catalog?

Put simply: Only use EIP files if you plan to use (or are already using) a structured, session-based workflow. Using EIP makes things simpler to organize but can cause problems if you manage your images in a Capture One catalog. The same is true if you use Media Pro to manage your images.

Media Pro supports EIP and, since version 1.3, can interpret any Capture One settings contained in an EIP file. It cannot, however, update metadata within an EIP file. This is because Media Pro is not designed to automatically compare and update settings and metadata, and updates have to be performed manually using the Synchronize function. This reduces the source of potential conflicts to whether the metadata in the image or the database has priority—a decision that you have to make anyway. Additional XMP sidecar files would be necessary in order to make automatic file comparison possible, and this brings us straight back to the question posed earlier; namely, why bother packing files into a single EIP file if you then have to create additional files to manage it?

In spite of these limitations, EIP is still a convenient format for use with catalogs and media databases, even if you only use it to move processed images and their settings between computers.

If you do decide to use EIP, the available options are quite simple:

1. You can pack your files automatically to EIP during import, whether you're shooting tethered or to a memory card.
2. You can use File > Pack as EIP or the context menu in the Filmstrip (right-click to access) to create EIP packages.
3. You can unpack EIP files using the Unpack EIP command in the menus listed in point 2.

The Image tab of the Preferences dialog contains an option for having Capture One automatically pack your files to EIP on import. This is a useful setting if you use a notebook on location and a workstation in the studio. You can add metadata, perform basic processing steps, and create LCC lens profiles on the road and transfer a batch of EIP files to your workstation via the network without having to gather together sets of sidecar files distributed across multiple folders and subfolders.

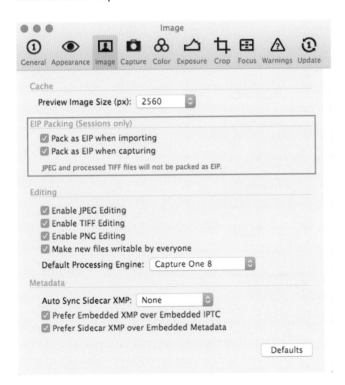

4.10 *The EIP settings in the Preferences dialog*

QUICK TIP

If you end up using a different raw converter or media database, you can still unpack EIP files using a trial version of Capture One—you don't have to purchase a license or deal with license activation/deactivation.

4.4 Importing Images and Basic Organization

4.11 To work with a catalog, you have to import your images first. Sessions are more flexible in this respect.

Experienced Aperture and Lightroom users know all about the importance of importing images. You can only work on your images if they are part of the catalog, and Capture One takes the same approach.

The right approach to importing images depends on how you like to work as well as on any restrictions on how you have to work. Do you work alone or are you a member of a team? Do you prefer to use keywords or longhand filenames?

To import images into a catalog, use either the Import Images button in the Toolbar or the File > Import Images command.

4.12 *In spite of its relatively simple-looking interface, the Import Images dialog is a powerful tool.*

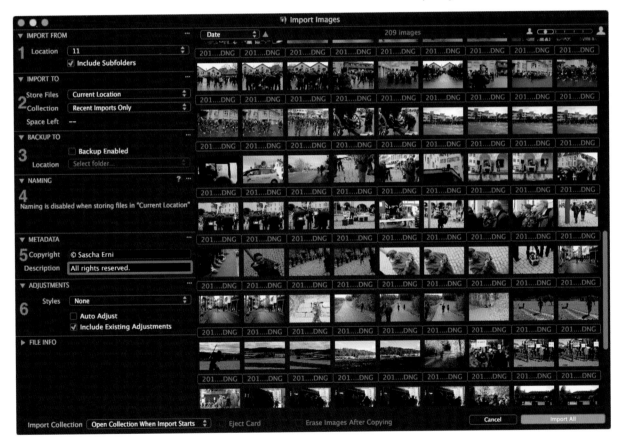

Most of the functions built into the Import Images dialog are self-explanatory. The major functions (as numbered in the illustration) are as follows:

1. **Import From:** This is where you select the source location. Capture One automatically includes attached cameras and memory cards in the drop-down list. Checking the Include Subfolders option does exactly what it says.

2. **Import To:** Your import target. In Catalog mode, you can also select the Inside Catalog option that imports your images to a predefined folder structure within the catalog folder, as described in sections 4.1 and 4.2. If you manage your images outside of the catalog, you can use tokens to automatically generate a predefined folder structure (more on this later). Use the Collections drop-down menu to determine whether new images are saved to an existing collection or to the default New Imports Only folder.

3. **Backup To:** Capture One gives you the option to make an immediate backup of your original files during import. This can be to an external disk, a Dropbox, or any other form of network storage. The original files are copied without renaming, adjustments, or additional metadata.

4. **Naming:** By default, Capture One imports your images with the original filenames found at the source. You can, however, rename your images during import using a wide range of built-in tokens (more on this later, too).

5. **Metadata:** During import, you can add a short description and copyright metadata—for example "All rights reserved" or "Creative Commons Attribution 3.0."

6. **Adjustments:** Here, you can select styles and presets that you wish to apply to all your images. Two clicks are all it takes to apply your favorite style. At this point, most users also add standard metadata such as contact details (email, web address, mailing address, etc.). Check Auto Adjust to perform the adjustments you have selected in the Adjustments > Auto Adjustments menu.

> **IMPORTANT**
> Check the Include Existing Adjustments option if you're importing images that you've already worked on using earlier versions of Capture One—for example, if you're importing an existing folder structure into a new catalog. If you don't select this option, the program will import "fresh" copies of your images and will delete your earlier adjustments and any non-XMP metadata you added (see section 4.9). Make doubly sure you select this option if you need it.

cornerfixed.jpg
dngneutral.jpg
komprimiert.jpg
20150320_001.ORF
20150320_002.ORF
20150320_003.ORF
cargo_01_20150321.ARW
cargo_02_20150321.ARW
20150320_004.ORF
20150320_005.ORF

4.13 Having three different file types in the same session spells chaos if you aren't careful.

Tokens are variables that Capture One uses to dynamically assign data paths and filenames.

Most of these options are available when you *import images to a session,* although importing images isn't strictly necessary for sessions—you can simply open and process images from their current location. Nevertheless, the Import Images dialog is useful for importing new images into an existing session and also enables you to rename files in line with your standard naming convention.

Points 2 and 4 earlier mention tokens. Tokens are placeholders that Capture One uses to unify and automate certain steps such as numbering files, adding a focal length to a batch of images, writing a job number to metadata, or adding the photographer's name to the filename during output.

The tokens listed here are only a selection, and the range of available tokens increases with every new release. Take the time to check the list after every update—you may find just the variable you've been waiting for.

Using Tokens to Create a Subfolder Structure

If, instead of managing your images within the catalog you wish to leave them in your own folder tree, you can use tokens to simplify and optimize the import process.

4.14 *The Location Sub Folder Tokens window in the Import Images dialog*

1. Click the button with three dots in the Import To area to open the Tokens window.
2. The Format field contains the current settings for the creation of subfolders, whereas the Sample field shows how these settings are interpreted.
3. The Group drop-down list offers collections of variables, such as "Date and Time" or "Metadata – EXIF – Camera." Our example uses the Date and Time group.

4.15 *The token selection menu for the Date and Time group*

4. Drag the tokens you wish to use to the Format field.
5. Select your desired format by clicking the arrow icon at the right-hand end of the token field.

4.16 Taking shape...

6. Save your choices as a User Preset or click OK to use your selections without saving them. The same selections remain in place until you alter them.

The selections shown in the illustrations create subfolders for each day in the target folder. If you use a new target folder every month, Capture One will automatically create new Year, Month, and Day folders within it.

The Import Images dialog only includes Description and Copyright metadata fields, although most photographers like to add contact data as well to make it easier for potential clients to find them. Contact details are just as important as copyright information, and you can add them during image import using a User Preset.

4.17 The result is a clear and easily readable folder structure.

Adding Contact Details During Image Import

1. Select an image that you've already imported and navigate to the Metadata tool tab.

4.18 It's time to fill out the IPTC – Contact data fields.

2. Enter your details in the IPTC– Contact fields.
3. Click the Manage and Apply Metadata Presets button at the top right in the Metadata tool tab and select Save User Preset. ☐ 4.19
4. Select the fields you wish to include in the preset and click Save. ☐ 4.20
5. Return to the Import Images dialog.
6. In the Styles drop-down list in the Adjustments section, navigate to the preset you've just saved via User Presets command. ☐ 4.21

4.19 Use the Manage drop-down list to create new presets and apply or delete existing ones.

4.20 Only select the fields you wish to add; otherwise, you'll add loads of unnecessary metadata every time you use your preset.

4.21 And you're done!

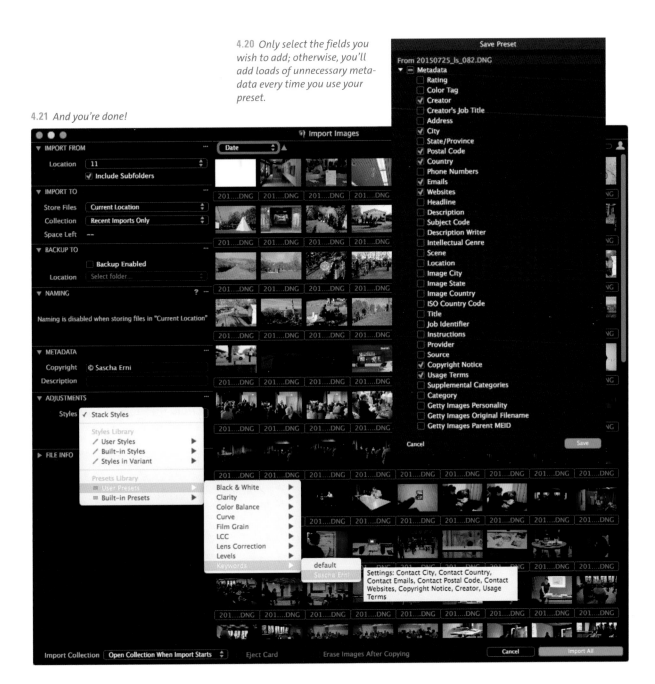

You can add multiple presets during image import—for example, general contact details for your agency combined with a second preset that names the creator of each image. You can use any or all of the presets you've saved, including develop settings—for example, you can convert all imported images to black and white or add keywords that are relevant to a particular client. Presets are a great way to save time by automating repetitive tasks.

4.5 User Collections and Folders

In general, Capture One automatically organizes your files for you, but it also gives you a number of options when it comes to grouping and storing your images—either virtually in the form of User Collections and Session Albums or physically by way of your computer's filesystem. The virtual approach is preferable, especially if you're working in Catalog mode. Let's start by taking a look at User Collections.

4.5.1 User Collections

Catalogs and sessions give you the option to organize your images in virtual containers called projects, groups, and (Smart) Albums. Not all of these options are available in both catalogs and sessions.

Regardless of whether you process your images in sessions or catalogs, you have to keep them organized. The Filters tool (see section 4.6) makes it easy to find individual images that contain sufficient metadata, but it is often much simpler if you can open all the images that relate to a certain project or client with a single click. In Catalog mode, you can choose among Albums, Smart Albums, projects, and groups to do this. In Session mode, you can choose between Albums and Smart Albums.

These virtual containers help you to organize your images without actually altering the physical location of the files. Even if an image is part of multiple collections, the actual file exists only once and uses a small amount of disk space.

4.22 Images can be dragged to Albums and Albums dragged to projects and groups.

To include an image in an Album, drag it from the Browser to the appropriate Album in the User Collections area of the Library tool tab.

Capture One differentiates between Catalog Collections and User Collections. The Catalog Collections window is a fixed part of the user interface and shows all the images in the current catalog, recent imports, recent captures, and the trash. The last 10 Imports and last 10 Capture sessions are always available here. In Session mode, session folders perform the same function as Catalog Collections.

Albums, groups, and projects together make up the User Collections that you manage yourself. In Session mode, Session Albums perform the same function as User Collections.

4.23 *The structures of Catalog Collections and session folders are predefined, but you can still organize your images according to your needs in User Collections and Session Albums.*

The three types of containers available for organizing your archives are as follows:

- **Albums:** Used to group images that belong together—for example, a particular them or genre, or perhaps your last vacation.
- **Groups:** Used to create loose groups of Albums, projects, and other groups. For example, the People Photography group could include Albums and projects such as street photography, portraits, snapshots, and the like, and the Food group could contain things like fast food, gourmet meals, and restaurant shots.
- **Projects:** Similar to groups, these can contain various Albums and groups but can't contain other projects.

The difference between projects and groups lies in the scope of the associated search functionality and therefore the behavior of Smart Albums (see section 4.7). If you're working within a group and search for images using a particular keyword, the results will also include images that don't belong to the group. In this case, the search tools and Smart Albums use the All Images Catalog Collection rather than the current User Collection or group.

In contrast, if a Smart Album is part of a project, search results will be limited to hits within the project. In this case, search tools and Smart Albums only search the project itself.

Whether you prefer to use groups or projects depends on how you work. If you prefer a loose approach and don't mind sifting through global results, groups are probably the better option. If, however, you are on the lookout for more specific results without having to specify complex search parameters, projects will serve you better.

4.24 *Distribute your image across multiple Albums, sort your Albums into groups or projects, and sort these into other groups and hey, presto—you're looking at a well-organized archive!*

> **QUICK TIP**
> Using the search function within projects and groups sounds more complicated than it actually is. To visualize how it works, open a few Albums from the User Collections area, add some images, and distribute some of the Albums to a group and a project. Now create a Smart Album with the same base parameter (for example, four stars or more) in the group and the project. The difference between the two sets of results should be obvious—the Smart Album in the group will show all appropriate images from the entire catalog, whereas the one in the project will only show results from within the project itself.

Separating Business and Personal Work

Imagine you are a freelancer photographing an event for a client but you also have the camera you use for personal projects with you. You never know, maybe your next business shoot will provide some great outtakes for your "Potted Plants of the Banking World" project or your "Emotional Sunsets" collection. Albums, projects, and groups are a great way to keep your professional and personal work separate without having to waste time thinking about which catalog to use when you import your images.

If you work in Catalog mode, I recommend that you use the following basic Albums, groups, and projects:

4.25 *Each client has its own project, and each job its own Album—you can bundle your personal work in a bunch of Albums stored in a single project split among additional groups (if necessary).*

The benefit of this approach is that you can specify how comprehensive you want your search results to be. If, for example, you need only the best-rated images from a particular job, select the appropriate Album and use Filters to find the right files. If you want to filter the highest-rated images for a

particular client, use a Smart Album within that client's project—this way, pictures from other clients and, more important, your personal projects aren't included in the results. However, you can still drag images from a client's project to a personal Project Album if you want.

If you prefer to use sessions (where you can only use Albums and Smart Albums), the easiest way to separate commercial and personal work is using individual session folders for each, as described in section 4.1.

> **IMPORTANT**
>
> As previously mentioned, the image files themselves are not moved or copied from Album to Album, which means that any changes you make to an image appear in every project, Album, and group the image belongs to. In other words, Albums and groups *aren't* designed to let you apply different keywords to a single image for private and commercial purposes. If that's what you want to do, use multiple sessions or catalogs.

4.5.2 Folders and System Folders

It is sometimes necessary to access files via your computer's filesystem— say, because you want to move images from a catalog to an archive disk, or because you need to view images you've received via email in a session. This is where the Folders panel (in Catalog mode) and the Session Albums panel (in Session mode) come in.

In Catalog mode, the Folders section shows only the folders that contain images included in the catalog. Because your images can be located anywhere on your system, Session mode lists all the system folders.

> **IMPORTANT**
>
> If you're working in Catalog mode, never move files using the Windows Explorer or Mac Finder. If you do, Capture One will no longer be able to find the path to the original raw file. If you need to perform system-level file operations, always use the Capture One Folders panel. This saves a lot of hassle searching for lost images later on.

Let's take a look at the System Folders panel in Session mode.

The folders the panel contains are images of the actual folders they represent. Any operations you perform here are duplicated on your "real" filesystem. The folders are always up to date, and when you select a sub-folder, Capture One shows all the files it supports.

If, for example, someone has sent you an image for review, you can click through to your mail program's downloads folder and view the image in the Capture One Browser without having to import it first. On the other hand, remember that if you delete a folder using the context menu in the System Folders panel, it really will be deleted from your computer's filesystem.

4.26 In Session mode, Capture One shows the entire system folder tree for all available disks.

*4.27 The catalog Folders panel looks al-
most the same as the System Folders panel
in a session but has different functionality.*

*You can only access image files in Catalog
mode once you have imported or synchro-
nized the corresponding folders.*

*4.28 Right-click a folder and select the
Synchronize command to open the catalog
synchronization dialog.*

> **IMPORTANT**
> Take care when performing file operations in the System Folders panel—these
> operations actually take place within your *computer's* filesystem. Operations
> you perform here are real, not part of a virtual file structure.

The Folders panel in Catalog mode works slightly differently, showing only
the folders that contain images that are part of the catalog and providing
features that are only useful in Catalog mode.

Notice the green bars on the right. These show that the corresponding
drives are available, whether locally or on a network. If a drive is not avail-
able, Capture One switches to offline mode (see section 1.7.1) and uses its
internal previews to display any adjustments you make.

In Session mode, clicking the "+" icon creates a new, real folder in your
filesystem, whereas doing the same in Catalog mode adds a folder or drive
to the catalog. This means that the program is now aware of the new lo-
cation but still has no direct access to the files stored there. To gain access,
you either have to import the images into the catalog or synchronize your
folders in the Folders panel, as described in section 4.4.

The dialog itself is mostly self-explanatory.

- ⊙ Checking the "Include known subfolders" option searches for all altered
 images that are part of the catalog.
- ⊙ You can import new images directly (that is, using linked locations) or, if
 you select the Show Importer option, you can apply all the usual renam-
 ing, backing up, and moving options offered by the Import Images dialog.
- ⊙ The "Remove missing images" option compares the contents of the
 folder you are syncing with the contents of the catalog and removes any
 images that are no longer in the folder from the catalog.

Note that the filesystem options available in Session mode (such as renam-
ing) are not available in Catalog mode. This is because Catalog mode only
displays the parts of the filesystem that it contains, rather than the actual
filesystem. If you remove a folder from the catalog using the "−" button, it
is removed from the catalog view but isn't deleted from the system.

There are no rules without exceptions. When you drag an image from the Browser to a folder displayed in the catalog view, it is physically moved to the new location within the computer's filesystem. This can be useful if you want to move images from your fast main disk to a slower archive disk.

4.6 Filters

Filters are powerful tools that play an important role in Capture One. This hasn't always been the case; versions prior to Capture One 8 left it to users to organize their images (using sessions or a personal folder tree) and to find the ones required for a particular project. Using color tags was the only way to label key images or trash.

The introduction of the catalog module was the first step toward upgrading the program's search and filter functionality, based on the assumption that software-based searches are more effective than human ones. Still, even with version 9, the search tools aren't quite up to the standard of those in a mature asset management system like Media Pro, but they're good enough to cover most photographers' daily needs.

Filters enable you to navigate around your archives without having to know exactly where the image files are stored.

4.29 The clearly organized Filters panel is part of the Library tool tab.

Like many of Capture One's tools, the Filters panel is mostly self-explanatory. You can filter ratings (i.e., the number of stars), color tags, keywords, places, and dates, and you can select which filters to display in the tool's action menu.

> Filters are applied to the currently selected image(s), so, if you've selected the All Images Catalog Collection, the program will search the entire catalog for appropriate images. If, however, you're working in a specific User Collection (see section 4.5.1), the tool searches for your selected parameters only within that collection. If you can't quickly find the image you're looking for, check that the correct collection is active. If you still can't find the right file, you can always switch to the All Images collection and search there.

Although not immediately apparent, the Filters tool enables you to apply global filters and to create (Smart) Albums from your search results (see section 4.7).

4.6.1 Global Filters

Global Filters determine which file types are shown or hidden within a catalog.

The global filter options determine which file types are displayed within a catalog or session. The options you select are truly global and are not affected if you select a User or Catalog Collection.

Capture One was originally developed as a raw developer, and its ability to process JPEG, TIFF, and other file types was added later. Capture One cannot yet process video files, so it can be useful to hide videos on a global level.

4.30 Global Filters can be found in the action menu in the Filters tool. The options you select apply to the entire catalog or session you're working on.

"Processed TIFF Files" are copies of processed images that you have produced and added to a session or catalog, so it can be useful to hide them if you want to view only your original images.

> **QUICK TIP**
> If you find that not all the images you expected are included in a catalog or session following image import, check the global filter settings. These settings apply to the entire active session or catalog, even if you reboot your computer and restart Capture One. If you can't see files of a certain type that you know were saved on your memory card, it's usually because of global filter settings you made earlier and forgot to reset.

4.6.2 Saving Filter Settings as (Smart) Albums

Capture One enables you to combine filters with the Search tool.

The Advanced Search dialog helps you perform searches using sets of filters that are more complex than those you can set using the options in the Filters tool. You can, for example, search for metadata written to your files in the camera (such as exposure time or camera model) or metadata that you add manually later on (such as genre, the subject's name, or custom keywords). Advanced searches can be saved and applied to other collections, too.

Instead of saving a search as a preset, you can create an Album (or Smart Album) that contains your search results. A Smart Album updates automatically to include newly imported or deleted images. We will go into more detail on Smart Albums in the next section.

Rejecting or Hiding Images

Unlike Aperture and Lightroom, Capture One has no built-in keystroke or functionality for pruning your catalog of duds by labeling images as rejects. However, you can work around this limitation using a search preset:

1. Open the Advanced Search dialog in the Filters tool.

2. Select the following criteria: Color Tag, "is not," and "red."

3. Save the search as a preset (Presets > Save Search Preset) and give it a meaningful name such as Remaining Images.

And that's it. By default, Capture One adds the red color tag if you press the minus key, but this can quickly get confusing if you're tired after a hard day's shoot.

4.33 *Lots of rejected images...*

The Aperture and Lightroom Reject Image functionality grays out or deletes the corresponding image from the Filmstrip, and the search preset we have just created does the same. Next time you are viewing a fresh set of imported images or an existing collection, select the Remaining Images filter in the Browser. Now, every time you press the "−" key, the current image will be automatically hidden. ☐ 4.34

The advantage of this approach is that hidden image files remain where they are, so you can show them again by applying the standard red color tag filter. ☐ 4.35

4.34 ...that are easily hidden using our new search preset.

4.35 Rejected images are hidden but not removed from the catalog or deleted.

4.7 Smart Albums

Imagine you're a street photographer and you prefer photos of T-shirts with ironic slogans to ones of retirees with bent umbrellas. Smart Albums are the ideal tool for creating collections that update themselves automatically when you import new images that fit the bill.

There are many reasons to use Smart Albums. You may want to group a certain type of subject with a minimum rating, or isolate lone subjects in a particular context. Or say you want to separate black-and-white and color images that belong to a certain genre, or perhaps all the images you uploaded to flickr that were captured after a particular point in time? If you want to view all your landscapes that don't contain any buildings but were captured in Italy or Switzerland, or simply view all the images that you haven't yet keyworded, Smart Albums are what you need.

Smart Albums are based on sets of saved search options.

4.36 Selecting the right search criteria will take you a long way toward finding the right images—but only if appropriate metadata is available in the first place.

All of these examples have two things in common:

- They require a well-thought-out metadata system.
- They are based on search/filter presets (see section 4.6).

Smart Albums continually search the active catalog or session for images that fulfill your selected criteria and automatically display the results in a virtual folder. To keep the system effective, you have to carefully consider which metadata and keywords you apply to your images.

4.7.1 Creating and Managing Smart Albums

Creating a Smart Album is simple:

1. Click the "+" button in the User Collections section of the Library tool tab and select the Smart Album option.

2. Edit the title of your Smart Album. Our example is called Black and White Portraits.
3. Select your search criteria.

4. Click OK to save your new Smart Album.

Smart Albums are powerful and can be based on any or all of the filter and search options available in Capture One, including geodata, genre, and the name of the subject.

QUICK TIP
The range of searchable metadata depends on the type of camera and file format you use. To get an idea of the available data, switch to the Metadata tool tab and check out the values it displays when you click through the images in the Filmstrip.

4.7.2 Keywording Strategies

As the previous example shows, Smart Albums are especially powerful when you use them with keywords and IPTC metadata. However, this approach works well only if you consistently add meaningful keywords to all the images you add to your archives.

Poor metadata means "dumb" albums. Only well-organized metadata can be used to create genuinely "smart" albums.

Capture One Pro 9 doesn't fully support controlled vocabularies (that is, commercial or custom sets of predefined keywords). Controlled vocabularies are available in DAM systems such as Media Pro and replace personal keywords like "bike" with a standardized word like "bicycle." The use of these terms is enforced over the creation of new ones. This type of system ensures that your keywording remains consistent throughout your archives. However, since version 9, you can import and export vocabularies with Capture One Pro. If you stick with the autocomplete suggestions or what is listed in your Keyword Libraries, you can approach the functionality of a "real" controlled vocabulary. More on this in section 12.2.

It is essential to consider early in the archiving process which keywords you're likely to want to search for later on. If separating color and monochrome images, use a keyword like "BnW" to label black-and-white images. If you often have to find images that show a particular person, make sure you always fill out the IPTC Personality field or add a keyword with the subject's name. If you shoot different genres (such as landscape, portrait, or architecture) but don't use separate catalogs for each, make sure you fill out the IPTC Category field.

The standards you set yourself are the backbone of your keywording system.

These are just a few examples that show how important it is to plan metadata handling. The best approach is to spend an afternoon clicking through your image archives and reviewing how they're organized. Do you use subfolders for different genres? Do you use keywords or IPTC metadata to identify different types of images? Do you photograph animals in the wild that you need to label with zoological terms? Or do you shoot a lot of people pictures that you need to sort quickly by subject?

4.37 If you stick with Capture One's auto-complete suggestions, you'll ensure that your search terms are consistent.

4.8 From a Session to a Catalog and Vice Versa

Capture One gives you a choice: you can work in catalogs and sessions, or you have the option of switching between the two. Let's look at how to move images from a session to a catalog.

4.38 You can import a session in just two clicks.

If you want to import an entire session into a catalog, all you have to do is use the File > Import Session command and select the appropriate session file. The program will then automatically import the session, including all adjustments and metadata. This process doesn't import the original raw files into the catalog—it creates virtual links to them instead.

IMPORTANT

Always take the time to "clean up" a session before importing it into a catalog. Capture One imports everything, and because the files are referenced rather than copied, no renaming, metadata, or adjustment options are available. This means that if inconsistencies exist between the keyword sets in the session and the catalog, these will end up being embedded in the catalog.

If you want to import selected images, you can do so directly using your mouse or via the Import Images dialog.

If you drag an image from the Browser to a User Album in a catalog, it will be added to the Album and linked to the catalog with all the corresponding adjustments and metadata. The original file is neither moved nor copied.

Because sessions have a predefined folder structure, it is simple to open the Import Images dialog and add session folders to the catalog in the normal way. If you take this route, you can also add new images to the catalog (or import them to a different location) and rename them instead of just linking them as just described.

4.39 *You can only drag images from a session to Albums within a catalog. Capture One has yet to implement the ability to drag to normal folders and Smart Albums.*

4.40 *The catalog Import Images dialog can be used to import images from session folders. Be sure to check the Include Existing Adjustments option—otherwise, your adjustments will not be imported. To ensure that the metadata and adjustment settings in the catalog remain unchanged, uncheck all presets and the Auto Adjust option.*

You have to export the adjustments you make in a catalog if you want to retain them in a session.

Things get more complicated if you want to make fresh adjustments to se-lected images (or an entire catalog) within a session and manage the results via the filesystem. Because sessions aren't designed with image import in mind, there is no "Import Catalog as a Session" option. Additionally, your develop settings and metadata are part of the catalog and aren't stored in your computer's filesystem.

To retain your adjustments, you have to export your images:

1. Select your images in the Browser.
2. Open the Export dialog by selecting File > Export Images.

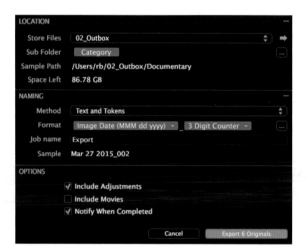

4.41 The Export dialog is similar to the Import Images dialog and includes the same renaming and storage options.

3. Select an export folder.
4. Alter the subfolder and naming settings as necessary. Naming conven-tions are governed by the token system described in section 4.4.
5. Check the Include Adjustments option.
6. Click the Export button.

If necessary, the export function creates new folders and stores the original raw files and their corresponding XMP sidecar files there. It also creates Set-tings8x and Cache files for your develop settings and previews. The export process doesn't take as long as applying adjustments or outputting images.

> **QUICK TIP**
> If you're exporting a large catalog, select a subfolder and add tokens that suit your new folder structure—for example, one subfolder for each camera, genre, month, or year. The better organized your images are when you export them, the easier it will be to manage them later.

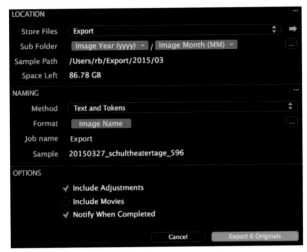

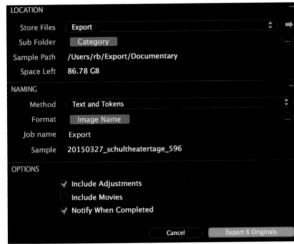

4.9 XMP Files and Metadata

To preserve data integrity, the metadata you add to files in sessions and catalogs is *not* saved to the original files. As I've often stressed, Capture One takes no risks and never alters your original image files. Because additional metadata is stored in the active catalog or session, this works fine as long as you open, process, and manage your images within Capture One (see section 4.2). Things look different if you need to process your images using another raw developer or if you need to use your ratings, keywords, and other metadata in a third-party DAM or database system. This is where Capture One's XMP options come into play.

As described in section 1.7.2, there are various ways to automate XMP metadata synchronization. In addition to global, system-wide settings, you can synchronize metadata selectively using the tools located in the Metadata tool tab. See chapter 12 for more details.

4.42 *The settings shown on the left export the original images and their sidecar files to monthly subfolders, whereas the settings on the right create subfolders that contain images according to the IPTC Category tag.*

To aid sharing metadata with third-party software, Capture One offers you the option of saving metadata to XMP sidecar files. This also gives you an additional safeguard when it comes to saving and backing up your work.

4.43 *Access the XMP synchronization options via the action menu in the Metadata tool tab.*

4.10 On the Safe Side: Backups and Integrity Checks

Don't rely only on Capture One's built-in backup system. Always make your own backup copies of your images and catalogs and automate the process if you can.

4.44 Set the backup interval in the Catalog Backup section of the Preferences dialog's General tab. My system is set to back up once a week to my dedicated backup disk.

Version 7 of Capture One introduced backup notifications that remind you at regular intervals to back up your catalog. This function is retained in later versions and has been refined along with the program's built-in catalog integrity checks.

Catalog Backup

Remind on close: Once a week

Location: /Volumes/OpenShare/Backup

As discussed in section 4.2, the right backup interval depends on the way you work. If you use Capture One on a daily basis, it makes sense to run daily backups. However, most users quickly find the reminder pop-ups annoying and dismiss them without making regular backups.

If you use Capture One every day, my advice is to use the built-in backup system regularly and create your own additional backup once a week. If you make regular system-wide backups using Time Machine (Mac) or PureSync (PC), you'll be doing this anyway. You're more likely to take a reminder seriously if it pops up once a week. If you use Capture One only occasionally, use the Always option. This way, the catalog is backed up every time you quit the program.

When it creates a backup, the software checks the integrity of the database, looking for errors, "forgotten" files, and overall coherence. You can start a session or catalog integrity check manually if necessary—after all, as you saw in section 4.2, even a session has its own database that can break or be accidentally deleted.

To check the integrity of a catalog or session, do the following:

1. Open the filesystem window using the File > Verify Catalog or Session command.
2. Select the session or catalog you wish to check. If you select the catalog you opened the dialog from, Capture One will display a corresponding warning before closing the catalog.

3. A progress window is displayed while the software performs its checks. Once these checks are done, you can click the Open button to select a different catalog or session, and then click Verify to retest the current catalog or click Close to dismiss the dialog.

4. Capture One doesn't automatically open a catalog or session following verification. Click the program icon to open the filesystem dialog and select the session or catalog you wish to work on.

IMPORTANT

Capture One Pro's backup functionality is rudimentary but does its job adequately if used in conjunction with an independent backup strategy for your system and image archives. Capture One only backs up the catalog and session database, not your image files.

4.11 Importing Catalogs from Lightroom, Media Pro, and Aperture

Capture One Pro 8 and 9 are squarely aimed at photographers who are considering switching software, whether because their favorite raw developer is no longer available (Aperture), because they don't like the manufacturer's new licensing model (Adobe), or simply because they prefer the results Capture One produces. Capture One Pro 8 introduced filters for importing catalogs from Lightroom, Aperture, and Phase One's own Media Pro package. This is a really useful function, but even though it got better and better with the various 8.x point-releases and the introduction of version 9, it still has some limitations.

Imported catalogs don't always include all the original adjustments and color settings.

As discussed in chapter 1, the results produced by various raw developers can differ a lot. This is due on the one hand to the fact that third-party development presets such as Lightroom's B&W and Auto Tone are designed for use with the original program and can't be interpreted by Capture One. On the other hand, the current crop of raw converters all work differently for good reasons—otherwise there would be no need for dedicated photo software and we could just as well work with system-level software like Microsoft's camera codecs or the Apple digital camera RAW framework.

4.45 Wasn't this Lightroom image originally black and white?

Capture One can interpret some Aperture and Lightroom develop settings, and although your images are sure to look different once imported, the overall impression will be similar enough for you to carry on where you left off. As of this writing, the following settings were supported by Capture One Pro:

Lightroom
- Crop
- Rotate
- Straighten
- White Balance
- Exposure Corrections
- Saturation
- Contrast

Aperture
- Crop
- Straighten
- Flip
- Exposure
- Lightness
- Highlights & Shadows
- Definition
- Saturation
- Black Point
- White Point

The adjustments listed here will be applied identically as far as possible. Capture One's Crop and Rotation & Flip (straighten) tools are located in the Composition tool tab; Saturation, Contrast, Exposure, and the like are located in the Exposure tool tab. In cases where Capture One cannot duplicate settings, the values from the source catalog are handed over to the most similar tools available—for example, Aperture's Definition settings are transformed into Capture One Clarity settings, whereas Black Point and White Point settings are transferred to the Color tool tab.

One thing is certain: Images you transfer from one program to another will definitely look different when you're done.

> **QUICK TIP**
> If you import an existing catalog from a different program, be prepared for your images to look very different when you open them in Capture One. It's worth making JPEG or TIFF copies of important images so that you can still view them the way they looked before you transferred them.

Library and image management settings are simpler to transfer, and most ratings, color tags, keywords, and collections can be handed over seamlessly. The only two exceptions are as follows:

Convert Lightroom Smart Albums and Aperture Projects to "regular" albums and collections before you import them.

1. Capture One's import functionality supports neither Lightroom Smart Albums and Smart Collections nor Aperture Projects.
2. Color tags and other metadata that don't conform to IPTC standards sometimes get lost during the import process.

In theory, the solution for issue #1 is simply to convert your Smart Albums and Collections or projects to "regular" albums before you import them, although this can be tricky depending on how complex your existing albums and projects are. Capture One displays converted albums as User Collections.

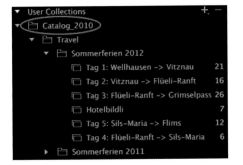

4.46 Capture One imports "regular" albums without issues, even if they are nested. Albums imported this way are displayed as User Collections.

Because Capture One adheres to IPTC standards and guidelines, lost metadata is much more difficult to restore (see chapter 12 for more details). Metadata guidelines are not always implemented the same way by soft-

ware manufacturers, so if you use a lot of IPTC extensions, it is quite likely that your Lightroom/Aperture metadata won't arrive fully intact in Capture One.

Phase One Media Pro catalogs can usually be imported without major issues. All collections and metadata can be imported without limitations or subsequent compatibility problems. Phase One continually improves its import functionality from version to version, and even the beta version 8.2 works much better than its 8.0 predecessor.

Preparing Catalogs for Import to Capture One
Switching catalog software is always tricky. To keep frustration levels to a minimum when importing catalogs from Aperture or Lightroom, prepare your catalog as follows:

1. Back up, back up, back up—not because Capture One is likely to destroy your files, but simply because the preparations you need to make will result in quite a lot of changes to your image archives. If you decide to go back to Lightroom or Apple Photos later on, it makes sense to have a copy of your original catalog on hand.

2. Do a trial run. Create a test catalog that contains just a few hundred images (perhaps the last three months or just one genre) and import it. Using only part of your archive to test the system means you can spot compatibility or file-type issues much faster.

3. Use transfer keywords. Create clear, new labels for metadata that Capture One doesn't recognize during your trial run. If a tag cannot be read, try adding an underscore and simplifying the description you use in the source database—for example, convert "Is marked in pink!" to "_pink." Make another trial run and check that your transfer keywords have been successfully imported. You can now proceed with importing and replace your transfer keywords with your original tags in the new catalog.

4. If possible, convert existing Smart Albums to "regular" albums. Ask yourself why you created each Smart Album and review the functions it fulfills. For example, you don't need to transfer a Smart Album that filters four-star ratings because Capture One has its own filters that do the same job (see section 4.6).

5. If you use very large collections, projects, or albums, import each one to a separate new catalog. This way, you can import your archives piece by piece.

6. Keep at least one copy of your original catalog and the corresponding version of the program you used to create it. This maximizes your chances of retaining access to your original archives following a switch to Capture One. Aperture should still work on your system even if Apple no longer maintains it.

QUICK TIP

Don't try to import your entire catalog at all costs. Lightroom and Aperture aren't going to disappear any time soon, and it's often more practical to import parts of your archives as separate catalogs—for example, if you were considering reorganizing your vacation photos anyway, use the opportunity to sort them out and give them their own catalog. Don't work in both programs simultaneously. Set yourself a deadline after which you only open and process new images in Capture One. You still have your old archive if you need it.

5 The Color Tool Tab

Capture One's many options are designed to produce pleasing rather than precise colors.

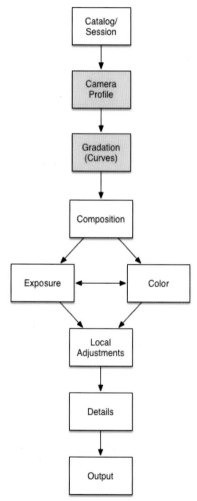

5.1 *The Base Characteristics are the jumping-off point for the Capture One Pro workflow.*

Capture One Pro has long had a reputation for producing pleasing, natural-looking colors. Unlike Adobe products, which are designed to produce measurably precise colors, Phase One creates its camera profiles using a combination of measured values, perceived quality, and experience. Experience is especially important when it comes to creating and fine-tuning ICC profiles that can be applied in a wide range of situations. This approach addresses questions such as "How do we deal with deviations from a neutral white point?" or "To what degree should colors shift when a user adjusts the color wheel or the tone curve?"

An ICC camera profile has to be carefully fine-tuned to ensure that it reacts robustly to different approaches to image development and processing. This is a lengthy process, and some profiles go through several iterations until they are deemed sufficiently robust for universal use.

And this is where the Color tool tab comes in. It can be used to creatively adjust image colors but also to tweak the basic camera settings to suit your own personal preferences. This chapter discusses the Color tools in the twin contexts of creative processing and the creation of your own default "look."

5.1 Base Characteristics: Rendering Engines, ICC Profiles, and Curves

The Base Characteristics tool determines *how* Capture One approaches raw data processing. If we compare our work with that of an interpreter at an international conference, the chairperson (Capture One) has to be told which language the speaker (the camera) will use to hold the lecture (the image) so that an interpreter with the right capabilities (the Base Characteristics) is given the job. If the speaker uses English, the chairperson will recognize this automatically, but different dialects require different interpreters. ☐ 5.2

As discussed in section 1.4, the choice of "interpreter" takes place via ICC/ICM profiles. Capture One doesn't provide multiple "dialects" for all the cameras it supports and gives priority to studio-based devices. Whatever camera you use, Capture One can only deal satisfactorily with its images if it has access to a corresponding ICC camera profile (the interpreter).

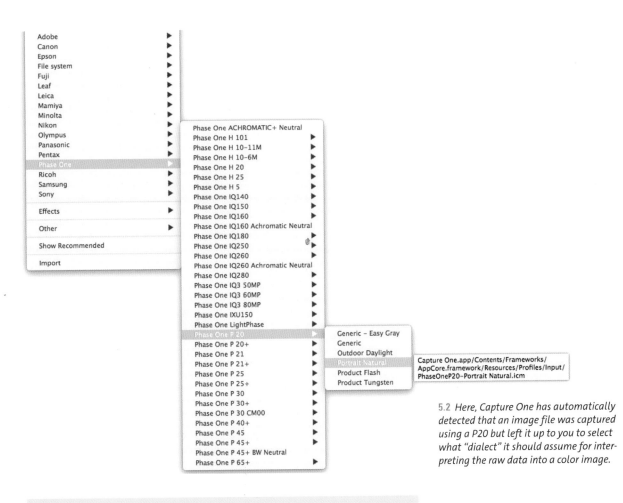

5.2 *Here, Capture One has automatically detected that an image file was captured using a P20 but left it up to you to select what "dialect" it should assume for interpreting the raw data into a color image.*

QUICK TIP

Color rendition is a matter of taste, so feel free to experiment with various ICC profiles for each of your cameras—perhaps you'll find that you prefer the results produced by the profile designed for your model's predecessor better than its dedicated version, or perhaps even one from a different camera manufacturer altogether. To stick to our analogy, maybe you prefer the way a French interpreter pronounces English to that of a German or Spanish colleague.

Once you've found a profile you like, use the action menu in the Base Characteristics tool to save it as the default for your camera.

The next step is to determine how your raw image data should be modulated. Digital image sensors capture data linearly, but human perception isn't linear at all. Images developed using linear techniques often appear dull and lifeless, which can have its uses in reproduction or forensic imaging situations, but is less useful in everyday photographic situations in which we want to reproduce colors the way we remember seeing them. We modulate the image data using tone curves.

In our meeting analogy, if an ICC camera profile represents the interpreter, the tone curve represents the PA system that amplifies the speaker's voice

5.3 *Linearly developed raw files often appear "flat" and lifeless. The tone curve you use has a significant effect on the look of your images.*

Capture One provides four default tone curves: Film Extra Shadow, Film High Contrast, Film Standard, and Linear Response. Film Standard is the default curve and provides a basic look that appears natural to the human eye.

5.4 *The raw data (left) is processed using the selected tone curve (center). The result is an image with tones that are closer to those that humans instinctively perceive.*

Returning once again to our meeting analogy, the Film Standard curve increases bass and treble (like the loudness dial on an amplifier). Film High Contrast has the same effect but also increases the overall volume to make the content easier to perceive. Film Extra Shadow raises the midtones, whereas Linear Response switches everything to zero.

As when you are using an audio amplifier, the settings you use depend on the source material and the effect you wish to achieve. How much loudness (contrast) do you need to play a finely honed piece of chamber music (equivalent to a portrait photo)? At which point do the effects outweigh the look of the original, and which settings underscore its intended effect?

QUICK TIP

Film Standard is a good choice in most situations. Use it as default for all of your cameras and use other curves only for individual images that demand you "pump up the volume."

5.2 Histograms: Evaluate and Understand

Histograms display the range of tonal values in an image graphically. They tell you how dark the shadows are, how bright the green midtones are, and how the entire range of tonal values in the image is distributed. If, as I recommended in the previous section, you've already experimented with different tone curves and camera profiles, you'll have noticed that the histogram display in the Color tool tab changes, too. □ 5.5

Capture One displays histograms at various points in the workflow. They are all based on the same source material but refer to different stages of the pipeline.

5.5 *Two histograms for the same file—with the Linear Response tone curve applied (top) and with Film High Contrast (bottom).*

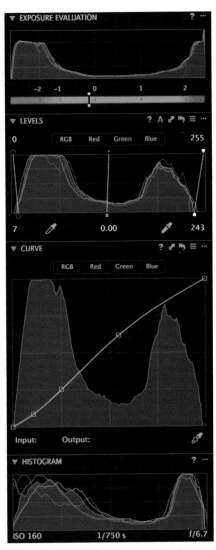

5.6 *An image and its histograms at various stages in the pipeline*

The Histogram tool is located by default in both the Color and Exposure tool tabs and shows the current state of the active image. This includes all the adjustments you have made, whether to the tone curve, the camera profile, white balance, or exposure. This is a display-only tool and provides no means of making further adjustments. In other words, it shows the current "internal" distribution of tonal values in your image.

Further histograms can also be found in the Levels tool, the Exposure tool tab, the Exposure Evaluation section of the Capture tool tab, and the Curve tool. This might be a little confusing for beginners, so the following sections take a closer look at each to enable you to better evaluate the effects of the adjustments you make. □ 5.6

The Exposure Evaluation Histogram

5.7 Exposure Evaluation helps you judge under- and overexposure.

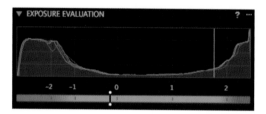

This histogram displays the undeveloped, linear raw image data to help you judge whether an image is under- or overexposed. This display never changes. We'll come back to it later in the context of tethered shooting (see chapter 14), the area where it's most useful and the reason it's included in the first place.

The Levels and Curve Histograms

These two histograms work in tandem and are included by default in the Exposure tool tab. Unlike the other two histograms, they are both active tools and not just designed for evaluation purposes. We'll take a closer look at them in chapter 6.

5.8 The Levels histogram enables you to adjust shadows, midtones, and highlights separately for all three color channels or simultaneously.

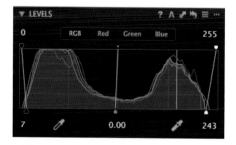

The Levels histogram displays the current state of the image, including all adjustments to exposure, white balance, the camera profile, HDR settings, and so forth. However, it *doesn't* react to changes you make using the Curve tool, which works *in sequence* with the Levels tool. In other words, the Curve

tool bases its display and adjustments on all previous adjustments, including Levels. Note that changes you make using the Curve tool don't influence your previous adjustments and are therefore not reflected in the Levels histogram. To oversimplify a little, the Curve tool is used to fine-tune the look of an image shortly before output.

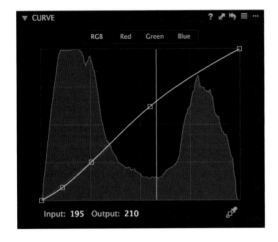

5.9 *The Curve tool enables you to fine-tune the look of an image—if necessary, separately for each RGB color channel. It is used to modulate the tonal values in an image at the end of the development process the same way the Base Characteristics curve does at the beginning.*

The Histogram Tool

Like the Exposure Evaluation tool, the Histogram tool offers no adjustment options and instead provides a purely informative display of the current state of your image, including proof profiles. In other words, it displays the tonal values that would end up in your image if you were to output it *now*. This makes it the most important of all the histogram displays. The levels of shadow and highlight detail also depend on the process recipe you use (see chapter 13), and only the Histogram tool includes the selected output profiles in its display. It pays to keep it open in the Exposure tool tab or float it on your desktop. With a little practice, you'll be able to judge image quality without having to output a copy—a glance at the histogram is all you need to check whether your image is too dark, too bright, or just right for output to your selected medium.

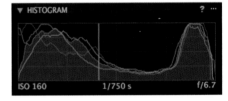

5.10 *The Histogram tool shows the tonal distribution in the finished image that you save to disk.*

QUICK TIP
Practice by opening all four histograms in the Exposure tool tab (right-click within the tab to add a tool). Hide all other tools except Exposure Evaluation and the histograms and experiment with various exposure, contrast, and saturation settings. You'll quickly learn which histogram reflects which adjustments and which histogram is most useful at the various stages of the workflow.

5.3 White Balance

5.11 *White balance is a central element of all the color adjustments you make in Capture One. Always make setting it the first step in your workflow.*

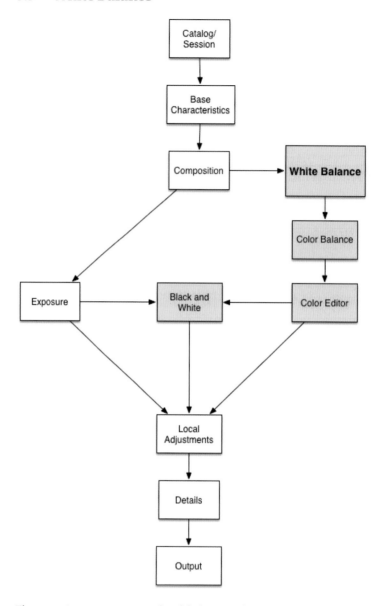

There are two reasons you should always adjust the white point before you make any other adjustments to an image:

1. The white point in a freshly captured image is saved only as part of its metadata, whereas the pixels themselves are still "raw." Every raw developer interprets white points differently.
2. A neutral white point isn't right for every image. For instance, who wants to "normalize" a spectacular sunset to neutral gray?

Point #1 is one of the reasons raw files look different in different programs. Daylight in Lightroom is not the same as it is in Capture One, and is usually different again from the JPEG preview displayed on the camera monitor.

5.12 The same file, displayed using the default settings in Lightroom (left) and Capture One (right)

5.3.1 Setting White Balance Using a Gray Card

Selecting a neutral white point is a common way of "normalizing" an image for further processing. The easiest way to do this is to photograph a piece of gray card in the same lighting situation as your subject and use the Pick White Balance tool (access using the W shortcut) to select it.

Using a gray card is the best way to ensure that your camera produces neutral colors.

5.13 Setting white balance using the Pick White Balance tool

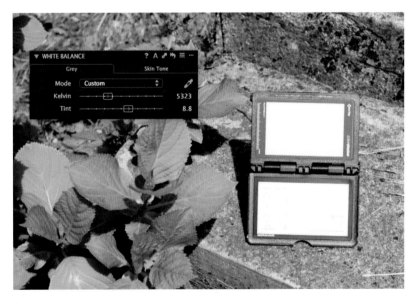

Alternatively, if you don't have a gray card or you're not sure whether yours is still truly neutral gray, you can use the tool to pick an area that appears to have the right neutral tone. Portrait photographers often use the whites of their subjects' eyes as a reference.

Gray cards are constructed using spectrally flat colors that always reflect the same amount of light. Most gray cards are built to reflect 18 percent of the incident light, and the white balance function built into most raw developers (like the auto white balance setting in your camera) is based on the same metric. However, gray cards lose some of their reflectivity with age, making precise measurements impossible. Make a note of when you purchase a gray card and store it in a lightproof box or bag when it's not in use.

5.14 *The X-Rite ColorChecker Passport is well built and folds away into its own lightproof case when it's not in use. The built-in date-of-purchase field helps you to estimate its age and degree of reflectivity.*

If you need to adjust white balance manually (for example, because the gray card you used was no longer neutral), use the Tint slider in the White Balance tool. If your image has a green cast, move the slider to the right. If it has a magenta cast, move it to the left. If you click the value directly, you can use the up and down arrow keys to fine-tune the value in increments of 0.5. If you do the same with the Shift key pressed, the increment switches to 2.0.

5.3.2 Auto White Balance

Auto White Balance often saves a lot of effort but sometimes has to be manually fine-tuned.

Capture One has a built-in Auto White Balance function operated by clicking the A icon in the title bar of the White Balance panel. This calculates a (hopefully) neutral white point value based on the RGB values contained in the image. You might have to adjust the auto value a little, but it usually produces usable results for images captured in daylight or full-spectrum studio light.

5.15 *The White Balance panel with the Auto White Balance button highlighted in orange*

If you find that the Auto White Balance option is good enough for most situations, you can activate it globally using the Adjustments > Auto Adjustments > White Balance command. You can then apply it to all of your freshly imported images using the Auto Adjust (Cmd/Ctrl+L) command

or by checking the Auto Adjust option in the Import Images dialog (see section 4.4).

5.16 If you are happy with the results produced by the Auto White Balance function, you can opt to apply it automatically during image import.

5.3.3 The Skin Tone Tool

The Skin Tone tool is unique to Capture One. It offers Beige, Honey, and Rose tones, each with Deep, Medium, and Light settings. These presets won't apply to everyone, but they offer a useful range of starting points when you're capturing skin tones in artificial light without the help of a gray card. The tool comes into its own if you regularly photograph the same person:

The Skin Tone tool is particularly useful if you often photograph the same people.

1. Neutralize the white balance settings in the Grey tab of the White Balance tool, if possible using a gray card held by your model.
2. Switch to the Skin Tone tool.
3. Check the "Pick to create new" option.
4. Use the Pick Skin Tone eyedropper to select a well-exposed and evenly lit area of your model's face (the forehead, for example) and save your selection under a meaningful name in the dialog that follows. ☐ 5.17

You have now saved a skin tone preset that perfectly matches your model's skin. Next time you're photographing the same person, simply select the appropriate preset in the Skin Tone drop-down list and use it to select the part of your subject's face you used to create it.

This method is never as precise as using a gray card. Changes in makeup and the your model's current mood can make a difference in the value you measure, but the tool is still useful for saving a basic look that you can fine-tune during each session.

5.17 Using the Skin Tone tool with a live subject

If your model is looking paler or rosier than usual, you can still fine-tune your preset using the White Balance tool.

As mentioned in section 5.3.1, in most situations you will have to fine-tune white balance using the Tint slider in the White Balance tool's Grey tab. This is especially true if the real subject is an item of clothing rather than the model. Manual corrections are also necessary when colored reflections occur or some of the ambient light is absorbed—for example, if you're shooting among trees or with mixed light sources.

> Since version 8, white balance can also be adjusted locally, which is often necessary if you're shooting with mixed light sources. See chapter 10 for more on local adjustments.

5.4 Color Balance

The Color Balance tool is one of the most popular in Capture One's bag of tricks. It uses a color wheel to adjust the overall look of the image. If you want your image to look a little cooler, all you have to do is shift the wheel toward blue. Conversely, if you want to make things look a little warmer, a shift toward yellow/orange usually does the trick. All versions of Capture One ship with presets for such a "Cool Look" and "Warm Look," with three strengths, numbered 1 through 3.

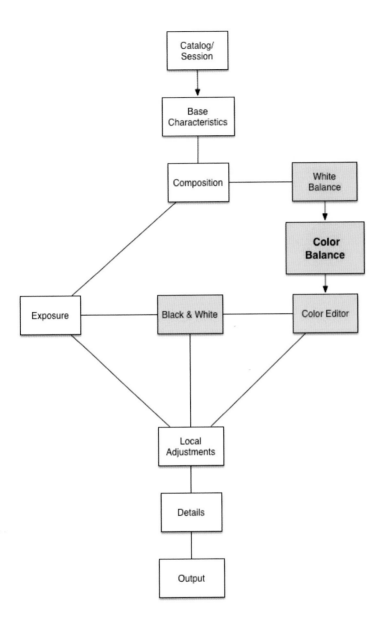

5.18 *The Color Balance tool is central to the workflow pipeline and influences all other tools that are based on tone curve adjustments. Always adjust color balance after you have adjusted the white point but before you make any other color adjustments, or before you convert an image to black and white.*

During version 8's life cycle, Phase One rebuilt the tool from the ground up. Color Balance as seen in Capture One Pro 9 is the final version—for the time being. Phase One might tweak the algorithms in the background for future point-releases, but the tool's look-and-feel also found its way into the revamped Color Editor (see section 5.6). If you're coming from an earlier version of Capture One, don't be intimidated by the new tool; you can still easily make general adjustments that range between cool and warm, but you can also make complex adjustments that previously required a lot of time and effort fiddling with the Levels and Curve tools or third-party software like Google Nik Collection Color Efex Pro and Adobe Photoshop.

You can use the Color Balance tool to alter the tone of the white point separately for shadows, midtones, and highlights.

In its simplest form, the Color Balance tool works the same way it always did.

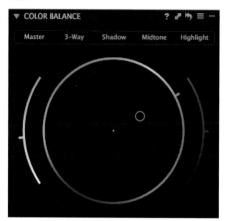

5.19 *The Color Balance tool, as we have come to know and love it.*

You use the color wheel to select the color you want to use to "tone" the white point. It's kind of like dyeing your hair—you don't want to turn your blond hair blue, but perhaps give it a reddish shimmer. The Color Balance tool gives that boring old neutral white point a cooler or warmer touch. Because the white point is the most important metric for the rendition of all the colors (see section 5.3), even slight alterations make a big difference to the overall look of an image.

5.20 *From left to right, these images were toned using the Cool Look 3 preset, a neutral white point, and the Warm Look 3 preset. The screens beneath show the corresponding settings in the Color Balance tool.*

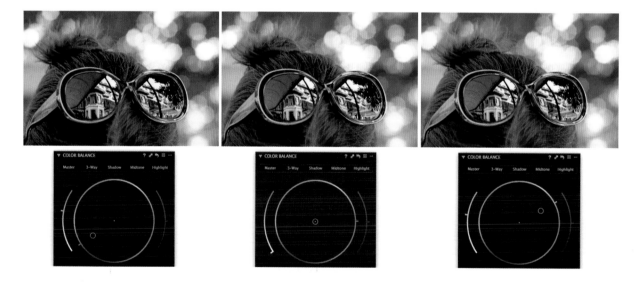

In addition to the basic tool, version 8.1 introduced separate shadow, midtone, and highlight toning options like the ones in Apple Aperture. Even with its expanded capabilities, the tool remains intuitive to use and has thus seen very little change even with Capture One 9.

The tool works in basically the same way as the black, gray, and white Tint dials in Aperture and Lightroom's Split Toning tool. You select a color and then the strength of the toning effect—Capture One automatically alters the shape of the tone curves to match.

> In principle, you can achieve the same effect using the Levels tool in the Exposure tool tab—both tools adjust your image at the same stage of the pipeline, although the Color Balance tool is much easier to understand and use. If you have created your own presets using earlier versions of the tool, you can still use them with the latest iteration.

The tool is controlled using color wheels with built-in sliders. The setting in the wheel determines the hue, whereas the left-hand slider controls saturation and the right-hand one lightness.

> **QUICK TIP**
> If you want to give an image a slightly cooler or warmer look, stick to using the Master color wheel and ignore the other options. Used this way, the tool will adjust the entire image to suit your setting and saves you the effort of setting three separate sliders.

Creating a Cross-Processing Filter

The Color Balance tool is designed as a creative tool rather than a means of correcting image errors. It is great for copying effects that you like and creating your own styles. Cross processing is one of the most popular develop effects around, and it's based on the analog darkroom technique of developing C-41 color negative film in E-6 slide development chemicals, or developing slide film with black-and-white chemicals.

5.22 *This is a look we all know.*

One of the most popular cross-processing looks is achieved by developing slide film using color negative chemicals. The resulting images have high levels of contrast, blue-tinted shadows, and yellow-green highlights. The following steps explain how to re-create this effect using the Color Balance tool:

1. Select an image with average contrast but highly saturated colors. This will help you to see the effects you apply. Now switch to the Color tool tab.

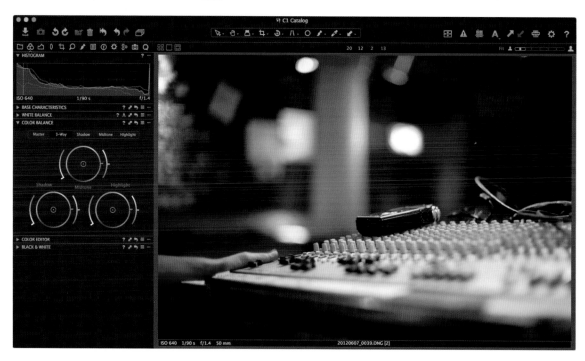

2. Switch to the 3-Way tab in the Color Balance tool. All three color wheels will be set to neutral.

3. Switch to the Shadow tab. Slide film developed in C-41 chemicals usually has a deep blue cast in the shadows. To reproduce this effect, shift the lightness slider (on the right) and the saturation slider (on the left) all the way to the top and click your desired blue hue in the color wheel.

4. Readjust your lightness and saturation settings until you get the effect you are looking for in the shadows. Remember: Less is more! High saturation and lightness values produce dramatic effects, but lower values produce images that look more natural.

5. Switch to the Highlight tab and perform the same steps as before, this time using a yellow hue.

6. The 3-Way tab gives you simultaneous access to all three color wheels. Adjust their saturation and lightness settings in the shadows and highlights to produce a pleasing overall look.

7. If midtone areas such as human skin end up looking unnatural, use the Midtone tab to select a hue on the opposite side of the circle to the one you wish to correct. In our example, the subject's skin looks a little too green, which is why we selected a pinkish hue.

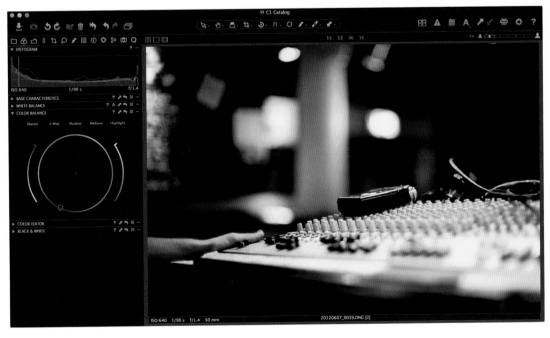

8. Once again, use the lightness and saturation sliders to eliminate the color cast and that's it—you have now produced an image with a cool cross-processed look.

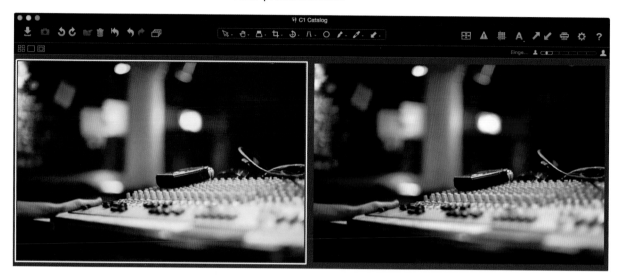

> **QUICK TIP**
>
> Unless your project has critical colorimetric guidelines (reproduction work, for example), there is no right or wrong approach to working with colors in Capture One. Some people like skewed, "lomographic" colors, whereas others prefer their images to look as natural as possible. Always save color balance settings that you like (use the Save User Preset command in the Manage and Apply menu). You'll quickly build up a library of "process simulation" presets that you can apply to a wide range of images. If you find after a while that an effect is too heavy-handed, you can tweak it and save it under the same name.

5.5 Black & White

For a long time, conventional wisdom upheld the notion that you need dedicated software to produce monochrome results that look like "real" film-based images rather than just desaturated color photos. In view of the endless possible combinations of films, emulsions, and developers, it's pretty obvious that simply dialing out the colors won't produce a genuine-looking black-and-white image. For a black-and-white conversion to look convincing, you have to precisely adjust its tonal values and take into account the effects of different colors.

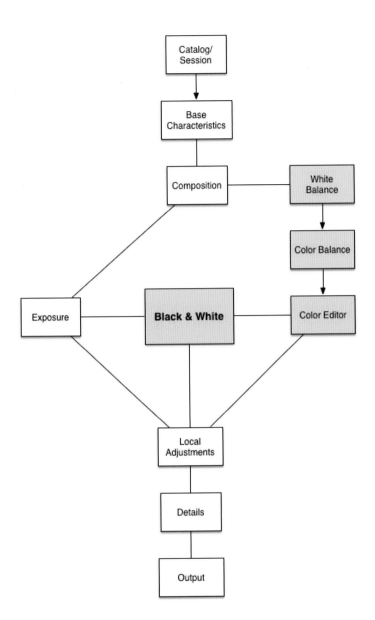

5.23 The Black & White tool bases its adjustments on the current state of your image—including the white point setting, tone curve adjustments, and color balance—so it's usually a good idea to use the Black & White tool as the final step in your workflow.

Google Nik Collection Silver Efex Pro is one of a number of specialized programs that prove just how expensive high-end black-and-white know-how and algorithms can be, but is nevertheless a popular option among monochrome enthusiasts. Such programs are built from the ground up with monochrome conversion in mind, and offer a range of tools that are optimized for this kind of work. Additional tools such as a digital Ansel Adams-style zone system ensure that many photographers stick to using dedicated software and don't even consider converting their images at the raw development stage.

5.24 *Silver Efex Pro is a powerful but simple-to-use program designed explicitly for working in black and white.*

The Levels, Curve, Black & White, and Film Grain tools give you all the options you need to make perfect monochrome images.

The downside of such specialized software is that it only works with TIFF, PSD, or JPEG image files, so you have to develop your raw images before you convert them. In turn, this means that you have to keep the raw version of each image with its associated settings as well as a copy for conversion. Additionally, if you adjust the original, you'll have to convert it all over again. Even though Silver Efex Pro can be used as an Aperture or Photoshop plug-in that enables you to adjust the black-and-white layer separately from the rest of the image, the plug-in still requires bitmap data to work on.

If you discover a major error such as dust on the sensor that only becomes apparent when you apply a film simulation, or a source image that wasn't sharpened enough at the import stage, you simply have to start over. And this is where black-and-white conversion at the raw development stage comes into its own. Capture One has been a favorite among monochrome enthusiasts for quite a while, and the new Film Grain tool (see section 9.5)

enables you to produce authentic-looking high-end monochrome images for display on a monitor or printing. Because the black-and-white conversion takes place on a raw data level, you can easily make further adjustments to your original images without having to repeat the black-and-white conversion process.

The settings in the Color Sensitivity tab determine how your virtual black and white film reacts to the colors in the visible spectrum and can also be used to simulate the use of filters. Yellow and red filters are often used in black-and-white photos—for example, to darken the sky, brighten grass, or shift skin tones into a more appropriate tonal range (or "zone" as Ansel Adams would have said). The greatest benefit of converting to black and white at the raw development stage is that you don't have to use filters while you shoot. Because you're working with raw image data, you can add and fine-tune whichever filters you like during processing.

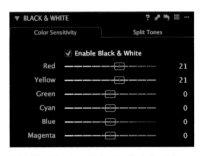

5.25 *The Black & White tool's default location is in the Color tool tab. Right-clicking the Color tool tab title bar opens a context menu in which you can add a dedicated Black & White tool tab that contains the Black & White, Exposure, Levels, Curve, Clarity, Vignetting, and Film Grain tools.*

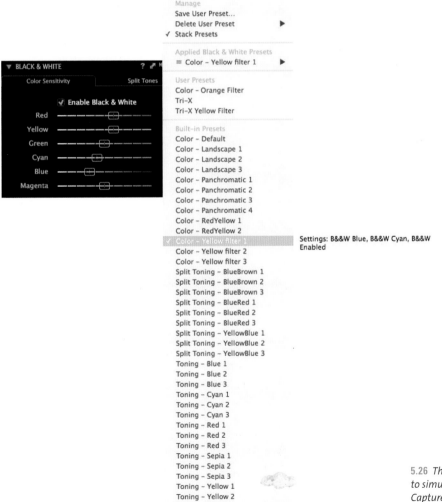

5.26 *The Color Sensitivity tab can be used to simulate the effects of color filters. Capture One provides a wide range of filter presets for you to experiment with.*

IMPORTANT

Try not to overdo your Color Sensitivity settings. Capture One is very good at producing smooth color gradients, but if you aren't careful, you can easily produce unwanted banding effects, especially in high-contrast images. Regulate your settings until any artifacts are no longer visible.

The Split Tone tab enables you to tone the highlights and shadows in your image separately. Most people are familiar with sepia-toned images, but special analog chemicals and paper types can also be used to produce other colors and combinations of tones in the light and dark areas of an image—and this is the type of effect the Split Tone sliders create.

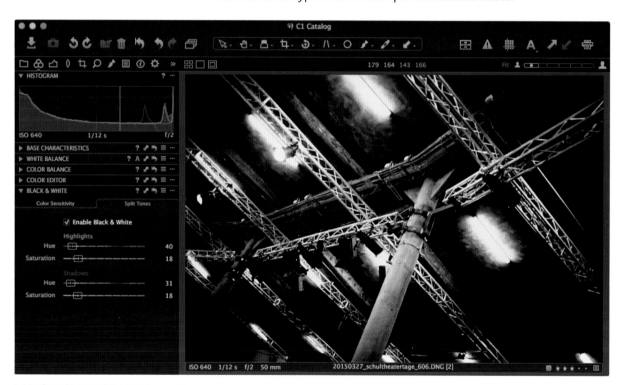

5.27 *The Split Tone sliders can be used to simulate coffee-colored grays on a "cool" paper just as easily as a conventional sepia tone. The Black & White tool offers a range of presets.*

QUICK TIP

It is up to you to decide which stage in your workflow is best suited to applying the Black & White tool's effects. The advantage of performing your monochrome conversion in Capture One is that it enables you to decide whether, when, and how you apply each tool. However, when working in black and white, it's always a good idea to clone your original color image before you convert it. This way, you can optimize the Curve and Levels settings in your monochrome image without spoiling the work you've already done on the color version. To clone an image, right-click it in the Browser and select Clone Variant.

Producing Perfect Black-and-White Images for
Printing or Online Publishing

Capture One makes it simple to create and manage multiple versions of your images. This is particularly useful when you're working on monochrome variants, because you never know when you might want to go back to your original color version. Additionally, images destined for online publishing often have to be prepared differently from those that you wish to have printed at a lab or that you print at home. The following steps explain the most efficient way to produce black-and-white versions of your images for print and online sharing.

1. Select an image and develop it; then copy it using the Clone Variant command in the Browser context menu.

2. Check the Enable Black & White option in the Black & White tool to display your image with desaturated colors.

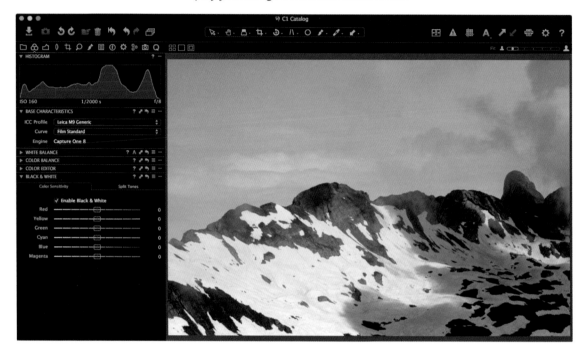

3. Begin by adding filters. For this example, use the Color – Yellow filter 1 preset to darken the sky.

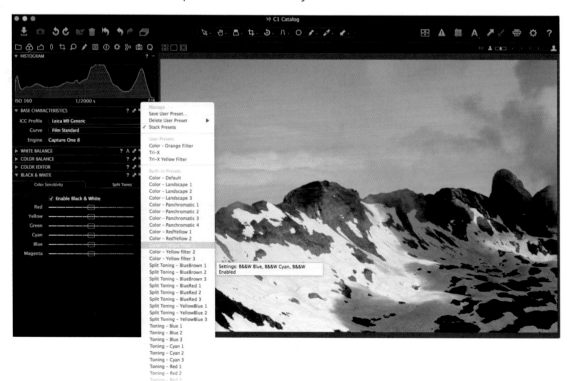

4. The preset works well but still doesn't produce quite the effect we're looking for, so use the settings shown here to fine-tune it.

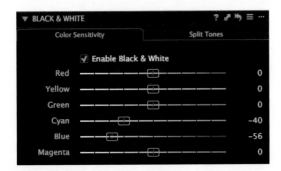

5. Adjust the tonal distribution to keep the main foreground subject mid-gray while increasing overall contrast. To do this, select the Curve tool in the Exposure tool tab and drag the curve into an S shape.

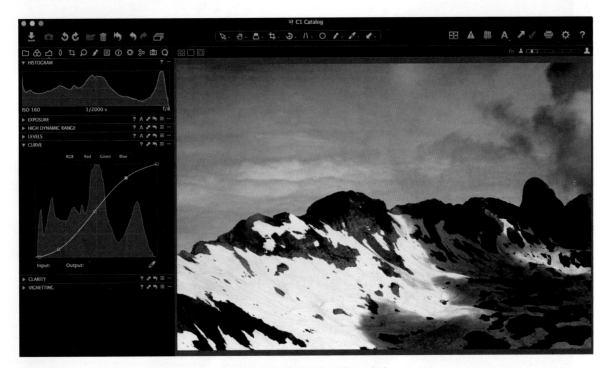

6. Our image looks better, but the shadows aren't dark enough and the main subject is still too dark. To sort this out, switch to the Levels tool and increase the midtone value while moving the highlight and shadow zones closer together.

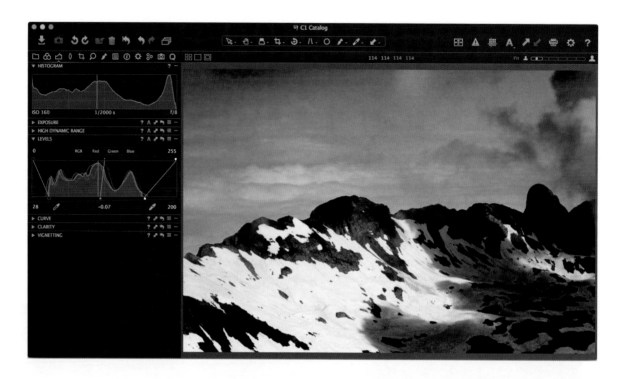

7. Now let's adjust the details. To fine-tune overall texture and tweak the contrast between the main subject and the rest of the frame, switch to the Clarity tool and select the Punch method.

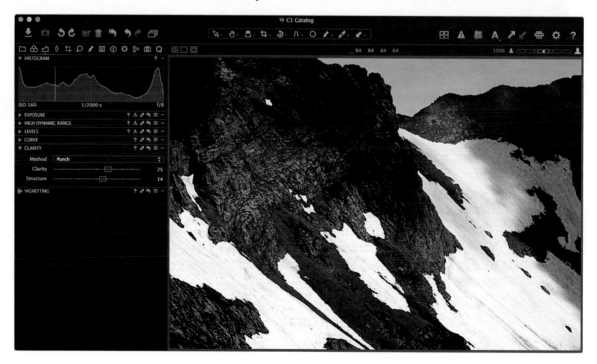

8. Now adjust the shadow and midtone settings in the Levels tool to achieve the right compromise between a punchy overall look and sufficient shadow detail. Zoom into the 100% view to check your settings and readjust them if necessary.

9. Adding a grain effect adds to the analog feel. To do this, switch to the Details tool tab and a 100% view and select the Silver Rich option in the Film Grain tool. Adjust the Impact and Granularity sliders until you achieve the effect you are looking for.

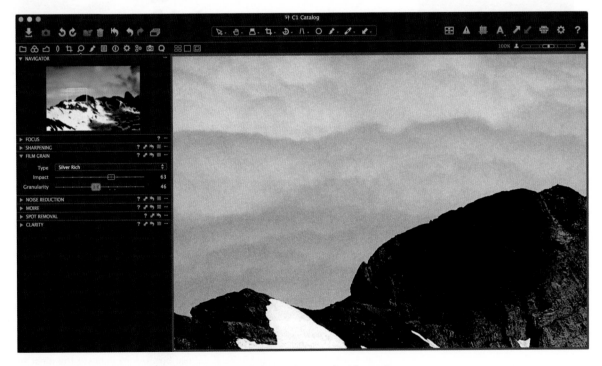

10. If you've followed the steps so far, you now have an image that is ready for inkjet printing. Create another clone using the Clone Variant option in the Browser context menu.

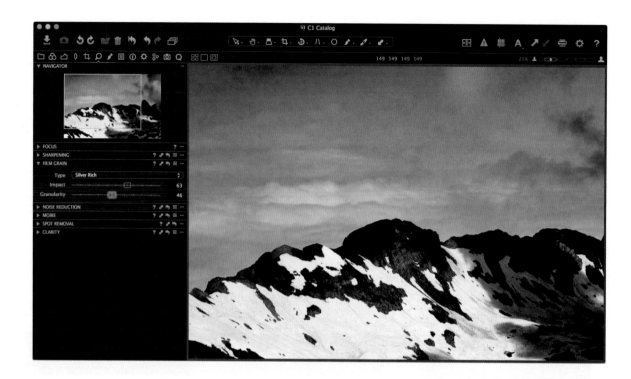

11. If you scale your image down for web viewing, the grain effect and the effects of your Clarity and Structure settings will change accordingly. To compensate, increase the Granularity value by 30–60 points and the Clarity and Structure values by 10–20 points, depending on the size of the web version. In our example, I scaled the image to 50% of its original size and set +30 for Granularity and +10 for Structure and Clarity.

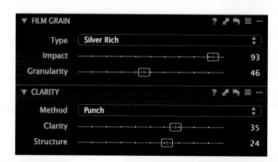

This example doesn't provide ideal values, but it does indicate the ideal sequence in which to apply the steps involved in a black-and-white conversion. See chapter 6 for more on the Levels, Curve, and Clarity tools. The Film Grain tool is discussed in detail in chapter 9. Section 9.5.2 includes further details on combining grain, clarity, sharpening and noise reduction in web-based images.

5.6 The Color Editor

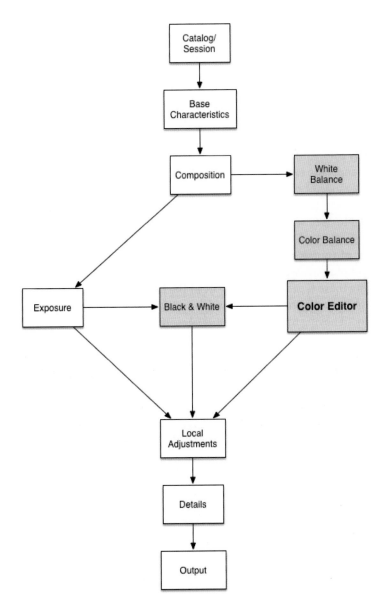

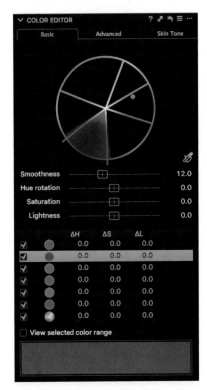

5.28 In our idealized workflow, the Color Editor follows the Base Characteristics settings (see section 5.1), but nevertheless reacts to all previous and subsequent color adjustments. We recommend using the Color Editor after you have made any adjustments using the Color Balance and White Balance tools.

The Color Editor is one of Capture One's most popular tools, and some users maintain that it was deactivated in the Express version of the program to get more people to upgrade to the Pro version. Once you've spent a while working with the Color Editor, you're sure to be impressed by the ease and speed with which you can perform high-quality color edits.

5.29 The look and feel of the Capture One Pro 9 Color Editor tool is adapted from that of the Color Balance tool. It may look confusing but is, in fact, just complex!

Among other things, you can use the Color Editor to do the following:

- Correct color casts—for example, if you have to shoot in (poor) artificial light.
- Compensate for the color errors produced by a weak in-camera infrared filter.
- Creatively recolor image details, such as the iris in a subject's eye or a flower.
- Clean up skin blemishes and irregularities, even if your model used makeup.
- Intensify color effects—for example, to make a sunset more dramatic or give a landscape extra punch.
- Select a range of colors, and then create a new Adjustment Layer from this selection to edit these image areas with tools other than just the Color Editor (see section 10).

These are, of course, all tasks you can perform in Photoshop or by using specialized plug-ins like Color Efex. However, as described in section 5.5, performing these types of adjustments at the raw development stage produces higher-quality results and enables you to alter your color settings later without having to trash all your other settings.

> **QUICK TIPS**
>
> Settings you make using the Color Editor can be saved as ICC color profiles using the action menu (the three dots at top right in the tool panel). This makes the Color Editor a useful tool for making ad hoc adjustments to camera profiles (see section 5.1) and offers a much easier way to desaturate, brighten, darken, and modulate colors than creating a new ICC camera profile from scratch.
>
> Also in the action menu, you will find the option to Create Masked Layer from Selection. When you choose this option, the selected color range is used to create a new Adjustment Layer in the Local Adjustments tool. This makes it easy for you to not only fine-tune the tone of blue in the sky (i.e., do color edits), for example, but also to use tools such as Sharpening, Noise Reduction, Clarity, or Exposure correction on the selected range only. Sticking with the sky example, you usually don't want high levels of sharpness in a uniform sky because it would only accentuate sensor noise or dirt spots. Use a masked layer of the sky, switch to the Local Adjustments tool tab, and turn off Sharpening—done.

5.30 The Basic tab in the Color Editor is clearly laid out and is great for making quick color adjustments or performing on-the-fly creative tweaks.

The Color Editor makes it quick to adjust and retouch colors.

5.6.1 The Basic Tab

The Color Editor offers Basic, Advanced and Skin Tone tabs. The Basic tab is the simplest to use: pick a color using the Color Picker (eyedropper) or one of the color ranges (or "slices") displayed in the lower part of the tool's panel and use the Smoothness, Hue Rotation, Saturation, and Lightness sliders to tweak it as you wish. ▫ 5.30

The Saturation and Lightness sliders are self-explanatory. The Hue Rotation slider rotates the selected color slice within the color wheel.

5.31 *Here, I selected the green color range and rotated it toward blue (on the left) and toward yellow (on the right).*

Imagine you have shot a session under a tree and your subject's face has turned out looking too green. All you have to do is click on the face using the Color Picker and use the Hue Rotation slider to shift the color wheel toward red. If a photo of a sunset doesn't turn out as dramatic as your memory of it, select the sky and rotate the blue slice toward violet. The Basic tab isn't designed with high-precision adjustments in mind, but the Smoothness slider and the "View selected color range" option make it effective for quick adjustments.

5.32 *Checking the "View selected color range" option desaturates the image in the Viewer and displays only the selected range in color. Used together with the Smoothness slider, this enables you to precisely fine-tune the range of tones included in the selected range.*

The Smoothness setting determines the degree of similarity between the colors that are included in the selected range. The default value 12 includes tones that vary only slightly, whereas a value of 1 affects only the tone you've selected, and a value of 29 affects a wide range of tones on both sides of the selected one.

You can use different settings for each color range and the settings you select are shown in the ΔH, ΔS, and ΔL columns in the tool panel. Δ stands for the Greek letter delta and denotes the difference between the displayed and original values. The check boxes next to each color range show which of your adjustments are currently active.

5.33 The blue color range has been shifted toward green, darkened, and its saturation increased. The orange range has been shifted slightly toward red but is otherwise unchanged.

		ΔH	ΔS	ΔL
☑	⬤	0.0	0.0	0.0
☑	⬤	0.0	0.0	0.0
☑	⬤	-14.3	34.2	-2.5
☑	⬤	0.0	0.0	0.0
☑	⬤	-9.1	0.0	0.0
☑	⬤	0.0	0.0	0.0
☑		0.0	0.0	0.0

The last entry in the range list applies to all the tones in the image instead of just a selected range. If you select this entry, the Smoothness slider will be grayed out.

This option is useful for performing quick repairs on color casts—for example, if you forgot to use a yellow filter for a black-and-white shot or if the blue spotlights in a theater shot turn out too pink.

5.6.2 The Advanced Tab

The Advanced tab enables you to create your own color ranges and make adjustments that are more precise than those you can make in the Basic tab.

In principle, the Advanced tab works just like the Basic tab. You select a color, define a range, and adjust your tones accordingly. The difference between the two tabs lies in *how* you select colors and the tools available for adjusting them. To understand fully how the Advanced tab works, let's first take a closer look at the color wheel.

5.34 The Capture One color wheel

The color wheel is based on the traditional color model that you perhaps encountered in art classes at school. Complementary colors lie on opposite sides of the wheel, and saturation increases toward the edges (that is, the center is white where all colors are completely desaturated and the edges show completely saturated colors). The Advanced tab enables you to precisely define and display the range of tones in a slice.

The color you select in the Viewer using the Color Picker (eyedropper) is indicated by a black dot, and you can precisely define the saturation and range in the slice by shifting the surrounding white dots.

5.35 *The tones you've selected are the ones that are affected by your adjustments. You can adjust the range and saturation by shifting the white dots in the color slice.*

The tools in the Advanced tab are the same as those in the Basic tab, with the addition of the Span Full Saturation Range and Invert Slice options.

The former increases the saturation range from the center to the edge of the color wheel as it does in the Basic tab, whereas the latter does exactly what it says and alters the selection to cover the tones you *haven't* selected.

5.36 *The Advanced tab in the Color Editor includes Invert Slice and Span Full Saturation Range options.*

5.37 *The original color range selection is shown on the left and its inverse on the right.*

The Invert Slice option comes into play when you want to prevent certain colors from being altered. The best-known example of this type of usage is in color key shots, in which all colors but one are shifted to grayscale. To do this in Capture One, follow these steps:

1. Use the Color Picker to select the color you wish to retain.
2. Check the "View selected color range" option at the bottom left of the panel (circled in red below) and alter Smoothness until the slice shows your desired range of tones.

3. Uncheck the "View selected color range" option and click the Invert Slice button at the bottom right of the panel (circled in red below).
4. Shift the Saturation slider all the way to the left.

5.6.3 The Skin Tone Tab

At first glance, the Skin Tone tab appears identical to the Advanced tab. However, on closer inspection you'll notice a couple of things:

● It only works for one very specific color range.
● Instead of the Invert Slice option, it includes an additional slider labeled Uniformity.

Because most portrait photos have only one basic skin tone, the Skin Tone tab doesn't offer a set of alternative color ranges like those in the Basic tab. The Uniformity slider is the killer feature in this tool. ◻ 5.38

Studio photographers spend a lot of time and effort ensuring that their models are perfectly made up, often with the emphasis on achieving a balanced look for the skin rather than concentrating on eye-catching lips or striking eye styling. News anchors often sweat under layers of makeup, politicians use face powder for press conferences, and models usually wear plenty of makeup, even if they are hired to promote a "natural" look. They do this to prevent unwanted glossy reflections and produce a clean overall look. The Uniformity slider helps you do the same even after a shoot is over. ◻ 5.39

It works by shifting similar tones closer to one another and, like the Smoothness slider, includes tones that are similar to (but not the same as) the selected one. The higher the Uniformity value you set, the more tones will be merged into one. The trick is that the tool doesn't smooth out wrinkles or hairs in the process so, unlike when you use the Clarity slider or the Photoshop Blur tools, you don't lose any image detail.

The Skin Tone tab is a specialized version of the Advanced tab.

5.38 *The Skin Tone tab is simple to use and makes life a lot easier for portrait photographers.*

5.39 *We shifted the Uniformity slider all the way to the right for the image on the right. The model's skin looks smoother but still retains all its detail.*

6 The Exposure Tool Tab

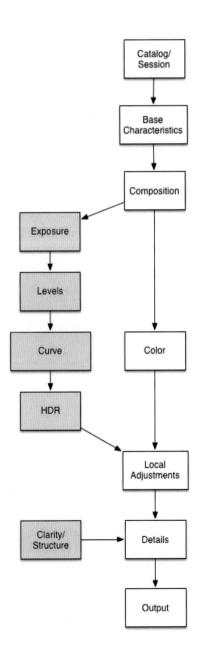

6.1 *Adjustments to exposure are one of the core elements of photography in general and of the Capture One workflow in particular. Along with the tools offered in the Color tool tab, the tools in this tab are what a raw converter is really all about.*

The Exposure tool tab contains all the tools you need to adjust and correct exposure errors and get your creative juices flowing. These tools are all about light rather than color, which is why they're grouped in the same tab, even if the grouping appears illogical at first glance.

6.1 The Basics: Contrast, Saturation, Brightness, and Exposure

Every digital image contains a range of tonal values, and the Exposure tool tab enables you to adjust their distribution and how they relate to each other.

The Saturation, Exposure, Contrast, and Brightness settings offered by the Exposure tool are the same as those in even the simplest image-processing applications, such as Apple's Preview or Microsoft Image Viewer, but they deliver much better quality than most of these alternatives. In Capture One Pro 9, Contrast and Brightness were overhauled; they deliver cleaner and more predictable results, and in many cases, replace the need for more complex work with the Curve tool.

If you click the Auto Exposure button (the A icon in the tool's title bar), the program shifts the exposure slider in an attempt to create an "average" histogram. It bases its adjustment on the values shown in the Exposure Evaluation panel (see section 5.2) and a mathematically calculated medium gray tone. This approach means that the Auto option will fail for certain types of images. The matrix and scene modes built into today's cameras evaluate exposure based on the content of the image—Capture One doesn't.

6.2 Capture One offers the same basic exposure sliders as most other image-processing programs.

Exposing for "medium gray" (that is, the average exposure that Capture One aims for) is the right approach for many subjects. In other words, Capture One's Auto Exposure function makes a good starting point for adjustments and fine-tuning. Nevertheless, if you do end up photographing the infamous black cat in a coal cellar or white rabbit in the snow, don't use the Auto Exposure function to tweak the results.

6.2 HDR

The HDR tool doesn't produce "real" multi-exposure HDR images and is instead aimed at recovering lost shadow detail and rescuing burned-out highlights, often producing HDR-style results.

The tool's name is actually rather confusing, because it has little to do with merging multiple source photos to create a single high dynamic range (HDR) image.

Photo cameras have a fixed dynamic range that is often expressed in terms of f-stops. This means that when you're photographing a high-contrast scene, you have to decide which details are most important and expose appropriately for the shadows, midtones, or highlights. In such situations, it's impossible to capture all of the subject's detail in a single image.

If you want to capture all the detail in a scene, you have to use a bracketing sequence with varying apertures to capture source images that you can merge into one later on. The camera's dynamic range covers only a portion

of the overall range of brightness in the subject, and HDR software merges the sequence of portions you capture to create an image that covers the entire range of contrast in the subject.

Capture One's HDR tool doesn't work with multiple images and can therefore only adjust the data captured by the camera in a single image. The functionality offered by the tool is the same as that offered by the Lightroom Recovery tool, which uses an algorithm to brighten shadows and midtones while simultaneously recovering highlight detail, hopefully without creating additional artifacts or banding effects. This simulates a greater dynamic range but actually compresses the range of tonal values to achieve its effect, thus creating a narrower dynamic range than that of the original.

6.4 *The histogram on the left displays the entire dynamic range of the original image, whereas the one on the right shows the dynamic range created by applying the HDR tool. The overall range of tonal values has been compressed, creating a dynamic range that is—mathematically at least—narrower than that of the original. However, the image itself appears more "dynamic" with more visible detail.*

So much for the theory. In practice, the tool is actually very good at brightening shadows.

6.5 *There is a drummer in the band after all.*

The HDR tool is easy to use. The Highlight slider attempts to recover over-exposed highlights by analyzing the surrounding pixels for remaining detail and combining what it finds with the colors in the Bayer pattern microfilters located in front of the image sensor (see section 9.2). This works well in moderately overexposed image areas but fails where all three color channels are completely overexposed, because the algorithm no longer has any reliable color data on which to base its extrapolations.

6.6 *The HDR tool is great for recovering highlight detail in a range of situations, but the quality of the results is often quite random.*

The Shadow slider works in a similar way; it attempts to guess the colors in the pixels surrounding ones in which "swamped" detail is no longer visible. Brightening shadows usually increases noise, although you can counteract this effect using the Noise Reduction tool in the Details tool tab (see section 9.3). One thing is certain: Extreme adjustments produce extreme results that are often relatively poor. The HDR tool is great for rescuing images that you would otherwise have to trash and is good at making images visually more attractive, but it doesn't represent a real alternative to exposing correctly during a shoot.

QUICK TIP

Because the results were often unpredictable, with the release of version 8, Phase One reduced the range of adjustments you can make with the HDR tool. However, if you still need to apply greater values than the standard tool allows, HDR is also available as a local adjustment, enabling you to use it multiple times on separate layers for added effect. See chapter 10 for more on local adjustments.

6.3 Understanding Levels and Curves

You saw in section 5.2 that the Curve and Levels tools are closely related, although they actually function quite differently from one another. The Levels tool enables you to adjust the position of the shadow, midtone, and highlight areas within the tone curve as well as the range for each (either for all three color channels simultaneously or for each separately), whereas the Curve tool modulates the shape of the tone curve that the Levels tool produces.

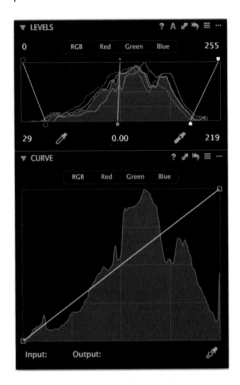

6.7 *The Levels and Curve tools both adjust tonal values but in very different ways.*

Phase One refers to the "input levels" that the Levels tool addresses. This is because any corrections you make are applied to the tonal values in the original image, thus providing input material for further tonal adjustments, whether in the Curve tool or elsewhere.

The Levels tool displays a histogram and provides six values that you can adjust to reduce, increase, and compress the range of tonal values in your image. You can enter your chosen values directly in the appropriate boxes or drag the top and bottom sliders for each. You can also use the Shadow and Highlight Picker tools (the eyedroppers located at the left- and right-hand ends of the histogram curve) to select white and black points in the Viewer.

The results of Levels adjustments form the input for further adjustments using the Curve tool.

6.8 Shadows, midtones, and highlights each have two sliders—the upper ones determine the input and the lower ones the output values. You can also set black and white points by clicking the appropriate area in the viewer with the Shadow and Highlight Pickers.

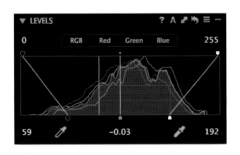

QUICK TIP

It helps to imagine the lines drawn by the shadow, midtone, and highlight sliders as a kind of funnel. If it's broader at the top than the bottom (that is, V-shaped), the input tonal values have been compressed, the histogram curve shortened, and contrast increased. If the funnel is broader at the bottom (that is, A-shaped), contrast is reduced and the image will have less punch. In other words, the Levels tool adjusts the distribution of tonal values to form either a narrow jet or a broad spray but always using the tonal values available in the original image file. The tool cannot create and add new tonal values.

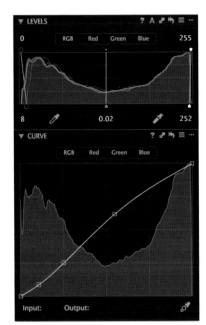

Once you've adjusted the levels, you can modulate the results using the Curve tool. Here, you can emphasize shadows, midtones, and highlights individually or for all three RGB color channels simultaneously by adjusting the shape and steepness of the curve. To adjust the curve, click on it and drag the handle that appears to the desired position.

6.9 The Curve tool modulates the output values produced by the Levels tool—in this case using the Contrast preset to increase overall contrast.

QUICK TIP

The Curve tool is aimed at experienced users who are familiar with Photoshop or other high-end image-processing programs. As explained in section 5.4, the Curve tool can be used to create split toning effects that adjust image data in selected image areas. It can also be used to adjust the linear data captured by the camera's sensor to suit human visual expectations, or used creatively to emphasize selected details.

Although these are all things you can do using other Capture One tools, it's useful to work with the Curve tool. If you're a beginner, you can stick to using the presets provided with the program. With practice, you'll learn which curve shapes suit which types of image, how to optimize individual images, how to develop your own styles for application to multiple images, and how to simulate the look of analog film. This will also help you to judge when the program's other tools are suitable for the job at hand. If you keep an eye on the histogram (introduced in section 5.2) while you work, you'll soon learn to recognize when you've overlooked a particular setting and when your output is likely to display banding or other artifacts.

6.3.1 Correcting Exposure and Optimizing Levels

With such a wide range of tools on offer, it's sometimes difficult to know which is best suited to which type of task. Every photographer has his or her own background and approach to processing, and some get on better than others with certain concepts. This example uses all the available exposure tools—not because it's necessary but rather to help you decide when to use which tool in the context of your own personal workflow.

1. Open a tricky image. Our sample image has a dynamic range that was almost too much for the camera's sensor—it is underexposed in some areas and overexposed in others.

2. We began by using the tools in the Exposure tool tab to regulate the settings for contrast, exposure. and brightness as we would in the camera. The result isn't too bad, but still has some "problem" areas.

3. Increasing the Exposure setting created additional burned-out high-lights, so we used the HDR tool to tone these down.

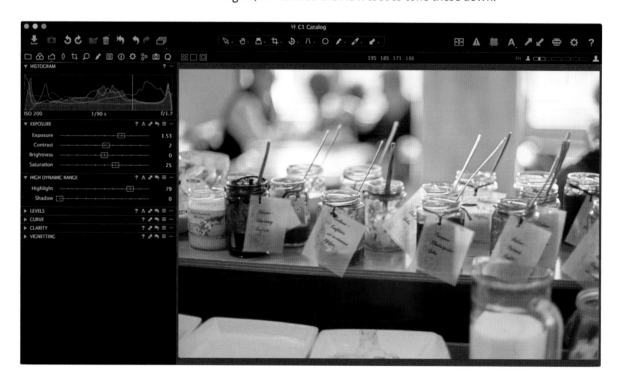

4. We're still not quite on target. Our next step involved applying a negative exposure compensation value and balancing out its effect by increasing the Shadow value in the HDR tool.

5. A quick look at the histogram shows that the distribution of tonal values is still not ideal and there are no really dark blacks any more, even if the overall look is well suited to the subject. We used the Levels tool to select a new black point.

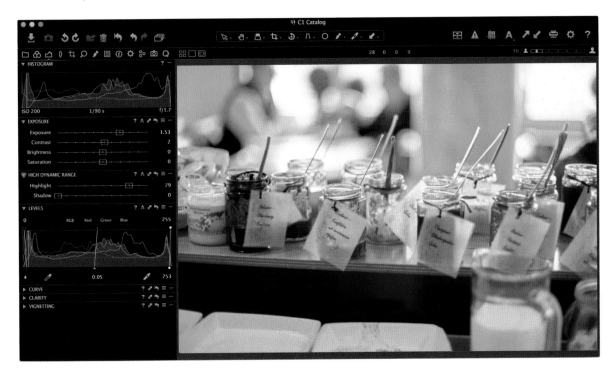

6. Not surprisingly, the tonal values have been squeezed through a fairly narrow "funnel" and the image is now oversaturated. We combatted this by shifting the midtone area up and reducing overall saturation using the Saturation slider.

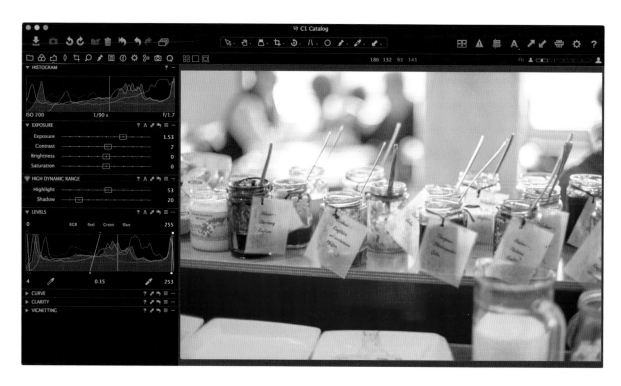

7. So far, so good. However, our image still lacks punch, so we applied the Contrast preset in the Curve tool.

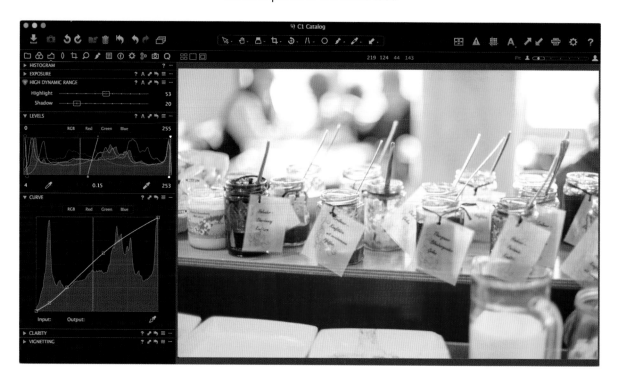

If you're thinking we could've used the Contrast slider in the Exposure tool to perform step #7, you're absolutely right. There are many ways to achieve the same visual goal, but the approach you take will influence the shape of your overall workflow. Contrast settings made using the Exposure tool are handed on to the Levels tool, whereas adjustments you make to contrast using the Curve tool are not. Because any subsequent adjustments you make using the Curve tool don't affect a whole raft of other settings, they usually produce predictable results. If you simply increase the Contrast setting, you'll probably have to adjust any HDR or Levels settings to match. Different approaches involve more tools whereas others involve fewer. It's up to you to decide which approach is simpler or more intelligible, or that makes the most sense in the context of your own workflow.

6.4 The Clarity Tool

Clarity tools are now built into most popular raw developers. This adjustment enables you to make a lifeless image more dramatic with a single drag of the mouse. On the other hand, reducing Clarity produces a softer look that can be quite flattering in portrait shots. As usual, the secret lies in applying the right amount—too high a value quickly makes an image look artificial, and setting it too low produces an overly soft, smeared look.

The Capture One Clarity tool is more flexible than the equivalents found in Lightroom, Aperture, and DxO OpticsPro but has too many side uses for inclusion in the Exposure tool tab. It would have been more appropriate to make it part of the Details tool tab instead. The Clarity slider affects coarse textures whereas the Structure slider affects finer details.

The Clarity and Structure sliders alter local contrast and saturation.

6.10 *The Clarity tool offers four different algorithms or "methods." The Clarity slider adjusts the look of the whole image, and the Structure slider enables you to adjust details.*

> **QUICK TIP**
>
> To help you understand the difference between the Clarity and Structure sliders, imagine a photo of a tree. Adjusting Clarity alters contrast between the silhouette of the tree and the background, whereas the Structure slider adjusts contrast in the finer branches and the bark (that is, local contrast within the silhouette). The Clarity tool is part of the hierarchy of tools that affect image sharpness, and the Sharpening tool in the Details tool tab is used to sharpen details that are finer than those affected by the Structure slider. See chapter 9 for more on the sharpening hierarchy.

The four Clarity methods influence how strongly the Clarity and Structure sliders affect an image, even though all four increase local contrast. The Punch, Classic, and Neutral methods also increase saturation in step with the slider setting. Punch is the least gentle method and Neutral the gentlest, and Natural doesn't affect saturation at all.

The following scenarios will help you to decide which method to use and when.

6.11 *An image detail processed using the four Clarity methods. From top left to bottom right: Punch, Classic, Neutral, and Natural.*

- **Punch and Classic:** Use for dramatic images of billowing clouds, backlit subjects, sunsets, and subjects that you select and separate from the background. Classic is a legacy Capture One method; Punch was added later due to user requests for a more vigorous effect.
- **Neutral:** Use to give all types of images extra verve, whether landscapes, street scenes, wildlife, or portraits. Take care not to dial in too much.
- **Natural:** Use for images in which you don't want the effect to be too obvious, such as portraits, product photos, or documentary work. Because it only affects local contrast, Natural is ideal for producing soft focus and blur effects. Negative Structure values reduce the visual effect of wrinkles and veins in portraits without affecting the colors.

It is, of course, up to you which method you use. The default setting is Natural, which is subtle enough to use with most cameras. Values from 5 to 10 are usually sufficient to give most images a slightly crisper look without falsifying colors or eliciting cries of "Photoshopped!" from viewers.

As mentioned earlier, the Clarity tool is also good for sharpening details. See section 9.5 for more details on this particular approach.

6.5 The Vignetting Tool

The term "vignette" is often used to describe edge softness. Without delving too deeply into the theory, it suffices to say that this usage is simply wrong. A vignette is a deliberately created effect, whereas edge softness is an indication of weakness in an optical system and is usually an unwanted side effect. The effect of both, however, can be quite appealing, and darker edges always steer the viewer's gaze toward the center of the frame. Bright edges often produce an esoteric, dreamlike look.

The Vignetting tool in the Exposure tool tab is a purely creative tool. Stick to the tools in the Lens Correction tab if you need to remove soft edges and the like.

6.12 *Different types of vignette affect the (emotional) perception of an image in different ways.*

Capture One's Vignetting tool has an Amount slider and three shape options, and will probably disappoint Lightroom users who are used to having more control.

The Amount slider sets the strength of the vignette in a range between −4 and +4 fstops, where positive values indicate a bright vignette. In the Method drop-down list, you can decide between circular and elliptical shapes and whether the vignette should scale to the new frame if you crop your image (see also chapter 8).

6.13 *The Vignetting tool is too simple for many users.*

Even if it isn't really powerful enough, you can still use the Vignetting tool to produce effects that subtly emphasize the content or message of an image. If you need more vignette shapes and tools, you'll have to either use Photoshop, Acorn, or PhotoLine, or apply your effect manually using Capture One's local adjustments. See chapter 10 for more details.

7 The Lens Correction Tab

There is no such thing as the perfect lens. Many lenses are sure to suit your personal shooting style and deliver near-perfect results, but a lens is nevertheless an optical/mechanical system that has physical limits and is subject to the variations in quality that are part of every manufacturing process. More than cameras, lenses are also subject to the Pareto principle, which states that the final 20 percent increase in quality costs 80 percent of the resources involved in the process. It is not without good reason that ultra-high-end lenses often cost as much as a small car.

Put simply, lenses are imperfect systems and the results of using them sometimes have to be corrected using software. Dedicated software packages such as ePaperPress's PTLens remain popular, but as so often in the context of digital image processing, it's preferable to perform as many lens corrections as possible during the raw conversion process. This chapter looks at the tools in the Lens Correction panel and explains how to use them to produce optimum results.

7.1 Lens Corrections and Profiles

Lens profiles describe precisely measured lens errors such as distortion, chromatic aberrations, and brightness falloff.

In addition to its camera profiles (see section 1.3), Capture One uses lens profiles to describe the known limitations of a lens. Not all "errors" detract from the quality of the images a lens produces—for example, many people consider brightness falloff toward the edges of the frame to be an aesthetically pleasing effect and often add it artificially to finished images (see section 6.5). Distortion is more of an issue, and although some distortion effects produce photos with an unusual look, they are usually a hindrance to the process of realistic image capture. This is where lens profiles come into play. ☐ 7.1

Capture One Pro is supplied with a huge range of built-in lens profiles that even includes the latest Sony/Zeiss lenses, so there is a good chance that your lens is supported. If not, you can use one of the two built-in generic profiles that are based on the assumed errors produced by a nominal virtual lens. This approach is, of course, a compromise and is not suitable for correcting complex issues such as mustache distortion. ☐ 7.2

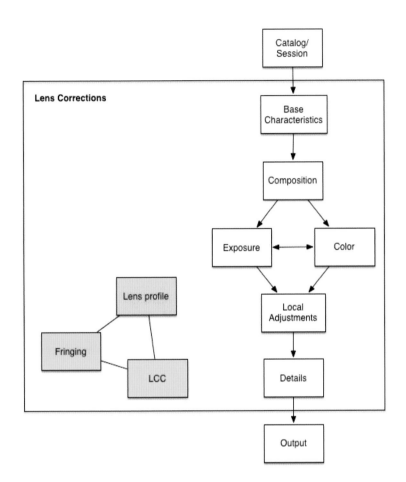

7.1 *Within the rendering pipeline, lens corrections run parallel to basic develop settings such as the camera profile and Curve adjustments. However, because they use a lot of processing power, I recommend that you perform them at the end of your workflow.*

7.2 *Lens profiles are selected in the Profile drop-down list. Capture One makes recommendations based on the metadata stored with your images.*

Unfortunately, because Capture One has no lens profile creator like the one Adobe provides for use with Lightroom, the generic profiles are the only option if your particular lens isn't supported. Currently, only Phase One can generate lens profiles for Capture One and, as explained in section 7.4, LCC profiles are not a real alternative to "proper" lens profiles.

> The people at Phase One will profile any lens they can get their hands on. If you have a "problem" lens that you often use, open a support query at the Phase One website—if possible, your lens will be included in a later release.

7.3 *The Lens Correction tool*

Corrections are simple to perform for supported lenses. The Distortion slider corrects distortion described by the lens profile, whereas Sharpness Falloff attempts to recover the lost sharpness (especially in the corners of the frame) that often plagues wide-angle lenses. However, be warned that the tool cannot perform miracles and can only approximate where no image data is available in the original file. The Light Falloff slider corrects the vignetting effects that often occur when you shoot at maximum aperture using a wide-angle lens.

Chromatic aberrations are errors that occur when a lens incorrectly focuses red and blue light waves and produces blue or purple fringing effects at high-contrast edges. The Purple Fringing function doesn't necessarily require an appropriate lens profile to work, and if no profile is available, Capture One analyzes each image individually and creates corresponding correction values. If you want to analyze multiple images simultaneously, select them in the Browser and choose the Analyze option in the action menu located next to the Chromatic Aberration check box.

7.4 *Analyzing multiple images can take some time, but the program opens a pop-up window to keep you informed of progress.*

The Hide Distorted Areas option automatically crops the Browser view of your image to remove any unwanted edge detail that's created when you adjust the Distortion slider.

> **QUICK TIP**
> Lens corrections use a lot of processing power and slow down even the most powerful CPUs and graphics cards. Only apply lens corrections when you're done with most of the other steps you wish to perform. If you don't want to perform any lens corrections, deactivate the tool using the Disable Default Lens Correction option in the tab's action menu. This prevents the program from automatically loading recommended lens profiles and noticeably speeds up all other processing steps, especially if you're using a notebook.

7.2 The Movement Tab

Tilt/shift lenses are traditionally used to correct errors such as converging lines in architectural photos, but they have recently gained popularity for producing fake miniature-style effects.

Use the Tilt/Shift options to optimize the effect of your lens profile.

7.5 Although it isn't what tilt/shift lenses were designed to do, the fake miniature effect has recently become so popular that even smartphone cameras have built-in fake miniature tools.

When you apply conventional tilt and/or shift movements, the data stored in the lens profile is no longer correct for the situation at hand, and this is where the Movement tab in the Lens Corrections tool comes in.

7.6 If the focal length and aperture values were recorded with the EXIF metadata in your image, Capture One will automatically enter those values into the appropriate boxes in the Movement tab.

All you have to do is enter the movements you make with your lens ("x" stands for horizontal and "y" for vertical movement). These then adjust the values stored in the lens profile to match the degree of shift. You don't have to enter tilt data because tilting the lens has no effect on the lens profile.

The horizontal and vertical shift values optimize the effect of the current lens profile without altering or negating the shift effect you apply in your lens. The more distortion the lens produces, the stronger the effect of the shift values. In other words, the image itself isn't altered, and instead of having their effects increased, the distortion and light falloff corrections simply function more precisely.

7.3 Purple Fringing

Purple fringing occurs at high-contrast edges and in areas with fine texture such as the branches of a tree shot against a bright sky, the spokes of a bicycle wheel, or chainlink fencing. Reflections in metal surfaces also produce fringing effects when their wavelengths differ from those of the actual subject.

The Defringe slider works independently of the active lens profile but works best if the profile matches the lens.

In earlier versions of Capture One, purple fringing correction took the form of an additional slider in the Lens tool tab in the Lens Correction tool and only worked if an appropriate lens profile was available. Since version 8, the function has been turned into a separate tool that works without a lens profile and is also available as a local adjustment.

7.7 The Purple Fringing tool is clearly laid out and simple to use.

Like the Chromatic Aberration function (see section 7.1), the defringing algorithm incorporates the data from the lens profile (if available) but is capable of working on its own if necessary. The results of working without a profile vary in quality and also depend on the particular combination of camera, lens, and subject.

7.8 Purple fringing effects can often be effectively removed without the help of a lens profile.

As with many of the tools we have already described, the best way to get a feel for the tool is to experiment with low values rather than dialing in the maximum possible effect. It also helps to clone your image before you begin (right-click and choose Clone Variant) and compare your results with the

original. Because it is often applied to highly detailed images, the Defringe tool produces side effects (such as destroying other purple textures) that are easy to overlook, so comparing your before and after versions will help you keep unwanted effects in check. But don't worry—the effects the tool produces are usually quite subtle.

QUICK TIP
If the Defringe tool doesn't help, you can always use the Color Editor to remove fringing effects. Most fringes are the same color, so all you have to do is use the Color Picker to select a fringed detail and desaturate it. If further purple details are affected, use the tool as a local adjustment. See section 5.6 for more on the Color Editor and chapter 10 for a comprehensive look at local adjustments.

7.4 LCC Profiles—For More than Just Lens Correction

In section 7.1 we explained why you need a proprietary Phase One lens profile to achieve the best possible lens correction results. However, even if your lens isn't supported, you can still use Lens Cast Calibration (LCC) profiles to correct some lens errors.

LCC profiles are used to correct light falloff and color casts but not distortion. They can also be used to eliminate the effects of dust on the camera sensor.

7.9 The LCC tool uses a test shot to create a custom lens profile.

Because LCC profiles are designed to work with a single combination of camera, lens, aperture, and exposure time, you'll usually need to shoot a test shot for each image to be sure of getting accurate results. In other words, an LCC profile corrects a specific image rather a specific lens—in theory, at least.

Many photographers save up to eight LCC profile presets per lens and use them to make general lens corrections. If you take this approach, you can simply select the appropriate profile—f/8 or wide open, for example—that matches the image you're working on.

IMPORTANT
LCC profiles aren't a replacement for "proper" lens profiles, which are more precise and correct a wider range of errors. LCC profiles can correct neither chromatic aberrations nor distortion, but can be used to perform additional dust and spot removal. Always use Phase One profiles if they're available.

To create an LCC profile, you need the following:

- Time to capture test shots
- An appropriate test subject

The first item is self-explanatory. If, for example, you're a reporter working in constantly changing surroundings, you may not have time or the opportunity to capture an LCC test shot.

The question of what makes an appropriate test subject is of more interest, and you have two basic options. The first is to capture an image of a spectrally flat, evenly lit neutral gray or white target that fills the entire image circle. Targets are available in a variety of shapes and sizes that fill all three channels with unvarying neutral light. If you're using a wide-angle lens, and especially one with a relatively large close-focus distance, you'll have trouble filling the image circle—unless, of course, you use an extremely large (and therefore expensive) target.

Using an opaque filter is often more practical than using a target to capture an LCC test shot.

The alternative is to use an opaque white balance or exposure correction filter to take a test shot of a bright subject such as the sky. ExpoImaging's ExpoDisc is probably the best-known commercial white balance filter on the market. It is made of a material that allows precisely 18 percent of the (spectrally flat) incident light to pass, rather than reflecting light the way a target does. The ExpoDisc is a precision tool manufactured to extremely fine tolerances and is correspondingly priced. The ClearWhite system is cheaper but just as good.

Because the LCC tool doesn't require the use of a high-end filter, you can use easily available materials to make your own—for example, try using the milky-white plastic lid from your next can of Pringles chips.

7.10 *The lid from a Pringles can is not as exactingly manufactured as a dedicated filter but is good enough for creating custom LCC profiles.*

Thanks to the industrial methods used to manufacture them, these lids are of even thickness and, because LCC profiles don't correct distortion, the molding mark in the center doesn't adversely affect the test shot. Scratches on the lid are too large to be mistaken for dust spots by the algorithm.

> **QUICK TIP**
> Don't scrimp on your filter if you don't have to. Let's face it, a filter for $50–$100 doesn't make a huge difference to a camera kit that costs several thousand dollars. Is it more important to save time or money? Do you like dabbling with home-build projects, or do you consider them a waste of effort? It's up to you to decide.

7.4.1 LCC as an Alternative to Proprietary Lens Profiles

The following steps explain how to use LCC profiles to replace some of the functionality of proprietary lens profiles:

LCC profiles cannot completely replace lens profiles based on precise lens analysis but can still be used to effectively counteract color casts and edge falloff.

1. Use your lens to capture test shots at all the aperture settings you use regularly. Be sure to include maximum aperture, because this is the setting at which light falloff is usually most marked.
2. Open a test image and switch to the Lens Correction tab.

3. Click the Create LCC button.

4. Uncheck the Include Dust Removal Information option and check the Wide Angle Lens with Movements option if you used tilt/shift movements that you need to compensate for (see section 7.2). Now click Create.

5. Every image with a new profile will now be marked with an LCC label in the Browser, and the LCC tool automatically activates the Color Cast option.

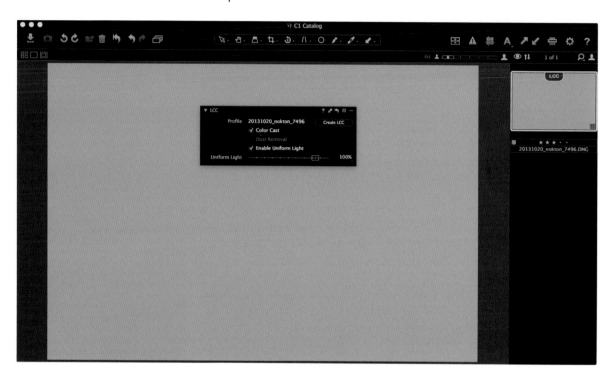

6. To correct edge falloff, activate the Enable Uniform Light option. This evens out the light levels throughout the frame.

7. Go to the Manage Presets menu (the button with three horizontal lines in the tool's title bar) and select Save User Preset.

8. Check the Profile option in the Save Preset dialog and click Save. Be sure you give your new profile an easily identifiable name that includes the name of the lens, its focal length, and the aperture setting you used to make the test shot.

Now that you've saved your new profile to the Capture One presets library, you can delete the test shot. You can apply your new profile via the Manage Presets menu in the LCC tool or by using the Adjustments > Styles > User Presets > LCC command.

7.11 *Flash foot with collar*

7.12 *Selecting an LCC profile to correct selected images. If you need to apply multiple presets, activate the Stack Styles option.*

If you decide to use LCC profiles this way, remember these tips:

- Always save new LCC profiles as presets. If you delete an LCC test shot without saving a preset, the new profile will be irretrievably deleted.
- Give your profile presets meaningful names. I use the lens name, the focal length, and aperture setting—for example, nikkor-28mm-f2, rather than just profile-1, which doesn't tell me anything.
- Always uncheck the Dust removal option for profiles that you're likely to use regularly. If you clean the sensor regularly (as you should!), the dust data in the profile will quickly become outdated and produce unwanted errors in new images.
- LCC profiles are especially good for correcting light falloff, but only if you use the right aperture setting. The larger the aperture, the more falloff there will be. If you don't want to take the effort to create separate LCC profiles for each aperture setting, use the LCC tool's Uniform Light slider to adjust falloff by eye.
- The amount of light falloff and the presence of color casts in images shot with a zoom lens depend on the focal length you set. When using a zoom, you need to create at least three LCC profiles for short, medium, and long focal length settings.
- Color casts appear at different strengths according to the type of camera/sensor and the ISO setting you use. If your sensor tends to produce high-ISO color casts that you wish to correct, create an LCC profile for your camera's normal ISO setting and the highest ISO setting that you use regularly.
- If you want to correct images immediately with a new LCC profile, select the test shot in the Browser and select the images you wish to adjust while keeping the Ctrl key pressed. Now right-click one of your selected images and select the Apply LCC command.

7.13 If you select images and the LCC test shot simultaneously, you can use the Apply LCC command in the context menu to apply the corresponding profile.

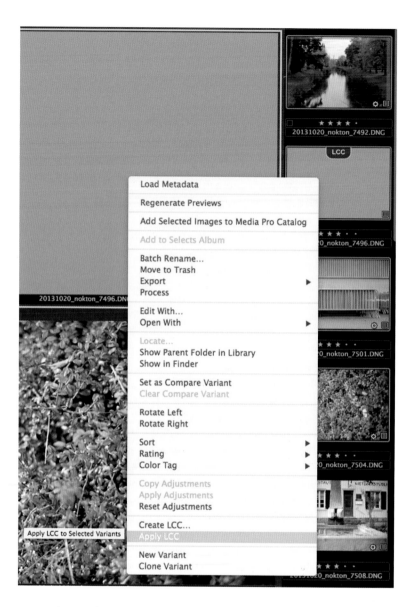

To accelerate the LCC profile creation process, go to the Creating LCC Options submenu in the tool's action menu (indicated by the three dots), deactivate the Include Dust Removal Information and the Include Technical Lens Correction Data options, and activate the "Don't show options when creating LCC" option. You can now create new LCC profiles by right-clicking an image in the Browser and selecting the Create LCC command. If you want to simultaneously create profiles for multiple test shots, select them and use the context menu command. And don't forget to save your new profiles as presets!

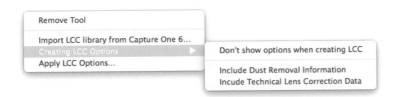

7.14 *The options located in the action menu determine which corrections a profile will be capable of performing and whether they're automatically applied.*

7.4.2 Custom LCC Profiles for Individual Images

As I've already mentioned, some photographers take an LCC test shot for every image, even if Capture One provides its own profile for the lens in question. This approach is particularly useful in high-end product photography situations. Editing poster-sized images or double-page magazine spreads involves a lot of resources, and spending a couple of seconds making an LCC test shot during a shoot can save you hours of dust retouching or color correction work at the editing stage.

Landscape photographers, too, can benefit from creating an LCC test shot immediately before or after capturing an important image. This way, you can be sure to achieve excellent image quality—quality that can mean the difference between success and disappointment, especially in fine art photography situations. There is nothing more annoying than finding a previously undiscovered dust spot *after* you have had a large-format print made.

LCC profiles work best when they're created for use with a specific image. This approach also enables you to apply automatic dust removal.

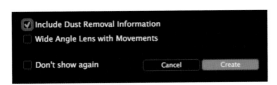

7.15 Automatic dust removal can save you a lot of work in critical situations.

To create a dust-removal profile, proceed as described in section 7.4.1. If a shoot involves large numbers of new profiles, Capture One's batch functionality can save you a lot of work creating and assigning them names:

1. Copy all the images you wish to correct and the corresponding LCC test shots to a new Album or session and click the "Toggle primary/selected variants" button in the toolbar (see section 1.8.2).

2. Open the action menu and select the Include Dust Removal Information option. If you used a tilt/shift lens during your session, select the Wide Angle Lens with Movements option as well. Finish up by choosing "Don't show options when creating LCC" in the LCC tool's action menu.

3. Select all your LCC test shots in the Browser while keeping the Ctrl key pressed, right-click one of them, and select the Create LCC command. Depending on how many profiles you're creating, now might be the right time to take a coffee break.

4. Once the progress pop-up has disappeared, your new profiles are ready for action. Because we're not using the LCC tool as an alternative to "real" lens profiles, we don't have to save each one separately as a preset.

5. To assign profiles automatically to the corresponding images, select all your images and test shots in the Browser, right-click to open the context menu, and select the Apply LCC command.

And that's it. The new LCC profiles remain assigned to their corresponding images even if you delete the test shots. A profile is deleted only if you delete the test shot without assigning the profile to an image.

Capture One automatically recognizes which profile belongs to which image by comparing the EXIF data stored with your raw originals. Images that were captured using the same exposure parameters as the test shot are automatically assigned the corresponding LCC profile. This function works best if you're shooting in a controlled (studio) environment or if you adjust your shooting parameters manually. Even the tiniest discrepancies can cause the automatic assignment of profiles to fail, but you can always assign profiles manually if necessary. To do this, copy your LCC settings to the Clipboard by clicking the double-arrow button in the tool's title bar and click your selected image(s) to apply them.

8 The Composition Tool Tab

The Composition tool tab gathers all the tools you need to alter the geometry of your images. As well as simple functions such as cropping and flipping, the tab includes the more complex Keystone and Overlay tools. This chapter introduces ways to use these tools creatively and also discusses their limitations and the potential pitfalls involved.

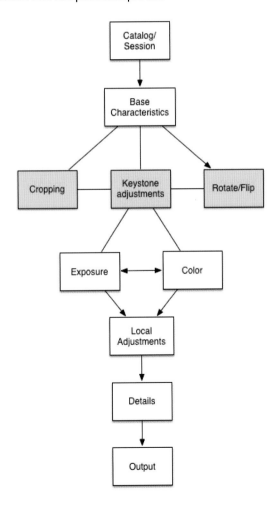

8.1 *Because tools such as Vignetting (see section 6.5) and Levels and Curve (see section 6.3) also affect crops and rotations, it makes sense to perform any adjustments that alter the shape or alignment of an image at an early stage in the workflow.*

8.1 Crop, Aspect Ratio, Grids, and Guides

Don't be scared of cropping! Cropping is more of a creative tool than a way of correcting poorly framed images, as shown in the work of Man Ray and many other well-known photographic artists.

The purists can protest as much as they like—altering framing on a computer after a shoot is a legitimate and often necessary part of the raw processing workflow. There are plenty of good reasons to crop your images:

❯ If you use a rangefinder camera, parallax errors make it virtually impossible to frame your subject precisely, regardless of how experienced you are (especially if you're using a wide-angle lens). A WYSIWYG (what you see is what you get) approach to shooting is only realistic if you use a DSLR with 100 percent frame coverage or live view, if available.

❯ If you use lenses that produce pronounced pin-cushion or barrel distortion, you'll probably use the Lens Correction tools to process your images. These tools often crop the edges of an image, requiring additional cropping to balance the final composition.

❯ If you often shoot portraits with the camera in a vertical position and prefer a 5:4 aspect ratio to the 3:2 ratio that's standard in most digital cameras, cropping is the answer.

❯ You prefer to shoot using prime lenses but occasionally miss having a zoom. Using the crop function as a "digital zoom" is a simple solution.

❯ A client requires multiple formats or enlarged details. Here, too, a crop is the best approach.

The Crop tool offers a cursor function (keyboard shortcut C) as well as grids and guides that you can show or hide using the Cmd/Ctrl+G command.

8.2 The Crop tool (highlighted in orange on the left) has additional grids and guides (highlighted on the right) that help you find precisely the right crop.

8.1.1 All About Crops and Aspect Ratios

Cropping is simple—select your desired aspect ratio (unconstrained, original, or one of a range of other presets) and drag the frame to size in the Viewer.

8.3 The Crop tool is clear and simple to use.

As well as this standard functionality, Capture One offers a number of additional features:

❯ The program always fills the selected aspect ratio as far as possible with the selected Size setting, but you may have to manually enter new height or width values to completely fill the frame.

◉ If an active process recipe includes a fixed image size, the Viewer displays the fixed size, not the size of your original image file. If the output size cannot be retained—for example, because it doesn't fit the aspect ratio—the side that doesn't fit is labeled with red rather than orange digits.

◉ A process recipe also determines the units you can use in the Crop tool and which are displayed in the Viewer. You can only alter the units if you select the "Fixed" Scale option in the recipe.

◉ The Output option doesn't constrain the ratio but labels the sides in red until the ratio fits.

> **QUICK TIP**
> If the Crop tool doesn't work as you expect or the Viewer displays red digits, this is usually due to the settings in the active process recipe. See chapter 13 for more on process recipes.

To save a specific aspect ratio as a preset, select the Add Aspect Ratio item in the Ratio drop-down list.

Aspect ratios that you save as presets are automatically added to the drop-down list in the Crop tool.

8.4 Use the New Aspect Ratio dialog to save custom settings like the 16:9 ratio shown here. As ever, always use a meaningful name for your presets.

The Crop Outside Image option enables you to work with image areas that are automatically cropped when you make Keystone (see section 8.3) or other distortion-based corrections. Automatically cropped areas remain part of the original image but are not displayed in the Viewer.

8.5 The Crop Outside Image option enables you to include automatically cropped image areas in the frame.

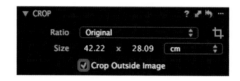

If you crop outside the processed image area, the discarded image areas are retained as transparent areas in the outputted image. You can then use a program like Photoshop to fill the transparent areas and recover details that would otherwise be lost. □ 8.6

Improving Crop Mask Visibility

Capture One's default settings mask the cropped areas with a very dark color and the frame itself has neither an outline nor handles, making accurate cropping quite tricky, especially if you're cropping photos of dark subjects.

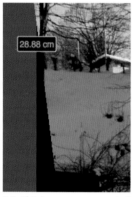

8.6 This image was corrected using the Keystone tool and the new crop lies outside the displayed image area. You can fill the discarded area (shown in gray) using the Photoshop Clone Stamp or Content-Aware Fill (or similar) tools.

8.7 The Crop Outside Image option enables you to include automatically cropped image areas in the frame.

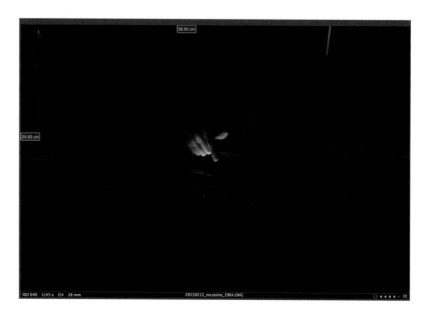

To make life easier, navigate to the Preferences dialog and set a lighter color using the Brightness slider in the Mask section of the Crop tab. Switch the Show Frame option to Always. This makes it much easier to see the edges and corners of the mask.

8.8 A lighter mask and a visible frame make cropping much easier.

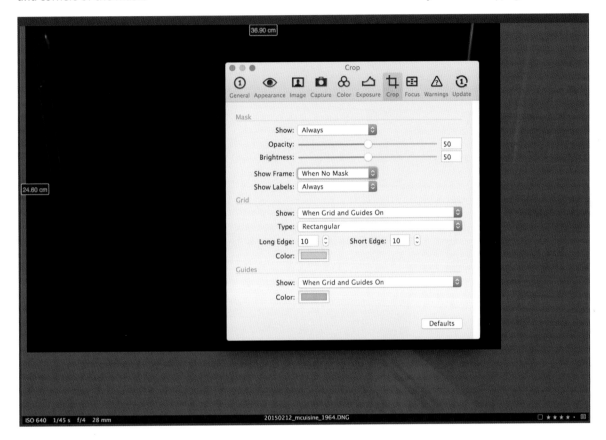

8.1.2 Grids and Guides

Grids and guides are not always necessary and are not up everyone's alley anyway, but for those who are used to using a grid in their camera monitor or viewfinder, the Capture One version of the feature will be a welcome bonus.

Grids and guides help you judge the effectiveness of your composition and make the right crops.

8.9 Live View and Capture One—you don't have to do without your familiar helpers during processing.

You can show and hide grids and guides by using the Cmd/Ctrl+G shortcut or by clicking the button in the toolbar. The default settings only show the grid when you alter the shape of the frame or move it around during cropping, but you can, of course, alter these settings using the options in the Crop tab of the Preferences dialog.

8.10 The options for adjusting the look and feel of the grids and guides. Additional options are regularly added to Capture One point-releases to accommodate the preferences of various users.

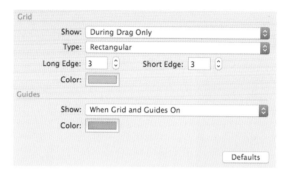

The Show drop-down list determines if and when the grid is displayed using the options During Drag Only, When Grid and Guides On, or Never. You can also set the grid type—the default is a grid of two horizontal and two vertical lines arranged quite close to the center of the frame to form a three-by-three grid.

8.11 The default grid setting emphasizes the center of the frame.

QUICK TIP

Experiment with the number of lines in the grid. If you use it to adjust your composition, between two and five lines create a pattern that is similar to the golden section. If you need to check alignment or the straightness of lines within the frame, use 10–12 lines to give yourself plenty of reference points without obscuring the subject.

The grid type can be altered only in the Preferences dialog and not on the fly, but you can use adjustable guides to help you analyze different parts of an image while you work.

8.12 *The options for creating new guides or locking and deleting existing guides are located in the View menu.*

Create new guides using the View > Add Guide command. When the cursor touches a guide, it becomes a double-headed arrow that indicates that you can drag the guide within the Viewer frame. Use the Lock Guides command to lock in the current position. Clear Guides deletes all current guides, and you can remove individual guides by dragging them outside the Viewer window.

Creating Previews That Work on Facebook and Other Social Networks

Facebook and other social and photo-sharing sites often show only a square detail as a preview, and it's a matter of luck whether the selected detail is actually the subject of the photo.

8.13 *These square previews look nice, but if the subject is outside of the automatically selected detail, the images don't have their full impact.*

To get people clicking your images in online albums, you can select your own preview details with the help of (locked) guides.

8.14 *Square guides help you to select the right detail for publishing as an online preview.*

You can show or hide the guides at any time using the Cmd/Ctrl+G shortcut and align or crop your image to fit within them.

Photo-sharing sites and social networks don't dictate the actual image format, and it's up to you to decide which you use. However, square guides will help you estimate in advance whether you'll have to tweak your previews to maximize their effect. If you're out and about, it is often simpler to tweak your images before you upload them than it is to use web-based tools later on.

8.2 Rotate, Flip, and Straighten

Rotate and flip tools are part of the basic toolset in every raw converter or image-processing program.

8.15 *The Rotation & Flip tool panel*

The Angle slider determines the degree to which your image is rotated, and you can adjust the value either by typing values into the boxes or by dragging the slider with your mouse. You can then fine-tune the result by clicking in the text box and using the up/down arrow keys. One click up adjusts the value by 0.01 degrees (or 0.1 degrees with the Shift key pressed). Grids and guides (see section 8.1) help you align your image accurately.

The left/right arrow keys rotate the image by 90 degrees let and right, and the Flip drop-down list gives you horizontal or vertical flip options. This is all pretty basic stuff, but the most interesting feature of the Rotation & Flip tool panel is the button with the circular arrow and a plus sign at the right-hand end of the tool panel. This is the Straighten tool.

Grids and guides are a great aid to accurate image alignment.

8.16 The Straighten tool is activated by using the button in the Rotation & Flip tool panel, the button in the Cursor Tools menu bar (see section 1.5.1), or the R shortcut.

This cursor tool has various options that are revealed by a click-and-hold on the button. The default option is Straighten. This enables you to use the cursor to draw a line in the Viewer that then becomes the new horizon or vertical reference line. The software automatically realigns the image to match the line you've drawn.

8.17 Two clicks are all it takes to correct a sloping horizon.

QUICK TIP

The Straighten tool also works when the Viewer image is zoomed, enabling you to realign it more precisely—after all, clicking just one pixel too far can equate to several degree-minutes of unwanted rotation.

The other Straighten options are Rotate Freehand, Rotate Left, and Rotate Right. The last two options have the same effect as using the arrow keys, whereas the Freehand option uses the mouse to drag the image to your desired angle just like you'd use a fingertip to straighten a print on your desk.

As usual, it's up to you to decide which approach best suits the way you work. Rotate Freehand is easiest to use with a graphics tablet and pen (see section 2.4), whereas Straighten is easier to use with a mouse or trackball. Whichever you decide on, you'll probably have to fine-tune the results using the angle boxes and guides anyway. A grid made up of 10 or more horizontal or vertical lines and a switch to the 66% view will help you judge the overall effect of your adjustments. If you straighten images regularly as part of your workflow, you can set up the default grid in the Crop section of the Preferences dialog (see section 8.1.2). But people have their own personal preferences—some people play first-person shooters using a trackpad, whereas others need a 12-button gaming mouse to feel comfortable.

8.3 Keystone

The Keystone tool is aimed primarily at architectural photographers but has its uses in other situations as well.

The Keystone tool enables you to correct converging verticals and horizontal lines that are no longer parallel. Here, too, you can enter precise values, make adjustments with sliders, or experiment with the Viewer image using your mouse.

8.18 With the exception of the highlighted button, all of the options in the Keystone tool work the same with every type of camera.

The A button in the Keystone tool is different from the one in Capture One's other tools. It doesn't perform automatic perspective correction like the equivalent Lightroom tool and is only designed to work with data gathered by the gyroscope built into Phase One's IQ-series medium-format digital backs.

Because most camera manufacturers write gyroscope data to raw files in a proprietary format, the program cannot interpret third-party data. If you use an IQ back, the Auto button will use the gyroscope data recorded with your images to automatically correct distortion caused by the camera tipping. If you use any other type of camera, you can ignore the A button.

If you don't have an IQ back, you'll have to perform your perspective corrections manually using the following options:

- **Vertical:** Corrects converging verticals.
- **Horizontal:** Corrects horizontal distortion (for example, lines that are no longer parallel).
- **Amount:** The degree to which the previous adjustments are applied.
- **Aspect:** This slider readjusts your image to compensate for vertical compression or stretching caused by the application of extreme adjustments.

You'll usually need to use a grid or guides to help you adjust an image using the sliders or manually entered values (see section 8.1.2). As usual, you can alter values entered in the boxes using the arrow keys. The up/down arrow keys alter values in increments of 1 (or 10 with the Shift key pressed). Once you've made your basic adjustments, you can fine-tune the results.

8.19 You can activate grids and guides by clicking the button in the toolbar or by using the Cmd/Ctrl+G shortcut. They are a great aid to manual perspective correction.

Instead of entering values or playing with the sliders, you can perform perspective correction in the Viewer window using your mouse to draw horizontal or vertical lines the same way as you did with the Straighten tool (see section 8.2).

8.20 The three keystone buttons at the bottom right in the tool panel determine whether you correct horizontal or vertical distortion, or both, as shown here.

Use the circular handles to move the reference lines to the position of the lines you wish to correct and click the Apply button that appears in the Viewer image.

> Keystone corrections are made on top of any rotations you have applied (see section 8.2). If you readjust a rotation after performing a keystone correction, you'll have to readjust that, too. In other words, it pays to perform keystone corrections before you straighten the horizon. You'll still probably have to make minor adjustments to your keystone correction following straightening, but these will be much less hassle if you straighten first.

Straightening Wide-Angle Images

Distortion is particularly prevalent in wide-angle shots and can quickly spoil the effect of an image. If you're using a wide-angle lens to capture as much detail as possible within the frame but strongly converging lines or an exaggerated vanishing point ruin the effect (or if you simply want to capture front-on images of buildings without any distortion), the Keystone tool is the one to use. The following steps explain how to get the best results:

1. We begin by selecting an image and cloning it using the Clone Variant command in the Browser context menu. Then we switch to the Composition tool tab.
2. We show the grid to gain an impression of the degree of distortion in our image.

3. At a first glance, the only issue in our sample image is the slightly converging verticals. We correct these using the Keystone Vertical option in the Keystone tool.

4. Unfortunately, we overdo the angle, making the result look slightly strange. To compensate, we adjust the Vertical slider and slightly reduce the Amount setting.

5. That's more like it. But the image is now on a slope and the camera no longer appears to be perpendicular to the front of the building. We select the Keystone tool (using the K shortcut) to set the horizontal lines in the building back to parallel.

6. We use reference lines to align the image before clicking Apply.
7. Nearly there, but there's still a hint of a slope. We add a guide (View > Add Guide > Vertical) near the center of the frame.

8. We switch to the Rotation & Flip tool, click the Angle box, and adjust the value using the arrow keys.

9. To finish up, we reduce the Amount value as far as possible while retaining a natural look in our image. We can now compare our result with the clone we made in step 1 to see if we've achieved the result we were looking for or whether the original was better, in spite of its imperfections.

IMPORTANT

The Keystone tool can be used to correct extreme distortion but, like all complex manipulations, does so at the expense of image quality. The stronger the distortion you have to correct, the more image data will be lost, especially at the edges of the frame. Strongly manipulated images look fine on the web but are usually too tweaked for use in fine art or reproduction situations. Don't rely on keystone corrections if you don't have to and instead get your image as straight as possible during the shoot. Your camera's built-in gyroscope will help you to keep things level, or failing that, you can use a shoe-mounted level instead. The bottom line is always the same: the less you have to correct your image in post-production, the higher-quality your results will be.

8.4 Overlay

The Overlay tool aids composition during tethered shooting sessions.

The layouts of most magazine covers follow the same formula, with the masthead, body copy, picture, and barcode in the same place every issue. The Overlay tool is designed to help the photographer visualize a cover during a tethered shoot. If Capture One supports your camera's live view functionality, you can even preview cover effects without taking test shots (see chapter 14). The tool ensures that all of the important elements of the cover image remain visible even when the layout department has done its job.

8.21 The Overlay tool makes life easier for photographers who shoot magazine covers.

Aside from cover shoots, the tool has other uses—for example:

- If you're shooting for a corporate client with a strong corporate identity that dictates precise positioning for its logos and letterhead
- If you're working on a Photoshop collage and you want to do as much preprocessing as possible at the raw development stage
- If your online portfolio requires a watermark in a specific place within the frame and you want to check its position
- If you're working on a long-term project (a time-lapse study, for example) for which the camera has to be located in exactly the same position for every shoot

This is just a selection of the situations beyond the realm of medium-format cover shoots in which the Overlay tool can aid your work.

8.22 *To aid composition, you can insert a draft cover image into the Overlay tool's preview box.*

To insert a draft into the Overlay tool preview window, proceed as follows:

1. Drag your draft from the Browser into the frame in the Overlay tool panel. If the draft file is not available in the Browser, click the button with the three dots to select it via your computer's filesystem.
2. By default, Capture One displays draft files at full size (that is, the same size as your raw images). Click Show to overlay the current image with a 50 percent transparent view of the draft.

3. Click the hand icon below the draft preview to move the draft within the frame. This feature is great for checking alignment with printer's register marks or a specific image detail.

4. Instead of dragging the draft in the Viewer, you can move it using the Horizontal and Vertical sliders or by entering values in the sliders' boxes. The Scale slider alters the size of the draft and Opacity its degree of transparency.

Tips for Working with the Overlay Tool

Keep the following tips in mind when working with the Overlay tool:

- If you need to check how a layout that obscures some of the details in your image will look, use a PSD file with a transparent background for your draft and set Opacity to 100—your image will then be displayed in the transparent areas, with the masthead and body copy superimposed on it.
- You can use any file format supported by Capture One (including raw) for your draft file. Raw draft files are displayed *without* any adjustments you have made.
- The draft you have selected applies to all of the images in the Browser. Once you are done with your session, delete the draft via the tool's Action menu.

- The draft file cannot be output (see chapter 13), which means you cannot produce a photomontage within Capture One. The Overlay tool serves purely as a visual compositional tool; but it saves you from having to do a lot of subsequent compositing work by helping you deliver an image that's already perfectly positioned, scaled, cropped, and straightened.
- On the subject of long-term sequences: If you use a previous image from your series as your draft, you can overlay your newer work and use the Composition tools to adjust it to match your earlier images.

9 The Details Tool Tab

9.1 *The Details tool tab in the workflow pipeline*

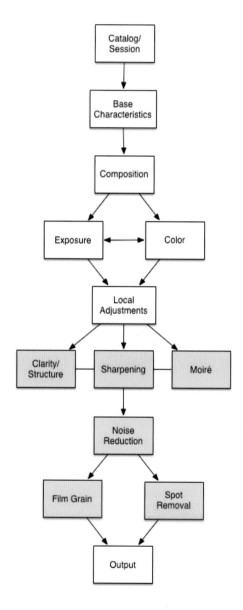

The Details tool tab contains nearly all the tools you need to sharpen, reduce noise, and generally pep up (or soften) your images. I say *nearly* because Capture One's default settings place the Clarity tool in the Exposure Tool tab (see section 6.4).

This chapter introduces and explains the Details tools in, ahem, detail. We'll also discuss how to achieve ideal sharpness and reduce noise, and how to combine the two adjustments for each individual image. Unfortunately, Capture One cannot perform miracles, and sharpening always increases image noise.

9.1 The Navigator and the Focus Tool

As its name suggests, the Navigator is designed to give you an overview of where you are in the active image. It is simple to use, with a frame that shows the current detail and an action menu for switching between zoom levels.

The Navigator helps you find your way around a zoomed image.

9.2 The Navigator is possibly the simplest of all Capture One Pro's tools.

To navigate around a zoomed image, either click on a detail in the Navigator window or drag the Navigator frame to the appropriate position using your mouse.

In section 1.8.1, we compared the Loupe tool with the corresponding feature in Apple Aperture. The most obvious difference between the two is that the Capture One Loupe interface disappears when you let go of the mouse button. To open a "permanent" magnifying window, use the Focus tool.

The Focus tool fulfills a similar function to the Loupe cursor tool but remains positioned at the focus point you select.

9.3 The Focus tool displays a zoomed view of the detail you select using its loupe function, activated by clicking the magnifier icon at the bottom right in the Focus tool panel. The stepless zoom range covers 25–400%.

The tool is simple to use. Click the loupe icon at the bottom right in the Focus tool panel and click a detail in the Viewer or the Browser preview. Use the slider to select an appropriate zoom factor. The "head and shoulders" icons at the right- and left-hand ends of the scale toggle between 25% and 100% views.

> **QUICK TIP**
> The selected focus point remains the same when you switch between images (for example, on your model's eye in a fashion shot). This is a great way to select the sharpest images in a sequence, especially if you're evaluating a sequence shot you focused manually.

9.2 Input Sharpening

Sharpening at this point in the workflow is called "input sharpening."

Capture One Pro offers a variety of ways to make your images crisper, although the Sharpening tool itself is only partially suitable for the task. This is because it is an "input sharpening" tool rather than a general-purpose image sharpening tool like Photoshop's Unsharp Mask and Luminosity Sharpening functions.

9.2.1 The Technical Side of Input Sharpening

Most digital camera sensors capture image data in black and white and are only capable of differentiating between luminosity levels (that is, differing brightness). When a light ray hits a sensor pixel, the electrical charge it generates is measured and stored in a grayscale raw image file.

9.4 Capture One's Sharpening tool fulfills a very different function from the similarly named tools in other programs, such as PhotoLine (shown here).

Input sharpening counteracts some of the technical shortcomings of digital camera sensors.

9.5 The right-hand image shows how the camera sensor "sees" the subject.

Most cameras use one of two major techniques to transform grayscale image data into a color image:

- The sensor consists of separate layers of pixels for each RGB color channel. Filters are located between the layers to prevent light of the "wrong" color from reaching the layer. The camera's firmware constructs a full-color image from the three single-color images that result. This type of sensor is still an exotic niche product.

9.6 *A Bayer pattern microfilter array*

❯ An array of red-, green-, and blue-colored microfilters is located in front of a single layer of pixels, and each pixel records data for the wavelengths allowed through by the filter. Once again, the camera firmware constructs a full-color image from the resulting data.

Sigma cameras with Foveon-brand sensors use the multilayer approach and have a reputation for excellent sharpness, but they provide lower light sensitivity than other sensor types.

Sensors with microfilter arrays are by far the most widely used in today's cameras, offering average pixel sharpness as a trade-off for greater light sensitivity. This approach requires two or three sensor pixels to produce a single pixel of color image data—in other words, image resolution is one half or a third of the nominal resolution of the sensor.

And this is where input sharpening comes in. Once the color data generated by the microfilter array has been combined with the grayscale luminosity data from the sensor (a process called *demosaicing*), the resulting image is sharpened. The raw developer software knows the precise luminosity values for each pixel (rather than just the average value from two, three, or four pixels) and is thus able to reconstruct a large portion of the sharpness in the original subject—ideally without producing too many additional color errors and artifacts in high-contrast areas.

Depending on the camera and sensor models involved, the various raw developers on the market produce results of wide-ranging quality, and some programs cope better with cameras from one particular manufacturer. Technological progress has ironed out a lot of these differences over the years, but most raw developers still have obvious idiosyncrasies. Capture One is said to harmonize well with the sensors used in Fujifilm's X-series cameras and in general with the charge-coupled device (CCD) sensors used in earlier Phase One digital backs (and some older Leica models).

9.2.2 Understanding the Capture One Sharpening Tool

The Sharpening tool has Amount, Radius, and Threshold sliders. The Amount setting determines how strongly the tool sharpens. The Radius setting determines the number of pixels. The Amount range of 0–1000 ensures finely differentiated settings.

The Threshold setting determines which areas of an image are affected.

The Threshold value is a little trickier to come to grips with. Put simply, it defines how little contrast there has to be between image areas before the sharpening effect kicks in. Low values equate to low contrast (that is, more image areas), whereas higher values equate to more contrast (that is, fewer, more precisely defined areas such as edges or backlit mesh patterns). The defaults are "fine weather" settings designed to counteract only a little of the unsharpness caused by demosaicing.

In a shake-free image captured at the camera's lowest standard ISO setting, Capture One will only sharpen gently where ultra-fine contrast exists—that is, where fine details have been lost due to demosaicing. The default settings leave everything else as it is.

9.7 *These two images, captured using a Leica M9, show the result of applying no input sharpening (left) and input sharpening using Capture One's default settings (right).*

As an example, let's take a look at the Soft Image Sharpening 3 preset, which is designed to rescue details that have turned out too soft. The preset has an Amount setting of 300 (about 30%) for everything above the Threshold value of 0.5—in other words, nearly every pixel. The Radius setting of 2.0 ensures that the effect is generously applied.

The aim of input sharpening is to make softer image areas crisper without creating too many additional artifacts in high-contrast areas. The overarching aim at this stage is to counterbalance the technical shortcomings of the image capture process and to prepare the image for further processing, not to apply sharpening fit for online or print output.

9.8 *From left to right: The results of applying no sharpening, applying the default input sharpening settings, and applying the Soft Image Sharpening 3 preset*

You can, of course, use the Sharpening tool to perform general sharpening. However, because optimum sharpness depends on the size of the final image, you'll still have to experiment to find the best settings. Additionally, because appropriate sharpening settings vary from image to image, output sharpening in Capture One can quickly become quite complex and you can easily find yourself adjusting and outputting even small numbers of images multiple times until they all look sharp enough but not oversharpened. I recommend that you perform only input sharpening in Capture One and leave output sharpening for small images destined for online publication to an image-processing program like PhotoLine or a dedicated sharpening program like Nik Dfine.

9.2.3 Finding the Right Sharpening Settings

Learning to find the right compromise between "sharp enough" and "over-sharpened" takes practice. If you're preparing small images for online publication, you can simply ignore the Sharpening tool or leave the default settings in place.

The presets provided cover most situations, although they are quite general and are designed specifically for use with Phase One cameras. The following steps explain how to find and save the right settings for your particular camera:

1. Open a shake-free image with a low or medium ISO setting, neutral exposure, a well-defined focal plane, and no creative light and shade effects.
2. Switch to the 100% view and set all three Sharpening sliders to 0. Use the Navigator to find where the image is sharpest.

3. Drag the Amount slider all the way to the right.

4. Increase the Radius setting until the fine details lost during demosaicing are once again well defined. To increase the Radius setting by increments of 0.1, click in the value box and use the up/down arrow keys.

5. Once you've found the right Radius setting, switch to a dark area. This doesn't have to be on the focal plane, since the next step is about noise rather than sharpness.

6. In step 4 you increased the level of visible sensor noise. Let's now reduce this effect using the Threshold setting.

7. Click in the Threshold value box, and once again, use the arrow keys to find the optimum value.
8. Switch to the Amount setting, starting with a value of 100.
9. Use the Navigator to shift the zoomed detail back to the focal plane and start to increase the Amount value. To adjust it in increments of 10, click in the value box and use the up/down arrow keys with the Shift key pressed.

You've now found the optimum settings for a "normal" image. To save these settings for the camera that captured it, open the action menu (the button

with three dots in the Sharpening panel) and select "Save as Defaults for...." To make these settings available generally, open the Manage and Apply menu (the button with three horizontal lines) and select Save User Preset.

9.9 *To reset the default values, open the action menu and select "Reset Defaults for...."*

> **IMPORTANT**
> Noise reduction also influences the amount of input sharpening you need to apply. To find the appropriate values for your camera, set Noise Reduction to its default values (for Capture One 9, this means Luminance 50, Details 50, Color 50, Single Pixel 10). This ensures that any sharpening presets you create can be more universally applied—when no noise reduction is required, you won't need to apply as much input sharpening, but you can still use the settings for a variety of source images captured at widely differing ISO levels.

9.3 Noise Reduction

The Noise Reduction sliders are largely self-explanatory. Luminance adjusts the amount of luminance noise and Color the amount of color noise, whereas Details is designed to restore details affected by the noise reduction process. The Single Pixel slider is used to reduce or eliminate "hot pixel" effects. We'll look at these effects in more detail in section 9.4.

As with all raw developers, noise reduction in Capture One works in tandem with input sharpening, and the less you reduce noise in an image, the less input sharpening is required. If you sharpen a high-noise, high-ISO image, you'll have to perform more noise reduction when you're done sharpening.

Compared with other raw developers, Capture One offers added functionality that automatically adjusts Noise Reduction settings to suit the camera and ISO setting you use. Noise Reduction settings of Luminance 50 and Color 50 always attempt to produce a balanced-looking image, whether you used a Leica, a Canon, or a Phase One back to capture it, and regardless of whether you shot at ISO 10,000 or ISO 160. The results will always show the same apparent level of noise reduction.

Noise reduction is adjusted to suit your camera model and the ISO setting you used. This means you won't have to use the Noise Reduction sliders much for correctly exposed images.

9.10 *With a little luck, you won't ever have to use three of these four sliders.*

Capture One uses profiles in which the level of noise reduction depends on the ISO setting for all the cameras it supports. Phase One calls the process "adaptive noise reduction," and its aim is to enable you to retain standard noise settings regardless of the ISO setting or the type of camera you use. However, you can still adjust the level of noise reduction without having to ask yourself whether a specific ISO value will cost you too much detail.

This unique approach makes it tricky to compare sharpening and noise reduction settings for different cameras. It also makes comparing the quality of Capture One's performance with that of other programs virtually impossible. It's quite possible that an Amount setting of 50 in Capture One reduces noise in an ISO 1600 image more than a setting of 75% in Adobe Camera Raw (ACR). In contrast, you may find that the same setting doesn't affect an ISO 100 image at all, whereas a setting of 10% in ACR causes a significant loss of detail.

However your images turn out, you can always use the Luminance, Color, and Details sliders to fine-tune the way they look. See section 9.5 for a hands-on example.

9.11 *At ISO 160, even adaptive noise reduction can't compensate for this much underexposure.*

9.4 Single Pixel

Camera sensors aren't perfect, and they often show their weaknesses in tricky lighting conditions. One of the more irritating technical shortcomings, especially in aging sensors, is the issue of "hot pixels." These are pixels that always register a full charge and appear brighter than they should, regardless of the state of the surrounding pixels. The result is random green, red, or blue dots in your image. If you're lucky, there won't be many, although older cameras can have as many as several hundred.

"Hot pixels" can be removed with a single click.

9.12 Hot pixels are a sign of an aging but not necessarily broken camera.

Fortunately, the Capture One Single Pixel slider offers a simple way to counteract the effect of hot pixels.

All you have to due is shift the slider until any visible hot pixels disappear, but you have to take care finding the right value if you don't want to affect areas without hot pixels.

Perhaps surprisingly, the best way to find the optimum setting is with the help of the Contrast slider:

1. Switch to the Exposure tool tab.
2. Drag the Contrast slider all the way to the left (−50).
3. Zoom in to a 100% view and check darker image areas for hot pixels.
4. Drag the Single Pixel slider to the right until the hot pixels are no longer visible. To make fine adjustments to the slider's setting, click in the value box and use the up/down arrow keys to adjust the value in increments of 1.

9.13 *Low Single Pixel values are often sufficient to eliminate the effects of hot pixels.*

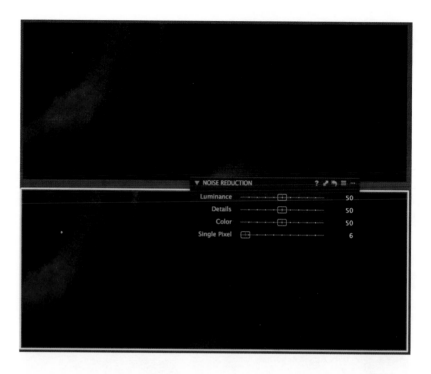

9.5 Enhanced Noise Reduction: Details and Film Grain

The effects of noise reduction, input sharpening, the Film Grain tool, and the Clarity slider are closely knit.

Capture One includes the Film Grain tool in the Details tool tab, which may not appear entirely logical at a first glance, especially when you consider that film grain effects usually obscure fine details. So why are we lumping them together here in a single section?

The answer is that Capture One's film grain effect is not produced by simply adding noise, but rather by an algorithm that's based on the image data that exists *before* sharpening and denoising is performed. This means you can recover details by adding film grain while simultaneously producing images with a more "organic" look.

9.5.1 All About Film Grain

Capture One's Film Grain effect doesn't just add noise but instead simulates the behavior of analog film in a chemical developer solution.

Up to and including version 7, Capture One's Film Grain tool offered a simple "fine-grained" effect designed to retain fine details while producing a look reminiscent of analog film. The aim of the tool was to reduce the artificial, rubbery feel that plagues so many digital images and to give them a more natural, more familiar analog-style look.

The tool was completely reworked in version 8. It's still simple to use but offers a range of different algorithms that simulate various film types. Together with the Impact and Granularity sliders, you can now produce hundreds of different monochrome styles and fine-tune each to suit individual images.

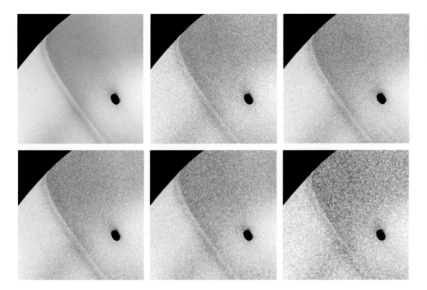

9.14 *The Film Grain effects, clockwise from top left: Fine Grain, Silver Rich, Soft Grain, Cubic Grain, Tabular Grain, Harsh Grain*

The Granularity slider determines how fine the effect will look, and Impact specifies its strength. Instead of adding a layer full of random noise artifacts the way other programs do, Capture One creates its grain effects by reinterpolating the image data based on brightness and contrast, thus simulating the look of analog film. The Type setting determines the overall look and distribution of the grain pattern and how it reacts to the settings you make for the tool's variable parameters.

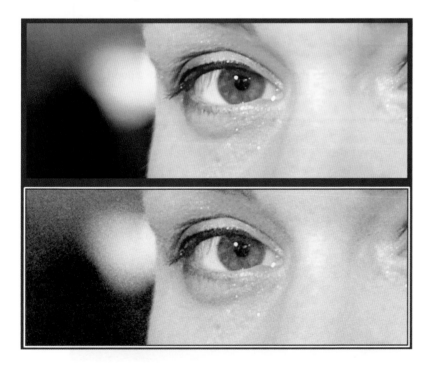

9.15 *The upper image has only a little added grain, whereas the lower one has more. Details in the lower image are more strongly emphasized but aren't swamped by noise, and white areas remain white.*

Black-and-white fans are sure to like the way the grain effect reacts to adjustments to exposure, just like real film. This means that monochrome images will still contain genuinely white and black areas, even if you've added a grain effect. ☐ 9.15

QUICK TIP

The effects of the Film Grain tool are based on the size of your original image files and work best in images destined for print output. Use the 100% view to try out the various algorithms and check the effects of your settings. If you're preparing images for online publication and you want to retain the look you have created in the 100% view, you'll have to increase the strength of the effect. Here's a good rule of thumb: every time you halve the surface area, increase Impact by 30. For example, if your original file measures 5000×3000 pixels and an Impact setting of 30 produces the right effect in the 100% view, you need to set it to 90 for a version scaled to 2500×1500 pixels for web viewing (one quarter of the original surface area means you have to add 2×30 to the Impact setting).

9.5.2 Producing Crisp, Natural-Looking Images

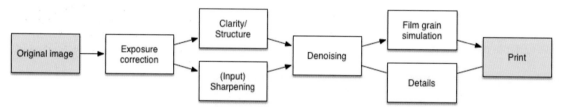

9.16 *This workflow will help you produce crisp-looking images.*

This section details the steps required to transform a poorly exposed photo into a usable image.

9.17 *Can we transform this underexposed photo into a usable image?*

Our sample image is underexposed by at least two stops and the camera was already set to its highest usable ISO level. The exposure time was long enough to produce some shake. So where do we start putting things right?

Because we need some areas with at least medium brightness to estimate where to set the white point, we begin by adjusting exposure followed by a correction to the color temperature.

9.18 There's no point in adjusting the colors (right) until we've fixed the exposure (left).

The shadows in the subject's face are still too harsh, so we use the HDR tool to lighten them.

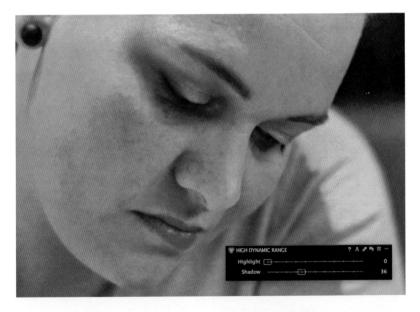

9.19 A reflector or fill flash would've produced much better results, but we've nevertheless managed to improve exposure for the subject's face. The downside of this adjustment is additional noise in the shadows.

Before we deal with the noise in the shadows, we perform some sharpening, starting with the Clarity tool to improve edge definition.

9.20 To keep the edges soft enough for a portrait shot, we select the Natural Clarity method.

To gain a better impression of the effect of our adjustment, we zoom in to a 66% view. Zooming to 100% doesn't help because we need to retain an overview of what we're doing. We now work through the sharpening hierarchy (see section 6.4). We've already improved the look of the subject's head and upper body using the Clarity tool, so we can concentrate on the details in her eyes and nose. We switch to the 100% view and adjust the Structure setting (a smaller view doesn't provide enough detail to judge the effect of the setting).

9.21 A low Structure value of 15–20 is sufficient to emphasize the details in the eyes, ears, and nose.

The final step in the sharpening process is to fine-tune the details such as our subject's hair and eyelashes without emphasizing her pores. To do this, we remain in the 100% view and switch to the Sharpening tool.

9.22 *The Soft Image Sharpening 1 preset underscores the detail in our subject's hair without emphasizing the pores in her skin.*

We remain in the 100% view and work on reducing color noise.

9.23 *Always use the lowest possible values—reducing color noise always reduces overall detail sharpness.*

We now use a relatively dark area to adjust luminance noise.

9.24 *Less is more, especially when it comes to preserving detail.*

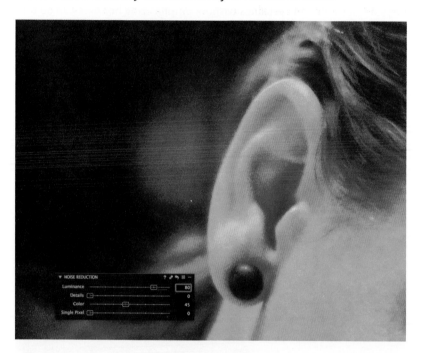

Too much adjustment makes our image look artificial and textureless, so we use the Cubic Grain setting in the Film Grain tool to give it a more natural, analog-style look.

9.25 *Our image is still quite noisy, but the random effect of the Film Grain tool gives it a more pleasing, natural look*

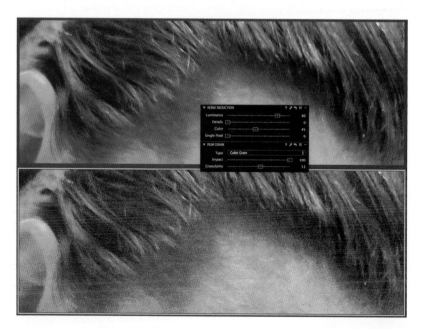

As you can see, the Film Grain tool has helped to recover detail. As a final step, we increase the Details setting in the Noise Reduction tool to bring back some of the details our other adjustments have suppressed.

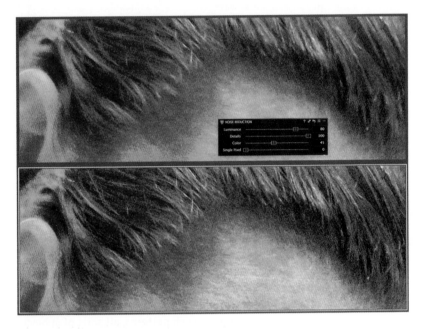

9.26 *We switch back and forth between the Luminance and Details sliders until we find the right compromise between the two settings.*

A few general adjustments help to consolidate the look we've created.

9.27 *Our unusable original has been transformed into a portrait with its own highly pleasing look and feel.*

Film grain simulations use a lot of processing power. If you're using a computer with a graphics card that isn't supported by Capture One's OpenCL implementation (see section 2.2), only experiment with film grain when you're done with *all* your other adjustments—otherwise, every adjustment you make will take forever.

9.6 Eliminating Moirés

Moirés are unwanted patterns that appear when fine textures in the subject interfere with the grid formed by the pixels that make up the image sensor. Some moirés can be easily eliminated whereas others can't be completely removed, so there's no ideal setting for the Moiré tool.

9.28 *This isn't modern art—it's just a moiré.*

Venetian blinds, brick walls, chain-link fences, the spokes in a bicycle wheel, and paving stones are all subjects that tend to produce moirés, which also appear in photos of tessellated patterns in fabrics. Camera manufacturers have experimented with optical, mechanical, and software-based methods of moiré prevention with varying results. All digital photographers encounter moirés at some point.

But what exactly is a moiré? Digital images consist of data collected when light rays hit the pixels in an image sensor, which are arranged in a grid. The resulting image is rasterized, as opposed to a vector image that's created by transforming mathematical formulas into lines and patterns. When two similar raster patterns are superimposed, the interference they generate creates unwanted artifacts in the resulting image. If the resolution of the sensor isn't sufficient to suppress such patterns, all sorts of subjects can end up producing moirés. Because most cameras use red, green, and blue microfilters to extrapolate color data (see section 9.2), the resulting moirés are often colored as well.

The Amount slider in the Moiré tool determines the degree of moiré removal. The Pattern slider specifies the degree to which the critical pattern interferes with the pixel grid in the sensor.

9.29 *The Amount and Pattern sliders in the Moiré tool*

Moiré removal is an imprecise science and is difficult to automate. Software cannot easily differentiate between patterns in the subject and unwanted artifacts. This means that moiré removal in Capture One can be quite fiddly:

1. Zoom in to 100% in the Viewer and use the Navigator to locate the area affected by moirés.
2. Adjust the Amount and Pattern sliders alternately in small increments until the moirés are reduced to your satisfaction.
3. Reduce both settings a little to ensure that you don't affect "real" patterns in the subject.

9.30 These Moiré settings are too high and cause extreme color bleed in the red pompoms.

QUICK TIP

The Moiré tool is available as a local adjustment, enabling you to apply it selectively and avoid destroying patterns you wish to retain. See chapter 10 for more on local adjustments and adjustment layers.

9.7 Dusty Sensors and Spot Removal

Dust is a pain not only at home but also when it finds its way onto your camera sensor or the rear element of a lens. No matter how carefully you work, and even if your camera has an automatic sensor-cleaning feature, time and again you'll find images with obvious dust artifacts. In addition to the LCC tool (see section 7.4) and Clone and Heal layers (see chapter 10), the Spot Removal tool in the Details tool tab will help you remedy this inescapable issue.

9.31 The Spot Removal tool

The Spot Removal tool is a Cursor tool (see section 1.5.1) but also has its own tool panel. To activate it, either click the circular button in the Toolbar or use the O shortcut. The cursor is then transformed into a kind of circular brush, whose Radius you can adjust in the tool panel or by right-clicking in the Viewer.

The tool differentiates between Dust and Spot artifacts (available in the Type drop-down list) and the brush behaves differently depending on which you select.

9.32 *The Dust brush (left) and the Spot Brush (right) in the Spot Removal tool*

With the Dust option, the program attempts to reconstruct the area you select using a context-sensitive algorithm. This means that the affected area is continually refreshed, even if you apply your current settings to a different image. The algorithm is designed to detect dust particles on the sensor or the rear lens element and does its job extremely well. However, it doesn't work for complex details such as insects or blemishes in a portrait subject's face.

9.33 *The Spot Removal tool is context-sensitive and always attempts to rebuild the background. It works very well for dust but usually fails when applied to other types of artifacts like the one highlighted here.*

The Spot option attempts to fill the selected area with colors and textures similar to those it finds in surrounding areas. This means you can use it to remove irregular artifacts such as insects, but only as long as the surrounding areas contain enough uniform detail.

9.34 *Spot Removal works best with uniform surrounding details like the green surface of the trash can in this example.*

The Spot Removal tool creates a mask that you can copy to other images, too. This enables you to remove identical dust artifacts from an entire sequence of images. Only use this function if you're using the Dust option. Other types of artifacts don't remain consistent throughout a sequence and can't be reliably detected and removed by the algorithm.

The tool works the same way for the Dust and Spot options:

1. Select the Spot Removal tool using the O shortcut or by clicking its icon in the Toolbar.
2. Adjust the size of the brush circle using the Radius slider in the tool panel or the context menu and select either the Dust or Spot option in the Type drop-down menu. Click on the detail you wish to remove in the Viewer.
3. In the Spot drop-down menu, you can directly select the spots you've already applied and adjust their Radius and Type values. Click the "−" button next to the drop-down menu to remove the selected spot from the mask. ▢ 9.35

The Spot Removal tool is great for retouching minor details but starts to leave obvious traces if you use it more than four or five times in a single image. For complex retouching, you're better off using the Clone and Heal tools in the Local Adjustments tool tab, since those are a lot smarter.

9.35 *You can adjust and move the spots you've applied at any time.*

Reliably Detecting Dust on the Sensor

Detecting dust particles isn't always easy, and you'll often find that you discover them only when you're editing your images, you've finished processing, or you've uploaded an image to flickr. The following steps explain how to reliably detect and remove unwanted dust:

1. Select an image with as much uniform detail and as little texture as possible, such as a cloudless sky. Right-click it in the Browser and duplicate it using the Clone Variant command.

2. Switch to the Levels tool in the Exposure tool tab and compress the tone curve by dragging the black and white point handles toward the center.

3. Vertical gray lines appear when you drag the handles. Drag the black and white points until these lines meet at an intersection of the red, green, and blue curves. The image in the Viewer will now have extremely high contrast but will still display sufficient detail for you to detect any dust spots.

4. Shift the midtone handle to the right to darken the image to the point at which you can clearly see the first few dust spots. Setting the Clarity value to 100 will help.

5. Switch to the Spot Removal tool and select the Dust option.
6. Click on each dust spot to remove it and adjust the midtone handle in the Levels tool regularly to make sure you don't overlook any spots.

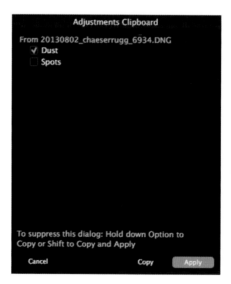

7. Once you've marked all the spots you can find, copy the mask by clicking the double-arrow button in the Spot Removal tool panel. Select the Dust option and click Copy.

8. Apply the copied mask to all the affected images by clicking the "Apply adjustments to all selected variants" button (the downward arrow) in the toolbar, or by using the A shortcut.

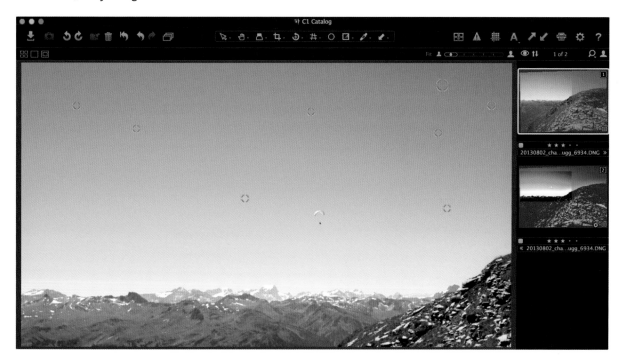

9. You're done! You can now delete the cloned variant you created in step 1.

You should, of course, clean your cameras regularly. However, if you can't do so immediately because you're on the road or busy shooting, save the spot removal mask. You can't save the mask as a Preset, so you need to go the User Style route. To do this, switch to the Adjustments tool tab, click the "+" button, and select only the Dust item in the Details section before clicking Save. See chapter 11 for more on saving and applying User Presets and Styles.

10 The Local Adjustments Tool Tab

10.1 *Local adjustments are made on a new layer that's added to the image you've already edited, so you should usually perform them at the end of the workflow pipeline.*

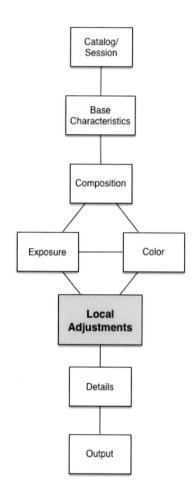

Local adjustments have been available in Capture One for a while now, enabling you to apply effects to selected areas on a separate image layer. In addition to White Balance (see section 5.3), the Local Adjustments tool tab in version 9 now includes Sharpening and Noise Reduction tools (see chapter 9); you can use the Curve tool selectively; and there are now separate Clone and Heal controls, too. These tools enable you to perform simple retouching on a raw data level so you'll have to export your images less often to Photoshop or other programs for further processing (see section 15.2).

This chapter introduces working with layers and masks in Capture One. We'll discuss how to handle layers in general, as well as the types of adjust-

ments you can make with them. We'll also take a look at the new Clone and Heal layers and show you how these can replace tasks you'd normally have to perform in Photoshop.

10.1 Adjustment Layers and Masks

Layer functionality enables you to keep your editing steps organized and apply creative effects to selected image areas. Layers are an essential part of most contemporary image editing processes.

Capture One's Local Adjustments functions are based on the same principle, enabling you to precisely select the area an adjustment affects. For example, you can increase exposure for some areas while retaining the original exposure levels in the rest of the image. Layers also make it simpler to organize individual editing steps, and you can superimpose your adjustments or switch their effects on or off as necessary. A clear layer-naming scheme also makes it easier to keep track of the individual steps you've applied.

Local adjustments in Capture One are facilitated using masks stored on separate image layers.

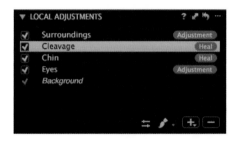

10.2 Layers enable you to perform individual editing steps separately and tweak, show, and hide them as necessary.

Layers enable you to apply adjustments locally, using a brush to "paint" your adjustment into the image—or, more accurately, you mask specific areas with the brush and apply your tool(s) of choice to the masked areas.

The list of tools that can be applied locally is growing all the time and consisted of the following as of this writing:

- White Balance (see section 5.3)
- Color Editor (see section 5.6)
- Exposure (see section 6.1)
- HDR (see section 6.2)
- Clarity and Structure (see section 6.4)
- Purple Fringing (see section 7.3)
- Sharpening (see section 9.2)
- Noise Reduction (see section 9.3)
- Moiré (see section 9.6)
- Curve (see section 6.3)

These are, of course, all tools that it makes sense to apply locally. Vignetting (see section 6.5) and lens corrections (see section 8.3), on the other hand, are tools that are designed for application to the entire image.

Let's look at an example based on White Balance settings. It's likely you've captured images using mixed natural and artificial light sources, or ones in which sunlit and shaded areas are of equal importance. The human brain can compensate automatically for such complex lighting conditions but camera sensors can't.

10.3 *White balance in the left-hand image is set for the sunlit part of the frame. In the version on the right, it's set for the shadows. The image in the center shows the result of applying a local white balance adjustment.*

Local adjustments present virtually endless editing options. For example, to remove a red-eye effect, all you have to do is select the subject's pupils and adjust Saturation for the selection to −100. To emphasize lips, simply select them and increase the Clarity setting. To remove wrinkles, mask the face and reduce the Clarity and Structure values accordingly. As an alternative to the color key method described in section 5.6, you can mask the image area you wish to tone, invert the mask, and desaturate the rest of the image to black and white. In addition to limiting the effects of your adjustments, local adjustments are fantastic creative tools, too.

10.4 *Masks are created and tweaked in the Local Adjustments tool.*

The options available in the Local Adjustments tool are as follows:

- **Brush Settings:** Click the double-arrow button at the bottom of the tool panel to adjust the Size, Hardness, Opacity, and Flow values of the brush. Flow defines how quickly the build-up of your virtual brush is supposed to happen and is most useful when you choose the Airbrush option. Brush Settings is also where you can activate the Auto Mask and Use Pen Pressure options. Also, with Link Brush and Eraser Settings, Capture One will use the same settings for both the paint-on brush and the eraser brush, making it easier for you to undo your strokes on the fly.
- **Draw Mask:** The next button activates the brush that is used to "paint" an adjustment into the Viewer image.
- **"+" and "−":** Use these buttons to create and delete layers.

The Auto Mask function uses brightness, contrast, and color detection algorithms to guess where the outline of the mask needs to be. It works very well for objects with a fairly obvious outline, such as a person in front of a studio background, the sky in a landscape, or an object photographed on a light table. It's ideal for quickly creating complex masks without having to do too much fiddly work with the eraser, and it's so sophisticated that it "notices" if you accidentally mask part of an obvious outline.

The Auto Mask function makes selecting complex objects a breeze.

The "+" and Draw Mask buttons offer various options that you can select by clicking and holding. The "+" button's default action is to create a new layer, and a click-and-hold (or right-click) reveals Clone Layer and Heal Layer options (see section 10.2).

10.5 Three brushstrokes were all it took to mask the sky in this image. The Auto Mask option saves a lot of painstaking brushwork.

10.6 Click-and-hold the brush button (either in the Cursor Tools toolbar or in the Local Adjustments tool panel) to open its options menu.

The brush options enable you to show or hide the mask, or show it only while you're drawing. You can also control the show/hide toggle using the M shortcut. The menu is where you can switch between drawing and erasing, and the eraser can also be activated using the E shortcut.

> **QUICK TIP**
> The B (brush), M (mask), and E (eraser) shortcuts make it simple to work on an image without having to use the mouse or your graphics pen to switch the cursor function. And by the way, a graphics tablet is the ideal tool for performing local adjustments, especially if you program its custom buttons with the masking shortcuts listed here.

Selecting the Gradient Mask option transforms the cursor into an arrow that you can use to drag a gradient in the Viewer image. This is a great tool for simulating a graduated filter or applying any other adjustment—for example, to increase Clarity from the top to the bottom of the frame or saturation from left to right.

10.7 *Click-and-hold the brush button or use the G shortcut to activate the gradient mask.*

The Show Selection Points option applies mainly to Clone and Heal layers, which we'll discuss in the next section. The tool's action menu contains commands for inverting, copying, and applying the mask to other layers.

10.8 *As usual, the action menu is activated by clicking the button with the three dots.*

- **Invert Mask:** Use this option to make a "negative selection" that you want to leave untouched when you apply an adjustment.
- **Fill Mask:** Use this option to fill the outline you draw with the brush. This option means you don't have to "color in" your mask by hand. If you haven't drawn an outline, Fill Mask masks the entire layer. This can be useful if you need to increase the value of an adjustment beyond its intended range (see section 6.2 for an example).
- **Copy Mask From:** Copying a mask from one of the other layers in an image overwrites the current mask. This is useful if you need to apply different tools to the same area.

10.9 *The circles in the mask cursor show which areas are masked and how strong their effects will be. You can adjust the relevant options in the Local Adjustments tool or in the Viewer context menu.*

> **QUICK TIP**
> Give your keyboard's Shift key a shot: If you press and hold the Shift key while painting, the brush will draw only straight lines—horizontal and vertical. If you want to do a second stroke, pressing Shift prior to painting will connect the new stroke with the previous stroke's endpoint. The behavior is hard to explain in words; it's easier to understand if you try it out. Open an image, add an Adjustment Layer, Show Mask, and go for it.

The inner circle in the masking cursor is the area of maximum opacity and shows where your adjustment will take effect. The outer circle shows the limit of the currently selected brush size, which you can adjust using the Size slider in the Brush Settings menu. Opacity at the outer edge is zero and increases to the value you've selected in the center. This enables you to alter the smoothness of the transitions between masked and nonmasked areas.

Size, Hardness, and Opacity settings cannot be adjusted once a brushstroke has been applied.

QUICK TIP

The degree of precision required in a mask depends on which tool you're using and the content of the image you're editing. Generally speaking, masks for dark areas don't need to be as precisely drawn as those in brighter areas. Rough masks are fine, too, for applying context-sensitive tools like Moiré (see section 9.6) or HDR (see section 6.2).

Let's look at an example: If you want to brighten a dark image area, you don't have to perform painstaking brushwork in a 100% view—all you have to do is draw a rough mask and increase the Shadow value in the HDR tool. If, on the other hand, you want to apply an Exposure adjustment to the same area, the mask needs to be more precise from the start, because the tool's effect doesn't take the surrounding pixels into account. If you need to darken a light area using the Exposure tool, the mask needs to be very precise indeed, whereas it can be a little rougher if you use the Highlight Adjustment in the HDR tool (although it still has to be more precise than the one you use to brighten shadows). Whichever tools you use, the stronger a local adjustment, the more precise its mask has to be.

Improving Suboptimal Lighting in Landscape Shots

If you don't happen to be shooting in the midday sun, landscape images are often difficult to capture as you remember them. Contrast is usually too great to be covered by the sensor's dynamic range, and exposing for medium gray produces either shadows that are too dark and/or burned-out clouds. Using subtle HDR adjustments to correct a situation like this often yields unnatural-looking results. You could use an averaged White Balance setting to balance out the shadows and highlights, or apply a greater Clarity value to foreground, or whatever other adjustments appear to make sense.

The following steps demonstrate many (but not all) of the available local adjustments and are aimed at helping you to learn to "think locally":

1. Our sample shows an early-morning scene that we slightly overexposed to retain as much image data as possible. The resulting image has little to do with how we remembered the scene, and the following steps are aimed at restoring the original dramatic mood of the sky without making the rest of the image look like an LSD trip.

2. We begin by making basic adjustments to exposure and the crop. It quickly becomes apparent that we can't set white balance to reproduce the dramatic red sky of the original scene while retaining detail and a cooler look in the shadows.

3. We switch to the Local Adjustments tool tab and click the "+" button to create a new layer that we call Sky.

4. We select the Brush tool and check the Auto Mask option in the Viewer context menu.

5. We activate the Always Display Mask option using the M shortcut (this option is also available in the click-and-hold brush menu).

6. A right-click in the Viewer opens the Brush settings menu, and adjusting the settings alters the shape of the cursor to match. Brushstrokes we've already made are not affected.

7. With the mask complete, we use the M shortcut to hide the mask and select the Background layer in the Local Adjustments tool panel. We now adjust the White Balance setting in the Color tool tab to give the foreground the cool look we remember. At this point, we ignore the effect of our adjustments on the sky.

8. We select the Sky layer in the Local Adjustments tool tab and adjust the White Balance setting to taste.

9. To finish up, we use the Clarity and Structure sliders in the Exposure tool tab to adjust the sky so it looks just as dramatic as we remembered it.

You can, of course, add more layers to process other details the same way analog darkroom specialists dodge and burn individual areas in a print.

As of this writing, Capture One supported up to 16 layers—a number that has already been significantly increased thanks to user feedback. Of course, you don't have to use all the available layers, and each new layer uses more processing power, so some computers will slow down to a snail's pace before you can create more layers anyway. But, even if you're working on a top-flight computer, applying too much of a good thing often produces the opposite of good. Ask yourself if you really need all the layers you've added. Even hundreds of layers can't rescue a badly exposed or poorly composed image.

10.2 Clone and Heal Layers

The addition of Clone and Heal layers was one of the most significant changes with Capture One 8, and Phase One continues to improve layer functionality with Capture One 9. You're probably already familiar with this kind of functionality in programs like Photoshop—instead of simply "painting over" details in an image, the Clone and Healing Brush tools enable you to copy and blend source pixels with the surrounding pixels in a selected target area.

The Clone and Heal tools have similar effects, although the Clone tool simply copies image content whereas the Heal tool blends the color and brightness of the source material with the surrounding pixels in the target area.

Capture One now offers the same functionality for application to raw data, thus saving you the trip to Photoshop and back when you need to make minor repairs to your images.

10.10 *The center image repaired using a Clone layer (left) and a Heal layer (right)*

Did I say minor repairs? The fact is, full-blown image-processing programs like Photoshop support many more layers than Capture One, enabling you to split complex retouching work into multiple substeps that you can refine, undo, and reorder as necessary. Try to estimate whether Capture One's layers will suffice before you start editing an image. If, after an hour or so of work, you notice that you're running out of layers, you'll have no alternative but to switch to Photoshop (or whatever program) and start over.

Clone and Heal layers are applied as follows:

1. Click-and-hold the "+" button in the Local Adjustments tool to create a new repair layer and select the appropriate tool from the drop-down list.

2. Hold the Alt key and click the source point in the Viewer.

3. If necessary, open the Brush Settings context menu to adjust the brush size.
4. Use the brush to apply the source material to the target area.

To move the source or the target, click and drag the corresponding handle in the Viewer image.

The Clone and Heal tools are relatively new (introduced in Capture One 8) and are still in active development with version 9. You cannot yet adjust the size of the source. However, you can expand the target area by adding brushstrokes, or reduce its size using the eraser. You cannot alter the Hardness or Opacity value of the mask once you've drawn it. This limitation is, however, simple to work around, too—all you have to do is create a new layer with the right settings and delete the old layer. This approach becomes really annoying when you're performing very fine retouching work, though.

Using low Hardness and Opacity values and adding brushstrokes to increase the effect of the mask gives you plenty of control, and you can always remove unwanted masked areas using the eraser. Because you have to redraw the mask every time you want to adjust its settings, finding the right values can be quite laborious.

10.11 *The eraser has the same Hardness and Opacity sliders as the brush, enabling you to adjust the strength of the undo effect.*

11 The Adjustments Tool Tab

In the chapters thus far, we've discussed User Presets, looks, and "adjustments" (that is, tool and metadata settings). The Adjustments tool tab is where you can manage all of these things and create new styles to apply to your images.

Many of the concepts discussed in the following sections are available at various stages in the Capture One workflow. Every tool has a double-arrow button for copying settings, the Import Images dialog gives you access to your User Presets, and the Adjustments menu gathers all your styles and presets together in one place. Because they're available at every stage in the process, the tools in the Adjustments tab don't have a specific position within the workflow.

11.1 Styles and Presets: Basics and Differences

Presets affect individual tools, whereas styles are collections of settings that can be applied using any tool.

As explained in chapter 1, Capture One's nondestructive approach to raw development enables it to apply tool settings to an original image in real time without affecting the original image file. What the software actually does is interpret the settings you make in the context of the currently selected image. The settings themselves are stored either as part of a catalog or in Session mode, in separate files (see section 4.2). The Adjustments tool tab gives you a meta-interface for handling all of these settings. You can't change them, but you can bundle and copy them, and apply them to other images. ☐ 11.1

What exactly are styles, presets, settings, and adjustments?

- ◉ **Settings** and **adjustments** are the individual values that you enter using the keyboard or adjust using a tool's sliders. Examples are the Saturation value in the Exposure tool, a Keystone adjustment, or the Creator metadata field.
- ◉ **Presets** are saved settings or sets of settings that apply to individual tools. For example, you could save a Saturation setting along with a Contrast setting in the Exposure tool, and then call the resulting preset *chic*; save a Keystone adjustment for application to an entire series of images; or combine the Creator, Address, City, Postal Code, and Email metadata fields in a preset called Contact Data.

⦿ **Styles** bundle settings made in multiple tools and enable you to apply them simultaneously to produce a specific look. For example, you could combine Saturation and Contrast settings in the Exposure tool with a Structure setting in the Clarity tool and a Curve adjustment to produce a style called *ultra-chic*. Keystone plus Black & White might end up as *Wide-angle monochrome sequence, May 2015*. The Metadata fields listed earlier combined with a keyword for a lens could produce a style called *Standard Nokton Import* (in this case, for a lens whose name isn't saved with the EXIF data in your images).

Capture One has a range of built-in presets that you can select in each tool's Manage and Apply menu (the one with the three horizontal lines), while you manage built-in styles via the Styles section of the Adjustments menu.

11.2 *These are the built-in presets for the Color Balance tool. Presets are located in the menu highlighted in orange.*

The terms "style" and "preset" sound very much as if they are things that influence the visual look of an image, but what they actually do is describe in general terms how Capture One has to treat an image file. Multiple metadata items that you wish to apply simultaneously (see chapter 12) are just as much a preset as the naming settings you make in the Import Images dialog (see section 4.4) or settings you save in process recipes (see chapter 13). Styles and presets are saved as text files that contain records of everything that you can tweak, set, or adjust in Capture One. See section 11.3 for more details on organizing your styles and presets.

11.1 *The Adjustments tool tab lists all the adjustment options for all the available tools.*

11.2 Saving, Copying, and Applying Presets and Styles

Presets are saved in the corresponding tool using the Presets menu.

11.3 *The Presets menu for the Black & White tool offers a wide range of built-in presets.*

Selecting Save User Preset opens a dialog in which you can choose which of the tool's settings you wish to save. Once you've made your choices, click Save to save your preset and give it a meaningful name.

11.4 *Creating a Black & White preset with conversion and filter simulation enabled but without the Split Tones settings (see section 5.5)*

To save presets for multiple tools as a new style, switch to the Adjustments tool tab and select a processed image in the Browser. Click the "+" button next to the Styles and Presets drop-down list to open a list of all the settings you've made for the selected image. ☐ 11.5

11.5 *By default, Capture One automatically selects all the settings you've altered. However, you can use the Save Style dialog to deselect settings you don't want to include in a style.*

> **QUICK TIP**
>
> To make styles useful in a larger variety of situations, try not to save too many settings and instead concentrate on the core idea that you want the style to embody. Deselect settings that you'll probably have to adjust individually anyway, such as exposure. If you're in any doubt, deselect more rather than fewer options. And take care with your metadata—for example, not all images that you apply a black-and-white style to will require the same keywords, color tags, and ratings as the original you used to create your style.

In its default setup, the Adjustments tool tab contains the Styles and Presets and Adjustments Clipboard tools.

The Adjustments tool tab is the place where all presets and styles can be viewed, sorted, combined, fully or partially copied, and applied.

11.6 *The drop-down list in the Styles and Presets tool can be used to select existing styles or save new ones.*

Stack Styles (in the Styles and Presets drop-down list) is an important option that you can also access via each tool's Presets menu or the Adjustments > Styles menu. Activating it enables you to simultaneously apply multiple styles or presets—for example, a monochrome conversion style combined with a custom denoising style and your copyright metadata.

11.7 *Stacking styles means activating multiple styles or presets in a single image. The styles you select are listed in the Applied Styles section of the Styles menu, where a brush icon indicates a style and the familiar icon with three horizontal lines indicates a preset.*

The Adjustments Clipboard tool displays any settings you've copied using the double-arrow button in a tool's title bar.

11.8 *The Adjustments Clipboard tool displays the settings you've copied from an image to the Clipboard, not the settings for the current Browser image or a style you've selected using the Styles and Presets tool.*

11.9 *The action menu contains options for altering what the tool displays and how it functions.*

The Copy button copies your current settings to the Clipboard and therefore to the Adjustments Clipboard tool, too. The Apply button applies the copied settings to the selected image(s).

To get an idea of how the Adjustments Clipboard works, let's take a look at the action menu in its title bar.

The Autoselect Adjusted option is activated by default. This means that clicking the Copy button selects all the settings you've adjusted in the course of your work. The Expand All and Collapse All options expand or collapse the settings lists, Select All and Select None are self-explanatory, and Select Adjusted is the manual version of Autoselect Adjusted.

You can copy settings to the Clipboard in one of three ways:

⊘ Right-click in the Browser and select the Copy Adjustments command. This copies all settings you've adjusted. The same command is also located in the Adjustments menu.

⊘ Click the Copy button in the Adjustments tool tab to copy the settings checked in the Adjustments Clipboard tool from the currently active Browser image.

⊘ Click the double-arrow button in any tool's title bar to open a dialog in which you can select the settings you want to copy.

11.10 *Clicking the double-arrow button in any tool's title bar (shown here in orange in the Color Balance tool) opens a dialog in which you can select the settings you want to copy. If you want to copy all the settings from an image without showing the selection dialog, press the Alt key while you click the double-arrow button.*

Copying and Applying Settings, then Saving Them as a Style

It is tricky to put the way the Adjustments Clipboard works into words, but the following steps should help you learn how to use it and also decide when you're better off using context menus and the double-arrow button. This example uses a Black & White style to demonstrate the principles involved:

1. Select your image in the Browser and switch to the Adjustments tool tab.

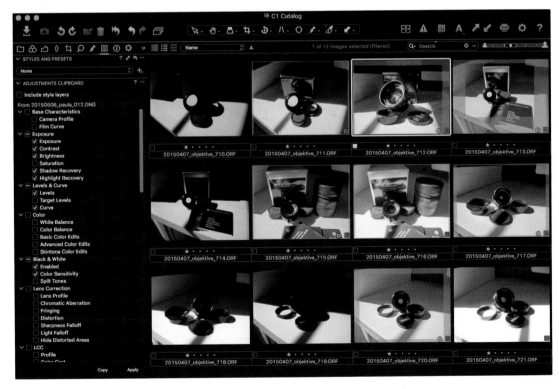

2. Use the Select None option in the action menu to deselect everything and activate the Autoselect Adjusted option.

3. Click the Copy button at the bottom of the Adjustments Clipboard tool panel. All the selected adjustments are now available on the Clipboard.

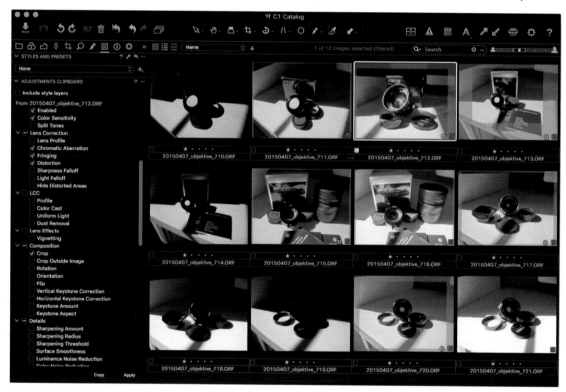

4. As well as the Black & White adjustments, these include Filter, Levels, Clarity, and Vignette settings. If you've added color tags or keywords, or if you've already cropped your image or adjusted its exposure, deselect these types of settings and any others that are too specific for application to other images (or to serve as the basis for a style). Be sure to retain the settings that most strongly influence the overall look of your image.

5. Hold down the Cmd/Ctrl key, and then select the images you want to apply your new style to.

6. Click the Apply button, and the selected images will be displayed in black and white in the Browser.

7. Select the Save As Style option in the action menu, give the style an appropriate name, and click Save. This approach saves you from having to use the Save Style dialog and reselect your settings (this already took place in step 4).

This method is ideal for applying settings to sequences of images. The differences between this and the conventional context menu/double-arrow button technique are that you can a) copy settings from multiple tools onto the Clipboard, and b) select only the settings that it makes sense to apply. If you want to copy and apply settings from one specific tool, you're better off using the double-arrow button. This allows you to select the settings that you really want to copy without having to scroll through a huge list of other settings in the process.

11.3 Organizing Styles and Presets

If you save a lot of styles and presets, swap presets with other photographers, or purchase ready-made libraries of styles, it's all too easy to lose track of your options.

11.11 *Importing style libraries using the Import command in the Styles and Presets drop-down menu makes the Clipboard list and each tool's Presets menu even longer and more confusing to use.*

Unfortunately, Capture One has no functionality for reordering, renaming, or creating folders for your styles and presets yet. Currently, you can only import, create, save, and delete them.

11.12 *If you touch a style or preset with your mouse without actually selecting it, Capture One automatically updates the preview, the Viewer, and the Browser. This makes scrolling through various styles a lengthy process.*

As previously mentioned, styles and presets are files saved within your Capture One installation, so the best way to organize them is at the operating system level.

From the operating system's point of view, style libraries are stored in two folders with an unlimited number of subfolders.

Styles and presets are stored in two folders: Styles and Presets60. These can be found at the following locations:

- **Mac:** /Users/[*user-name*]/Library/Application Support/Capture One/
- **PC:** [*drive*]:\Users\[*user-name*]\AppData\Local\Capture One/

Presets and styles are indicated by the .copreset and .costyle filename extensions. It doesn't matter to Capture One how these files are organized as long as they're contained in one of the two folders (or their subfolders). Presets only work with the specific tool they're created for, and Capture One automatically stores them in an appropriately named subfolder.

- ▶ 📁 Advanced Noise Reduction
- ▶ 📁 Base Characteristics
- ▼ 📁 Black and White
 - 📄 Color – Orange Filter.copreset
 - 📄 Tri-X Yellow Filter.copreset
 - 📄 Tri-X.copreset
- ▼ 📁 Clarity
 - 📄 Punch.copreset
- ▼ 📁 Color Balance
 - 📄 Correct DNG Cast.copreset
- ▶ 📁 Color Editor
- ▼ 📁 Curve
 - 📄 Ilford.copreset
 - 📄 Tri-X.copreset
- ▶ 📁 Exposure
- ▼ 📁 Film Grain
 - 📄 400ASA.copreset
- ▶ 📁 High Dynamic Range
- ▼ 📁 LCC
 - 📄 28mm_ASPH_2013-08-6.copreset

11.13 *The contents of the Presets60 folder, showing the subfolders for the individual tools. You can create additional subfolders to help you keep track of your presets.*

> **IMPORTANT**
> Never change the names of the tool folders. If you do, Capture One will no longer be able to find your presets. However, to make life easier you can create as many subfolders as you like within each tool's folder.

The best way to organize styles and presets is to create subfolders and give your styles and presets meaningful names:

1. Quit Capture One.
2. Switch to the application folder in the Finder or Windows Explorer. Our example uses a Mac.

3. Navigate to the Styles subfolder.

4. Create sub-subfolders to group related styles and keep the names short and sharp. For example, *Monochrome* is better than *Black and white for use with portraits of people.*

5. You can nest as many subfolder levels as you like. In our example, I've separated the black and white styles into "portrait" and "landscape" style types.

6. Once you're done, restart Capture One. Your new structure will be made available in all the places where you usually select styles and presets.

QUICK TIP

Don't create too many subfolder levels. If you nest your folders too deeply, at some point you'll overshoot the width of your monitor, making things just as confusing as they were before you began sorting. I've found that two sublevels are usually enough.

If a subfolder contains a large number of styles or presets, it helps to number them. By default, Capture One orders these files alphabetically, so a style called 1-monochrome will appear before one called color-1 in the program's menus and drop-down lists.

12 The Metadata Tool Tab

12.1 *You can work on metadata during image import/processing or shortly before (or after) the output stage. This is why I've placed the metadata tools outside of the workflow pipeline.*

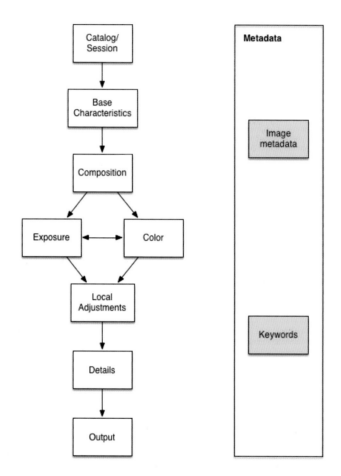

To put it politely, Capture One's metadata management tools have been fairly rudimentary since its inception. This is due to the program's origins in raw conversion for studio photographers—such a program assumes that you'll manage your data using a dedicated media database or DAM system and that the program doesn't need its own metadata management tools. Even selecting key images takes place without the use of metadata, and you can use a keyboard shortcut or a menu command to include images in a session's Selects folder (see section 4.2). If you require more management functionality, you can always turn to the Phase One Media Pro package. This was the reasoning up to and including Capture One 8.

Today, though, Capture One 9 is comparable with its competitors in terms of its tool sets for metadata management. And it's still improving—future point-releases of Capture One will focus on added metadata functionality and improvements in metadata handling. Compared to that of a full-fledged DAM system, Capture One's metadata management functionality may still be in its infancy, but it's growing up fast. Most users looking for a simple way to manage their image libraries will find Capture One 9 up to the task.

12.1 Applying, Copying, and Deleting Metadata

The Metadata tool tab is divided into Metadata, Keywords, and Keyword Library sections. Capture One provides two ways of assigning keywords:

1. Select an image in the Browser, type keywords in the Enter Keywords field, and press Return.
2. Switch to the Library tool tab and drag images from the Browser to existing keywords in the Filters tool (or enter a new keyword or place using the "+" button).

Even when you use method #1, Capture One 9 will add new keywords (but no other metadata) to all images selected in the browser—if you remember to enable the "Edit selected variants" option in the toolbar. This is different from previous versions, in which only the primary image received added keywords and you had to copy/paste the keywords to other variants via the Apply tool. You can delete single keywords from multiple image files in one go, and even arrange them at will.

In short, the keyword horrors so often discussed in web forums, blog posts, and articles are finally a thing of the past. If you are new to Capture One, you might not appreciate how big of a deal this is. Just as an illustration, the new keyword functionality is Phase One's main marketing approach for selling upgrades to Capture One Pro 9. Yes, keywording in Capture One used to be that dire. You'll learn more about the keyword tools in the next section of this chapter.

With version 9, Capture One's metadata management and editing functionality has finally caught up with that built into Lightroom and Aperture.

12.2 *Metadata you edit in the Metadata tool tab is saved either in the catalog/session and XMP sidecar files or only in the database files within the catalog or session. For more on metadata synchronization, see sections 1.7.2 and 4.9.*

12.3 *The Metadata tool still works as it did in previous versions and is thus the only tool in which direct changes (those not made using presets) affect only the primary image and not selected variants.*

12.4 *Dragging images from the Browser to the Filters tool is simple and works best for color tags, ratings, keywords, and place tags. You can add further filter labels via the Filter tool's Action menu, "Show/Hide Filters…"*

The metadata types included in the Filters tool can all be organized using your mouse. Add new keywords or place tags by clicking the "+" button and drag selected images to the appropriate ratings, color tags, place tags, and so forth.

Assigning Metadata Tags to Multiple Images

However impractical it may seem, you are sure to end up using the Metadata tool tab at some point. If you need to apply the same place tag, address, genre, or copyright data to multiple files, you have to copy the appropriate metadata and paste it to all the affected images. You can do this using either User Presets (see chapter 11) or the Apply Adjustments function in the Metadata tool:

1. Select all the images to which you want to apply metadata. They will appear with a thin border.

2. The image with the thick border is the master image. Write the required tags to this image (in our example, the Place tag). Navigate back and forth through the metadata fields using the Tab or Shift-Tab keystrokes. Press Esc when you are done.

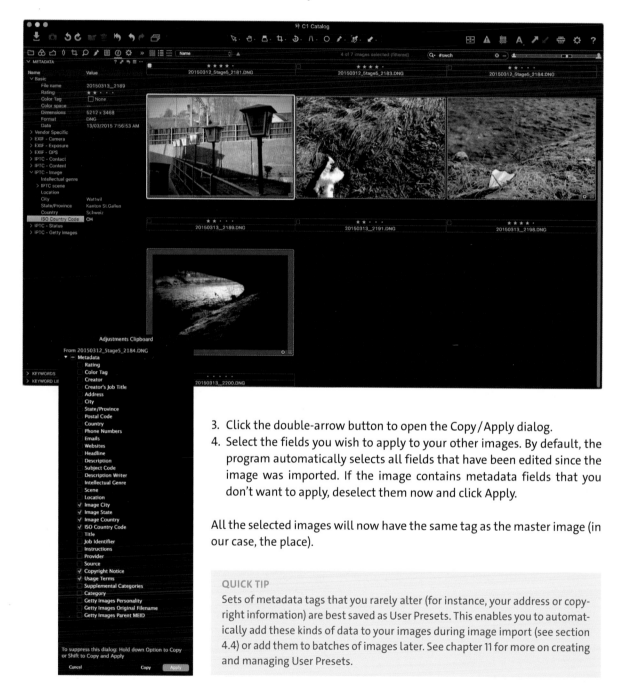

3. Click the double-arrow button to open the Copy/Apply dialog.
4. Select the fields you wish to apply to your other images. By default, the program automatically selects all fields that have been edited since the image was imported. If the image contains metadata fields that you don't want to apply, deselect them now and click Apply.

All the selected images will now have the same tag as the master image (in our case, the place).

QUICK TIP

Sets of metadata tags that you rarely alter (for instance, your address or copyright information) are best saved as User Presets. This enables you to automatically add these kinds of data to your images during image import (see section 4.4) or add them to batches of images later. See chapter 11 for more on creating and managing User Presets.

12.2 Working with Hierarchical and Nonhierarchical Keywords

Capture One supports keywords just like any other image management program. Keywords are descriptive terms—such as cat, beer can, or rock concert—that help you find the images you're looking for. This section explores how to assign keywords, work with keyword libraries, and develop your own robust keywording strategy.

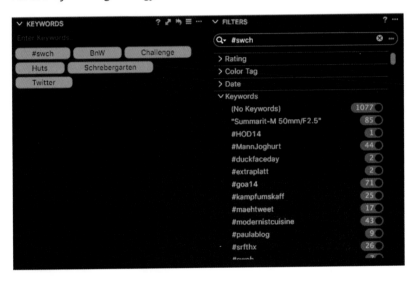

12.5 Assigned keywords (left) are displayed in list form in the Filters tool (right). Use the search field to find specific terms.

Basically, there are two ways to assign keywords to your images. You can drag-and-drop one or more image files onto the corresponding term in the Filters tool (see section 4.6); or you can add new or existing terms using the Keywords tool by either typing the terms into the text field or choosing them from a list of existing keywords collected in sets. Since the release of Capture One 9, the second option has become the preferred one—Phase One completely overhauled the rather basic set of keywording options and functions found in previous versions.

Capture One Pro bundles keywords in Keyword Libraries: sets of terms already used in either your catalog or session (called Catalog Keywords or Session Keywords, respectively); sets imported from vocabulary lists and other DAM systems, such as Media Pro; and sets you assemble inside Capture One yourself. Keyword Libraries structure your keywords, which makes it easier for you to stick with your preferred spelling and keyword choices. □ 12.6

You can also use the master image method described in the previous section to apply keywords to multiple images. As of this writing, this function does not allow you to choose which keywords you copy and paste; it's all or nothing—copy all of the keywords assigned to the master image, and paste all of them to the secondary images. However, unlike earlier versions of Capture One, version 9 merges already existing keywords with the ones you copy and paste. For example, if you previously added a person's name

12.6 The Keyword Library holds all of the keyword collections you've created inside the current Capture One catalog or session, those you've imported from a different Capture One catalog or session, and (controlled) vocabularies you've integrated into your workflow. Via the tool's Action menu, you can export keyword sets you've created as Plain Text files to move your keywords to different Capture One installations or other DAM systems, or to prune and simplify your keyword choices using a text editor.

to an image as a keyword, the name will not be removed when you copy and paste a whole slew of different keywords from another image file to that same image.

12.7 *You've tagged an image with a speaker's name (image on the left), then tagged another image with general keywords describing the situation (image in the middle). If you paste these general keywords to the first image, the already existing keywords are retained, and the terms are merged (image on the right).*

IMPORTANT

You should develop a robust keywording strategy by sticking to the suggestions made by the autocomplete feature or the keywords you've collected in a Keyword Library set. This makes it far easier to stay on top of your image collection. For example, if you've labeled all of your monochrome images "BnW" in the past, **stick with it** and don't use "BW" or "Mono" for new images. It is also a good idea to collect terms you often use in sets, such as those for animals, types of houses, or vehicles. This way you don't have to remember what terms you used three years ago or whether to tag an image with "bicycle" rather than "bike" or, if you're of a French persuasion, "velo." The Keyword Library feature makes it easy to minimize keyword clutter, keeps autocomplete suggestions manageable, and helps you find specific images quickly and reliably.

Hierarchical keywords are nested and help define the content of an image more precisely—for example, cat > mammal or USA > New York State > Orange County.

Regarding keywording strategy, the first decision you need to make is whether or not you want to use hierarchical keywords. ⬚ 12.8

Naturally, it's up to you to decide which approach to use, although the type of photography you pursue will make a difference, too. For instance, it makes sense for wildlife photographers to assign keywords that match the biological classification *Order > Family > Genus* (e.g., mammals > great apes > bonobo). It gets trickier if you photograph subjects that are more difficult to classify hierarchically. Portraits, for example, can be classified in any number of ways: *male > upper body > monochrome* or *wedding > happy couple > bridegroom* are just two examples that illustrate how diverse such classifications can be.

12.8 *A hierarchical keyword system is simpler to navigate but requires more discipline at the creation stage. A nonhierarchical structure is less tidy but easier to fill out.*

IMPORTANT

In Capture One 9's Keywords tool, all terms are shown as bubbles—hierarchically nested keywords are split up, so the representation of keywords is "flat." To see the position a specific keyword holds in the hierarchy, hover your mouse over the desired term, and the hierarchy will appear in a tooltip balloon. In the Keyword Library tool, all terms are shown in their hierarchical position.

Virtually any description can be nested, but the real question is whether it makes sense to YOU to do so. Some people like to keep things neatly structured, whereas others find labeling everything limiting. And others take issue with having to classify things to begin with and prefer nonhierarchical (flat), descriptive labels. If you decide to use a hierarchical system, you need to stick to it religiously. Mixing individual, ad-hoc keywords with a systematic approach makes it extremely difficult to find all of the relevant images later on.

QUICK TIP

Regardless of whether you use a hierarchical or nonhierarchical keyword system, you should always differentiate between the genre and content of your images. Use keywords to describe content and the IPTC Category field to describe the genre. This makes it easier to find appropriate keywords and locate all of the images that belong to a specific category. Words like "lovers," "umbrella," "romantic," and "dog" are keywords; "Street Photography" is a category.

12.9 *To create nonhierarchical keywords with multiple terms, separate terms using commas or the Return key. To create a hierarchy, separate terms using chevrons (< or >).*

Enough about theory; let's talk about how you go about assigning keywords in Capture One Pro. As described above, there are two main methods: you can use either the Filters tool or the Metadata tool tab with its keywording tools. The former is ideal if you use very few keywords and want to

assign existing keywords to multiple images on the fly; the keywording tools found in the Metadata tool tab are better suited for creating new hierarchical structures, adding lots of new nonhierarchical search terms, or managing huge keyword sets.

Follow these instructions to create and apply keywords:

- To create a new keyword, simply type it into the text field in the Keywords tool. The keyword is then added to all of the images currently selected in the Browser. To remove a keyword from selected images, hover the mouse over the tag and click the popup X.
- To add multiple nonhierarchical keywords, separate each term with a comma—for example: house, wood, flame, fire department. This approach is great for creating chains of associated terms that describe the content of an image. Capture One offers autocomplete suggestions whenever you begin to enter a keyword, and you can select a suggestion by using the up/down arrow keys and pressing Return. Using the autocomplete suggestions is quick and ensures that you stick to the same spelling for all of your keywords.
- If you need to create a new hierarchy from scratch, separate terms using chevrons. Use the orientation of the chevrons to indicate the direction in which you are classifying the terms—that is, if you're classifying terms from broad to narrow use the > symbol (accident > fire > house > wooden). Here too, Capture One makes suggestions that you should follow to keep your keyword structure consistent.

> Capture One supports hierarchical keywords when importing Aperture and Lightroom libraries, but sometimes has issues if the keywords contain special characters, such as German umlauts or Icelandic characters. If you suspect this applies to you, import a test library before importing your entire archive (see section 4.11 for details on how to do this). If your test reveals issues, try replacing all of the special characters before you begin the import process.

Unlike other DAM systems and library programs, Capture One 9 allows sorting of keywords: The order in which you organize the keywords by drag-and-drop will be retained even when exporting an image using the Processing tab. Why is this worth mentioning? When uploading a processed image to flickr or 500px, for example, the order of the keywords is kept in place. You can thus make sure that keywords you value highly or that are important (say, for marketing purposes) are listed in first place, rather than alphabetically reordered or randomly listed. This can be useful even if you don't plan to upload images to the web. Say you own and use older manual lenses and the camera doesn't record the make, aperture, or focal length, but you want to add this information as keywords for use when searching in Capture One. Ordering the terms in a sensible way such as "Make, Model, Focal Length, Aperture" makes it easier for you to scan for these specifics.

12.10 *Better than alphabetical ordering: Sorting your keywords inside Capture One makes sure that all information that belongs together stays together, even when using nonhierarchical keywords.*

QUICK TIP

This chapter only scratches the surface of keywording strategies. If you want to delve deeper into the topic, I recommend Peter Krogh's ***The DAM Book: Digital Asset Management for Photographers,*** 2nd edition (2009, O'Reilly Media). The book is based predominantly on Photoshop and Media Pro, but the strategies it discusses are just as valid for other DAM applications, including Capture One, of course.

12.3 Metadata Compatibility and Third-Party Applications

To ensure the compatibility of keywords, ratings, creator information, and copyright data, Capture One uses the XMP (Extensible Metadata Platform) standard. XMP defines how metadata is saved but not the type of data.

Capture One organizes and synchronizes metadata via XMP but sticks to IPTC standards for the individual terms.

XMP was developed by Adobe to create, manage, and share metadata between multiple types of digital files and applications. Today, XMP has become an ISO standard and is widely used in commercial and open source software.

XMP metadata is usually saved in a reserved portion of a file (in the case of DNG, JPEG, PSD, and MP3 files), or in a separate "sidecar" file (as is the case with most RAW file formats). Sidecar files carry the .xmp filename extension. Because Capture One never alters your original image files, it always saves metadata to XMP sidecar files or simply saves it in the current session or the library.

VERY IMPORTANT!

If your images archives contain XMP files, don't delete them. Depending on which program you use, these tiny files contain everything from ratings and library data to face-recognition tags to complete sets of edits and adjustments. If you need to get rid of XMP files, make sure that the data they contain is saved elsewhere (in your image database, for example), and *always* make a backup before deleting them.

Capture One uses the IPTC Core and Extensions guidelines to define the names and permissible content of its metadata fields. It doesn't save develop settings or Smart Album data to XMP sidecars or to the XMP data block in exported JPEG and TIFF files. This means that all common operating systems and third-party applications can completely and reliably interpret Capture One metadata.

12.11 Keywords assigned within Capture One are saved in XMP sidecar files and can be reliably interpreted by OS X (on the left) and Windows.

Unfortunately, the IPTC Core recommendations don't cover all the types of data that are nowadays common to most image management programs.

Color tags are not defined, so software manufacturers have to use IPTC Extensions to cover the deficit, and this is where the confusion begins. Many manufacturers look to the market leader Adobe for guidance, whereas others assign additional numbers (1 = yellow, 2 = red, and so on) to the XMP terms or use control characters instead. As soon as programs from different manufacturers attempt to communicate, these varying approaches virtually guarantee that errors will occur.

As described in section 1.7.2, your Preferences settings determine how Capture One handles metadata and XMP sidecar files. If you decide against automatic metadata synchronization, you can still read metadata assigned using a third-party program and save new metadata in XMP sidecar files using the action menu in the Metadata tool.

You can automate metadata loading and writing to XMP sidecars for an entire session/catalog or for selected image files.

12.12 *Use the commands in the Metadata tool's action menu to reload or sync metadata.*

- **Reload Metadata:** All metadata from the sidecar or XMP block of the selected image(s) is loaded into the current catalog or session. Any alterations you have made in Capture One will be overwritten.
- **Sync Metadata:** The opposite of the previous item—the current metadata in the selected image(s) is written to an XMP sidecar file.
- **Reset Metadata Completions:** Following a warning dialog, this option deletes the contents of the auto-complete memory.

13 The Output and Batch Tool Tabs

13.1 *Not surprisingly, output is the final step in the workflow pipeline.*

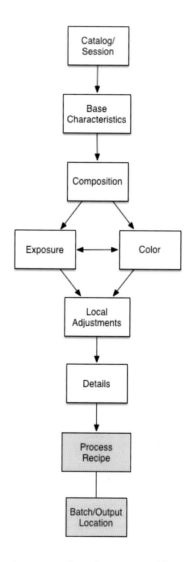

Capture One creates image copies when you publish an image or hand it over to a third-party application for further processing. This part of the process is handled by the Output tool tab, and the Batch tool tab lists all images that are ready for export or that have already been exported. This chapter explains what *process recipes* (also known as output recipes) are

and how to use them to create multiple copies of a single image. It also looks at how to find out what went wrong if your output doesn't look the way you expect.

13.1 Creating and Managing Output / Process Recipes

Once you've processed your images, you'll want to share them, either as prints or digitally on flickr or 500px, via social media platforms, or at home on an HD TV or a tablet computer. In the case of commercial work, most clients won't know how to deal with raw files and Capture One settings, so you'll usually have to provide them with a CMYK or RGB bitmap file that incorporates all of your adjustments and settings. For the purposes of this book we will call these files "copies."

Process recipes govern the size, format, naming conventions, and metadata handling for your output.

You can create a copy at any stage in the Capture One workflow. All you have to do is select an image in the Browser and select the Export Images > Variants command in the File menu. This opens the export dialog.

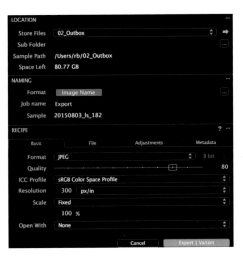

13.2 The contents of the export dialog (left) are very similar to those of the Output tool panels (right).

Process recipes are used to save your export settings for later use with other images and can be stacked (that is, you can use multiple recipes simultaneously). To output images, select them in the Browser, switch to the Output tool tab, select one or more suitable recipes and click Process. ☐ 13.3

The Output tool tab is split between the Process Recipes and Output tools. Check the boxes in the Process Recipes panel to select the recipes you wish to apply. The active recipe is highlighted in gray and is the one you selected in the Output option in the Crop tool (see section 8.1.1) or by using the View > Proof Profile > Selected Recipe command. The tool's action menu enables you to create new recipes and delete or tweak existing ones.

13.3 Manage your recipes in the Process Recipes tool.

13.4 The action menu contains a list of recipes supplied with the program. The same list is revealed by clicking-and-holding the "+" button in the Process Recipes tool panel.

The lower part of the Output tool tab contains a set of output tools. The settings in the Process Recipe and Process Summary panels only affect the active, gray-highlighted recipe, whereas the settings in the other two affect all the recipes in the list (that is, they function globally).

The settings you make here determine how Capture One names and saves your images when you export them.

> The tools used to define recipes are also available as options in the export dialog, which performs the same job as the output tools on the fly. I recommend that you use the Output tool tab to make your settings.

13.2 The Process Recipe Tool

The settings for format, size, color profile, and so on form the core of every recipe.

The name of the Process Recipe tool differs by just one 's' from that of the Process Recipes tool so, to avoid confusion, we'll call it the Recipe tool from now on. The settings you make here form the core of successful image output and are the only ones that vary from recipe to recipe. The settings in all the other tools in this panel apply to all the recipes in the list.

13.5 The Basic tab for the active recipe

To cover the huge range of options it offers, the Recipes tool is separated into Basic, File, Adjustments, Metadata, and Watermark tabs.

The Basic tab includes the following settings:

- **Format:** Choose between 8 and 16 bpc (bits per color channel).
- **Quality:** This setting determines the level of compression when you output your files as JPEG. The higher the setting, the less compression is used (i.e., the better the quality of your processed JPEGs).

- **ICC Profile:** By default, Capture One offers sRGB and Adobe RGB, which are the two most common profiles used with RGB bitmap files. If you need to deliver your wok with a different profile (for example, a CMYK profile for offset printing), select the Show All option in the menu to list all the profiles currently installed on your computer. Capture One cannot manage profiles directly, so you need to use the ColorSync utility (Mac) or Color Management module (PC) to add, alter, and delete profiles.
- **Resolution:** The default units are pixels per inch (px/in), and the value you select is applied only if you select a corresponding Scale value (see the next item)—otherwise, the Resolution value is written to the file's metadata.
- **Scale:** As well as outputting your files at their original size, you can scale them up or down. You can enter width or height (or both) and Capture One scales your file accordingly. If you select a unit other than pixels (px), Capture One incorporates the Resolution value you select to ensure that the scaled file contains the corresponding number of pixels. □ 13.6
- **Open With:** Copies are stored by default in the Output folder, but you can opt to have them automatically opened in a separate application (mail, Photoshop, or SilverEfex, for example). We'll discuss these options in more detail in chapter 15.

13.6 In this example, our image will be output with a length of 100 cm at 300 px/in, resulting in a 49-megabyte file that is 11,000 pixels long.

The File tab is important if you want to simultaneously apply multiple recipes. Here, you can enter a different output location from the one you entered in the Output Location tool (see section 13.3), which helps you sort your images into separate folders if you're outputting various sizes (for on-line viewing, DVD archive, iPad display, and so forth). For the active recipe, this setting has priority over the one in the Output Location tool. □ 13.7

13.7 The File tab in the active recipe

> **QUICK TIP**
> The File Icon check box determines whether an embedded thumbnail is created with your output file. By default, Capture One creates its own thumbnails the first time it opens a folder, but this option comes into play if you're using an unusual file format such as JPEG 2000 or DNG for which a client's computer cannot necessarily create an automatic thumbnail preview.
> On the other hand, embedded thumbnails are simply ignored by most online applications, so the disk space they use is a waste. Unchecking the File Icon option keeps your outputted files as small as possible.

The Adjustments tab determines whether your crop and sharpening settings (see chapters 8 and 9) are included or ignored in your output—checking each option switches the corresponding settings off. □ 13.8

13.8 The Adjustments tab in the active recipe

13.9 *The Metadata tab in the active recipe*

13.10 *The Watermark tab in the active recipe*

These options determine which metadata fields are embedded in your output. Think carefully about what your client really needs to know and deactivate the options accordingly. It doesn't always pay to let a client know how you rate the image you have just sold, and you may not want to tell Facebook the precise geolocation of your garden. If you're in any doubt, too little metadata is always better than too much. You can always add more tags later if necessary, but tags that you've already published or shared aren't going to disappear any time soon. ◻ 13.9

Some people hate watermarks whereas others never upload an image without one. For watermark fans, Capture One can automatically create or embed text and image watermarks during output. All you have to do is type your text, select a suitable font, and position the watermark the way you did using the Overlay tool (see section 8.4). If you prefer to use a logo, switch to Image mode and proceed as described for a text watermark. ◻ 13.10

13.3 Output Location

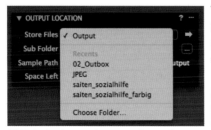

13.11 *In Session mode, output is saved automatically to the Output folder (see section 4.2). In Catalog mode, you can choose where to send your images.*

The Output Location tool determines where your copies are stored. Capture One automatically enters the previous five output folders in the Store Files drop-down list. To add a subfolder at your chosen location (perhaps to keep work for a specific client separate), type a name into the Sub Folder box.

13.4 Output Naming

The Output Naming tool enables you to decide whether and how you re-name your files for output. By default, Capture One gives outputted files the same name as the raw original, but this won't always be what you need.

Renaming uses the token system described in section 4.4.

13.12 *Giving output files a new name*

> **QUICK TIP**
>
> Always give images you share a new, meaningful name. This helps you keep track of the images you have outputted. A filename like theater-festival-2015 is a lot more useful than 20150320-006. You can save a lot of time if you use presets to rename images for regular customers.

You can use tokens to number your images, too (theater-festvial-2015-01, theater-festvial-2015-02, and so on). The counter continues where it left off when you switch tools or restart Capture One. To reset it, use the Reset Output Counter command in the tool's action menu.

13.13 *The action menu enables you to set start and increment values for the output counter, and reset it if necessary.*

13.5 The Batch Tool Tab: Queue and History

The Batch tool tab lists images that are queued for output and copies you've already made, and contains no other tools.

13.14 *The Batch tool tab contains Queue and History tabs.*

The only options are halting the queue...

13.15 *Stop!*

... or clicking on Reprocess Selected.

13.16 *If you accidentally delete a copy, the Reprocess Selected button puts things right.*

QUICK TIP

Although its functionality appears unimportant at first, the Stop button in the Batch tool tab is the fastest way to halt the queue if you click the Process button too soon and find yourself waiting forever for processing to finish.

14 Tethered Shooting

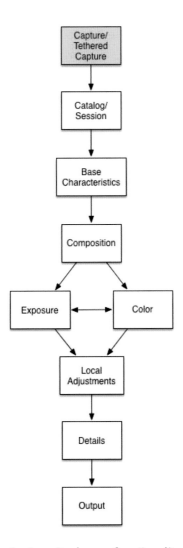

14.1 *Like image import, tethered shooting is the very first step in the workflow pipeline and provides the raw material for all the steps that follow.*

Tethered shooting is Capture One's core functionality and the reason the program has the word "Capture" in its name. Tethered shooting means transferring images via a cable from the camera to your computer without saving them to a memory card.

This chapter discusses the functions and options available for tethered shooting and also introduces a number of best practices for tethered shooting in a studio environment. We'll also take a look at the Capture Pilot iOS app, which offers much more than just a convenient way to keep your client quiet while you work.

14.1 Getting Started

Plan your shoot thoroughly before considering which hardware and software to use.

Before you plug your camera into your computer, you need to consider what you want your tethered shoot to achieve. The most obvious use for the tethered approach is to circumvent the image import process (see section 4.4), while in its most complex form, it represents the first step in a complete, automated imaging workflow (see section 15.3) that involves a team of specialists and your client. Begin by answering the following questions:

- Will I process the images on my own or will others be involved on location?
- Will the client be present, or do they expect delivery of finished images at a later stage?
- Will the session produce hundreds of images or just a few?
- Is time limited (perhaps because the model has another appointment) or will I be shooting all day?
- Will I have time to process the images later, or will I have to bring a printer along?
- Is the lighting controlled, and will I have time to meter it and set up the camera accordingly? Or will I have to keep checking my exposure parameters?

These initial planning steps are just as important as packing your bag and finding the right cables, so take your time.

In addition to general planning, you have to consider which hardware to use. As well as a computer and Capture One, you need to decide which other accessories you need and how to handle them. Experience has taught me the following best practices:

- Always use well-made, high-quality cables. If you aren't sure which ones to use, stick to the recommendations made by the camera retailer or rental agency.
- Cables should be as long as necessary and as short as possible. Avoid tripping hazards wherever you can in the studio and on location. It's

always better to use a cable that's a foot too long than one that drags on your expensive gear and increases the risk of accidents.

◉ If possible, use cable and connector locks. Loose connections are annoying on a tethered shoot.

◉ Always keep some spare memory cards handy—you may need to capture one or two handheld shots after all. If you do save images to a memory card, import them after the shoot and not during it.

◉ If you're shooting on location, always check that the cables you pack fit your computer. There's no point in packing a high-end FireWire 800 cable if your computer only supports FireWire 400. Don't use adapters—always use purpose-built cables if you can.

◉ Deactivate your camera's sleep and standby functions. In theory, Capture One can continue working when a camera wakes up, but experience has shown that the process of reestablishing a connection isn't always reliable.

◉ For the same reason, deactivate your computer's screensaver, energy saving options, and auto-sleep functions. If you use a Windows computer, deactivate the "Allow the computer to turn off this device to save power" option for the camera connection.

◉ Capture One sessions are designed from the ground up with tethered shooting in mind. Even if you prefer to work with catalogs, a session is the better option for a tethered session. See section 14.2 for more details.

◉ If you're shooting on location or at a client's site using Capture Pilot, test the Wi-Fi hotspot you'll be using. Connections that work fine in the studio are often less reliable in the field. Use your own hotspot device on location, even if the client offers you local network access.

○ Obviously, you need to charge all of your batteries and make sure you have a reliable power source for your computer. If the client suddenly decides you need to shoot out of doors or if all the sockets in the room are being used, extension cables and even a generator are extremely useful to have around.

> **QUICK TIP**
> Many of these considerations may appear obvious but are easy to forget in the heat of the moment. The list isn't exhaustive, and you're sure to make your own additions depending on how you work and the type of job you're doing. Use my list as a basis for your own checklist and update your list after every job or every time something occurs to you that you don't want to forget. After a few dozen shoots, you'll find that a comprehensive checklist saves you a lot of time preparing for the next job.

14.2 All About Tethered Sessions

Sessions are optimized for tethered shooting, although Capture One can also shoot tethered in catalogs.

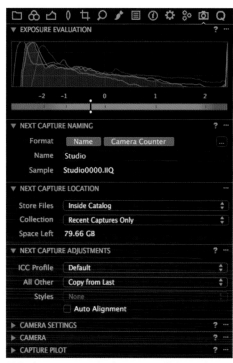

14.2 *The Capture tool tab contains all the tools you need for a tethered session, whether in Catalog or Session mode.*

The Capture tool tab is part of the Catalog and Session interfaces, and you can shoot tethered in a catalog if you want.

However, there are various reasons for using sessions rather than catalogs for tethered shooting. Not all of these will be valid for your own workflow, but the thoughts behind them are still worth considering:

○ A shoot is usually an isolated event that is over the moment you unplug your lights or the model leaves the scene. Sessions bundle all of the data associated with a shoot in a single folder, thus reducing the risk of losing individual settings and profiles (see section 7.4), or accidentally mixing up the results of separate jobs. Every session has its own trash folder, making it simple to find deleted images without having to plough through a catalog's "global" trash.

○ You don't have to manage your images while you shoot and you can concentrate completely on your work. You don't note keywords or the names of collections while you shoot handheld, and the same is true for a tethered session. In this case, the computer *is* the memory card and doesn't need to be occupied with catalog and database tasks while you shoot.

○ Captured images are saved in easily accessible, standardized folders that you can share with other members of the team via a network. A standardized folder structure also makes it simple to automate copy and backup routines using macros or AppleScript (see section 15.3).

⊙ Session mode enables you to bundle all additional XMP sidecars, and develop settings and LCC profiles with the original image in an EIP file. EIP files can then be sent as attachments, shared on a network, or imported into a catalog (see section 4.3).

⊙ Sessions were developed for precisely this type of scenario and have proved their dependability over years of use. Although version 9 is the third version of Capture One to include Catalog mode, sessions are still the most reliable way to use the program when shooting tethered.

So you've decided to use a session and you're ready to get started (see section 14.1). How do you set up Capture One so that you can go ahead and begin shooting?

1. Start Capture One, open a new session, and switch to the Capture tool tab.

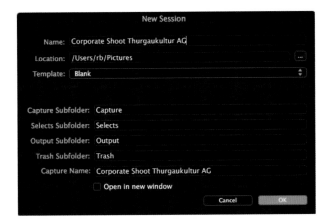

2. Connect your camera and switch it on. In most cases, Capture One will automatically identify the camera and display its details in the Camera tool panel. If your camera isn't automatically displayed, select it from the drop-down list.

Your camera is now attached and ready to go. To capture an image, click the large circular Capture button in the Camera tool or the camera-shaped button in the toolbar. The following sections go into more detail on the individual tools in the Capture tool tab.

> **IMPORTANT**
>
> For tethered shooting to work at all, Capture One has to support your particular camera model. Unfortunately, it doesn't support tethered shooting for all cameras whose image formats it can process. For example, as of this writing, it supported image processing but not tethering for the Sony a77; raw processing and tethering for the a7; and processing, tethering, and Live View for the a7II. The list of supported cameras and formats is constantly being updated and is available online at www.phaseone.com/supported-cameras.

14.3 Capture Location, Collections, and Naming

In a tethered session, your computer takes over the memory card function while the memory card itself is used either as a backup or is simply ignored, depending on which camera you use. This means you have to decide where to save your images and how you wish to name them before you start shooting. You can opt to save your images in a new collection or simply leave them in the session's Capture folder.

14.3 These two tools define where your captures are saved and how they're named.

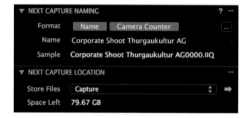

The Next Capture Naming tool uses the familiar token system used in the Import Images dialog (see section 4.4) and the Output tool tab (see chapter 13). The action menu contains the same counter settings as the Output action menu as well as additional Preferences and "Pair RAWs and JPGs" options.

14.4 The action menu in the Next Capture Naming tool is accessed via the familiar three-dot button.

- ◉ **Pair RAWs and JPGs:** You can decide whether to capture RAW or JPEG images, or both. This option displays corresponding pairs of images in the Browser, with the JPEG classified as a variant of the RAW version.

◎ **Preferences:** Opens the Capture tab in the Preferences dialog.

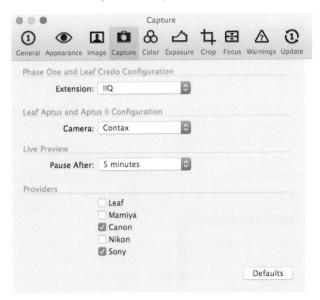

14.5 *Use the Preferences dialog to select which camera(s) you wish to use, the length of the pause between live previews, and the filename extensions you want to add to files captured using Phase One cameras.*

QUICK TIP

The options you activate in the Providers section of the Capture tab determine which camera interfaces the program loads at startup. Select only the manufacturers you really need—loading interfaces that aren't required increases the risk of bugs or mismatches during capture and slows the application down at startup. *Don't* deactivate cameras you use in nontethered situations, as this can cause issues when processing raw images you import from the camera's memory card.

The Next Capture Location tool defines where your tethered images are saved. The default setting is the current session's Capture folder, but you can select any other folder via the drop-down menu. If you're using a session, make sure your capture location is within the session folder (see sections 4.2 and 14.2).

14.4 Applying Automatic Adjustments during Capture

As its name suggests, this tool defines which basic adjustments are automatically applied to the *next* capture. These include the ICC profile (see section 5.1) and Styles (see sections 4.4 and 11.1).

14.6 *The Next Capture Adjustments tool defines which basic adjustments are automatically applied to freshly captured images.*

The settings you make here affect the *next* image, not the one you can already see in the Viewer. The tool helps you decide when to adjust your basic capture settings to alter the feel of the session. To make adjustments to an image you've already captured, select it in the Browser and use the tools discussed in previous chapters as you would for a nontethered shot.

The options in the ICC Profile drop-down list are Default (the program default for the current camera), Copy from Last (the profile selected in the Color tool tab), and Copy from Primary (the profile used for the current primary image).

The All Other drop-down list (that is, all other options apart from the ICC profile) offers various options for applying styles and presets.

14.7 The All Other drop-down list provides options for applying styles during image capture.

The default option is Copy from Last, and this does exactly what it says, applying the settings from the previous capture to the next one. If you apply a style or preset to the previous image, it will be automatically applied to the next one, too. The options available in the All Other drop-down list are as follows:

- **Defaults:** Capture One applies the default tool settings you have defined for the current camera (see section 1.6).
- **Defaults with Styles:** Same as previous but including styles selected from the Styles drop-down list (see chapter 11).
- **Copy from Last:** This applies the tool settings from the previous image to the next one.
- **Copy from Last using Clipboard:** Same as previous. The applied settings will also be copied to the Adjustments Clipboard (see section 11.2).
- **Copy from Primary:** Applies the settings from the primary image selected in the Browser.
- **Copy from Primary using Clipboard:** Same as previous. The applied settings will also be copied to the Adjustments Clipboard.
- **Copy from Clipboard:** If you review your images and find a look that you want to apply to the next capture, copy the settings from the image to the Clipboard and use this option.

The Auto Alignment option ensures that Capture One displays captured images in portrait or landscape format according to how they are captured. It also applies an automatic Keystone adjustment to supported cameras (see chapter 8 for more details).

The All Other menu can be confusing for beginners, so take time to familiarize yourself with how it works. The options are so complex that Phase One uses videos to deal with support queries for this particular tool.

14.5 Camera Control

Now that we have prepared the session, let's look at the tools we use to actually work with the tethered camera. These are Exposure Evaluation, Camera, and Camera Settings.

14.8 *The All Other drop-down list provides options for applying styles during image capture.*

Use the Camera tool to set basic shooting parameters such as ISO sensitivity, white balance, and aspect ratio. Some cameras even enable you to use a full-frame sensor in crop format—in this case, only data from the center portion of the sensor is captured in the raw file.

The functions offered by Capture One depend on the camera you use. For example, if Capture One doesn't support live view or manual aperture settings for your particular model, you can't select the corresponding option.

14.9 *The Live View window provides various options to help you adjust your composition, optimize the aperture setting, and set manual focus.*

The Live View Navigator is a great tool for studio work. Activate it by clicking the movie camera button in the Camera tool panel or using the Window > Live View command.

The Live View window is a bit like a miniature version of the Capture One interface. It has its own Info and Controls panels as well as a Navigator (see chapter 9) and a dedicated toolbar with its own Pick White Balance tool (see section 5.3). Also included are Live View, Focus (see section 9.1), and Overlay tools (see section 8.4). Live View is designed to help you optimize image composition, focus manually, and set the right aperture and exposure time (see section 5.2) without having to take and evaluate test shots.

> **IMPORTANT**
>
> Settings you make in the Live View window only apply to the live view and not to the raw images you capture. You have to make adjustments either in the camera or later using Capture One's built-in tools.

14.10 *If it supports your camera, the Camera Controls tool enables you to make basic camera settings from within the Capture One interface.*

The settings available in the Camera Controls tool are the same as those you can make in the camera itself, including flash mode, exposure mode, aperture, and exposure time. The available options depend on your camera model and the lens you use.

Once everything is set up, you can press the shutter button on the camera or click the Capture button in the Camera tool panel. The captured image is displayed in real time in the Browser and the Viewer.

> As previously discussed, tethered shooting is the aspect of working with Capture One that has most to do with the real, physical world and is difficult to describe in text form. If you want to delve further into the world of tethered shooting, participating in a workshop on the subject is a worthwhile investment.

14.6 Capture Pilot: Not Just for Studio Use

Phase One surprised its users in 2011 when it introduced the Capture Pilot app. Originally intended for displaying images from a tethered session on a second screen, it gave other members of the team (or the client) something to look at while you continue working undisturbed on your main computer.

Capture Pilot is a great way to remotely control tethered sessions, but the app has other uses within the Capture One workflow as well.

14.11 Capture Pilot running on an iPad (left) and in a web browser (right). The iOS version is more powerful, but both are fine for viewing and rating images on any smartphone or computer.

The app was an instant hit, especially with studio photographers, and has since been further developed to include tools for rating, tagging, zooming, rotating, and panning images, as well as a number of camera controls. Although the app itself is only available for iOS, its Web mode enables you to view and rate images on any device running any operating system.

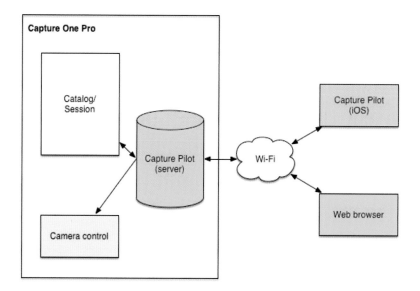

14.12 Capture Pilot uses a Wi-Fi connection to give iOS-based devices and web browsers access to selected images located on a server.

Capture Pilot accesses images via a server that you set up on your main computer and share via a local Wi-Fi network. This enables the iOS-based app or any web browser to access shared images. The following steps explain how to set up the server:

1. Open the (tethered) session or catalog that contains the images you want to share.
2. Switch to the Capture tool tab and expand the Capture Pilot tool panel.

3. In the Basic tab, give the server a suitable name and, if necessary, a password. Use the Folder drop-down list to select the folder you want to publish. In a tethered session, these are either the Capture folder (that is, all your photos) or the Selects folder (your selected key images). The Publish To drop-down menu gives you options for publishing to your mobile device, the web, or both.

4. The Mobile and Web tabs enable you to give users access rights that enable them to rate and tag images. You can also allow Capture Pilot users to remotely adjust and capture images.

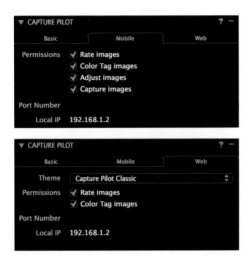

5. Click the Start Image Server button at the bottom of the Basic tab. Web browsers and devices running Capture Pilot can now access your selected images via the IP address displayed in the Mobile and Web tabs. Click the "envelope" button at the bottom right in the Basic tab to send an email invitation to your team, your client, or anyone else you want to share your images with.

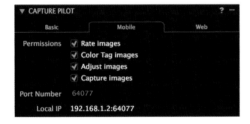

Although it's simple to set up, note the following points when using Capture Pilot and the Capture One Image Server:

- Changes made to ratings, tags, and image files (iOS clients only) are applied and displayed in real time in Capture One. Conversely, changes you make in Capture One are also displayed in real time in the iOS interface.
- Capture Pilot only works on local Wi-Fi networks, not via the Internet. iOS devices cannot access published images on a wired network.
- If your local network requires you to open specific ports manually, you can do this in the Mobile and Web tabs.
- The camera controls in the iOS version of the app are limited to aperture, exposure time, and ISO. The app displays the last captured image, not a live view.

Rating and Rejecting Images Remotely

Even if you rarely shoot tethered, the Image Server and the Capture Pilot app can still make your photographic life simpler—perhaps by viewing and sorting images from the comfort of your sofa or showing your partner your vacation photos without having to output them first (see chapter 13).

14.13 You don't have to sit down at your main computer to view and rate images.

A local Wi-Fi network is the ideal medium for accessing your work remotely. Why not start an image server for your current catalog or collection and view and rate your images from the comfort of your sofa using an iPad, a netbook, or a smartphone? Your back, and possibly your partner, will thank you.

15 Using Capture One with Third-Party Software

Capture One was originally designed for use with other programs, and sessions (with their predefined session folders) still represent a simple way to share selected raw files and finished TIFF, JPEG, or PSD copies with other applications. Finished copies can be accessed using filesystem operations or automated using the sync functionality in a media database. An automated system ensures that every time a finished copy is sent to the Output folder, it is automatically imported into your DAM system, for example, or opened in Photoshop. Macros and scripts enable you to scale images for attaching to emails or upload to a photo-sharing website, and can also be used to perform more complex tasks such as transferring the contents of a specific folder to a designated server every time the folder's contents change. Capture One started life as a "plain" raw converter that formed a single link in the raw processing chain, and today's Session mode still mirrors those roots.

The introduction of catalogs in version 7 made things a little more complex and positioned Capture One as an image management package. The managed files are still stored in "real" folders, but not always together with their associated metadata and develop settings (see section 4.2). A default output folder like the one in a session folder doesn't exist in Catalog mode, making it more difficult to use macros and scripts to automate processes. Additionally, you can't open random files in a catalog, and images have to be imported before Capture One can do anything with them. Catalogs aren't designed to work with third-party database or DAM software.

This chapter looks at ways of integrating Capture One into a multi-application workflow, either as the key element (see section 15.2) or as a link in the raw processing chain (see section 15.1).

15.1 Image Databases and DAM Systems

Maybe you already use an image database or work within a sophisticated editorial/DAM system that manages all your images, videos, and other documents. Or perhaps you want to switch from Lightroom to Capture One for editing purposes but you still want to manage your files in Lightroom. Or perhaps you simply can't stand Capture One's Catalog mode and prefer to use a third-party solution such as Media Pro, Apple Photos, or Adobe Bridge to manage your images.

If your workflow includes a third-party database or DAM software, you're better off using Capture One in Session mode.

There are plenty of reasons to use a third-party database instead of Catalog mode, and this is where Capture One sessions (see section 4.1) come into play. Sessions leave image management to the software of your choice and transform Capture One into a "pure" raw developer and image-editing suite. If you take this approach, you have to decide which role Capture One plays within your workflow:

1. It is your main raw converter. You develop and edit all of your images in Capture One but leave managing your originals and copies to a separate database.
2. It is a secondary raw developer that you use only when you require specific features that it provides.

And by the way, this is a good time to reread chapter 4.

If you want to use Capture One as the main entry point into your imaging workflow (scenario #1), proceed as follows:

1. Copy the images from your camera or memory card to the folders in one or more sessions. Feel free to use the built-in Import Images dialog, which saves all your metadata and develop settings within the session folder rather than in a catalog.
2. Develop and edit your images using Capture One and save your finished copies to the session's default Output folder.
3. Import all your copies and original raw files to your database.
4. If you need to alter a copy or create a new one, select the corresponding original in your database and open it in Capture One.

15.1 *Scenario #1: You develop and edit your images in a Capture One session and then export them to your database/DAM system. You can then reprocess your original raw files in Capture One as necessary.*

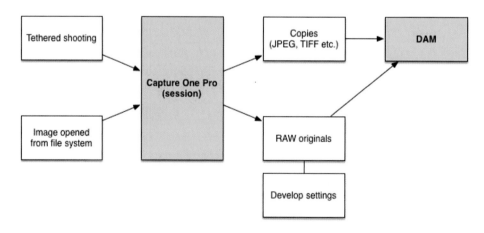

If you take this approach, you need to consider the following:

❯ Your database won't be able to display the adjustments you've made to your raw images, with the possible exception of the metadata. If you need to view your adjustments in your database, you'll have to store processed copies of your images alongside the raw originals.

- Adjustments you make in Capture One aren't embedded in the raw files and are instead stored in additional .cos sidecar files (see section 4.2). Make sure that you include these in your backups and, if you move your original files to a new location (for example, from a working disk to an archive disk), don't forget to move the sidecar files, too. Lost develop settings mean lost work!
- Assign as little metadata as possible from within Capture One and use your database to assign keywords and other tags. This saves you from having to make painstaking compatibility checks and experiment with metadata and XMP settings in Capture One. Make sure that tags you're likely to assign can be correctly interpreted by your database software.
- If you need to make fresh copies or you want to try out a new adjustment, synchronize the metadata in your database in XMP sidecar files (see sections 1.7.2 and 12.3). Open your images and check that the metadata from your database has safely made the transition to Capture One. If not, reload your metadata using the Load Metadata command in the context menu.

If you only use Capture One occasionally, you can follow the same steps, but begin by creating a new dummy session (see section 4.1.2) and leave all file operations—from importing to saving your finished images—to your preferred main application. In this case the original image files are not part of the session (or dummy session) and instead remain where you saved them using your main application.

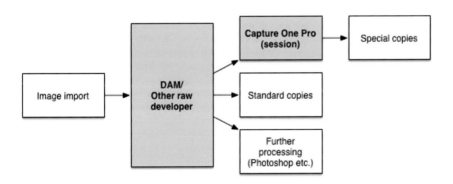

15.2 *Scenario #2:*
Your images are stored in your database or another application. Selected images are opened in a dummy session, but the files themselves remain in their original location.

What About Media Pro?

In 2010, Phase One purchased the Microsoft Expression Media software previously known as iView Media Pro and now sells it under the Media Pro banner. All of the new functions that Phase One has introduced are aimed at tightening integration with Capture One, which was originally conceived without image management and catalog functionality.

15.3 *Media Pro is Phase One's in-house media management package—or should I say "was"?*

Capture One supports Media Pro better than it supports other DAM systems. For example, you can add session albums and selected images to the Media Pro catalog via the context menu, and Capture One supports albums and collections created in Media Pro. Theoretically, Media Pro can display the current state of your Capture One edits and also knows where the adjustments you make in a session are stored. In other words, if you move or copy images within Media Pro, all subsidiary sidecar files, LCC profiles, and adjustments will be moved, too—theoretically.

In practice, Media Pro's development has often lagged behind that of Capture One, and the first version of Media Pro that worked well with Capture One 8.0 was released months after version 8.1 hit the market. And, with the release of Capture One 8.2 just a few weeks later, Media Pro once again lagged behind and no longer supported the latest preview and adjustment functionality. As of the time of writing, there is no version of Media Pro that properly works with the last version of Capture One 8 or any version of Capture One 9.

In spite of its many benefits, I strongly recommend that you use Media Pro in conjunction with Capture One as you would any other third-party image management package. Don't expect tight integration, and don't expect to see the results of your adjustments in Media Pro previews. If you move or copy files using the filesystem, make sure you move your develop settings too, and be sure to back up your sidecar files with your image files. Taking

this conservative approach will save you a lot of hassle if future Capture One updates produce new incompatibility issues or if Phase One finally decides to merge the two programs into one.

15.2 Plug-ins, Photoshop, and Other Raw Developers

As you've already seen, you can use Capture One to perform a lot of editing tasks that you previously had to perform using a separate image-processing application. However, you still have to leave the Capture One environment if you want to use plug-ins like the Google Nik Collection (such as SilverEfex Pro, Viveza, or HDR Efex Pro) or if you want to perform any kind of montage, panorama merge, or major retouching. Such tasks are still the preserve of programs like Photoshop.

To process images using plug-ins or create complex montages, you need to hand over your processed images to third-party software. It's not possible to embed plug-ins or other dedicated programs at the raw data level.

Because none of these third-party programs can interpret develop settings made in Capture One, you have to hand over finished copies of your images for further processing. This is the only way to ensure that you produce accurately processed results.

If this is the case, you can probably still process most of your images and manage them in a Capture One catalog, even if you use a different raw converter to process selected files. As discussed in section 9.2.1, cameras with Foveon sensors are not yet supported by Capture One, and it always takes a few weeks (or even months) for Phase One to produce profiles for newly released cameras (see section 1.4). Until Capture One catches up, you have no alternative but to use a different raw converter.

If your particular camera isn't yet supported by Capture One, you'll have to use a raw converter from a different manufacturer.

Fortunately, since version 8.1, Capture One includes Edit With and Open With functionality that sends images from the catalog to third-party programs.

15.4 Whether you use the Edit With or the Open With command depends on the task at hand. The commands are located in the File menu and the Browser context menu.

Edit With creates copies of the selected image(s) and opens them directly in programs and plug-ins such as Acorn, Photoshop, SilverEfex Pro, or Hugin.

15.5 *The Edit Recipe dialog is a condensed version of the standard export dialog.*

The Edit Recipe dialog contains options for image format and bit depth, enabling you to hand over high-quality 16-bit TIFFs if necessary. You can, of course, adjust these settings to suit the target application. The available settings are largely the same as those found in the Output tool tab and the export dialog, and include the Disable Sharpening and Ignore Crop options (see chapter 13).

Handing Over Images to and from SilverEfex

SilverEfex Pro was already a popular choice among black-and-white photography enthusiasts before it was purchased by Google. As mentioned in section 5.5, the program's Ansel Adams–style "zone" functionality and built-in curves for a range of analog film types make it ideal for use in a monochrome digital development environment. Many users still prefer SilverEfex to the raw-level black-and-white conversion functionality offered by Capture One. The following walkthrough is based on SilverEfex, but the same steps apply for any program or plug-in that you wish to use in conjunction with Capture One.

1. Select an image in the Browser and then click the Edit With option in the Context menu. This opens the Edit Recipe dialog.
2. Black-and-white conversions benefit from maximum bit depth in the source material, so leave the Format options set to 16-bit TIFF. Select SilverEfex in the Open With drop-down list. Although it is available as a Photoshop and Aperture plug-in, SilverEfex also works as a standalone application.

3. Click Edit Variant to create a copy of your image and open it in SilverEfex.

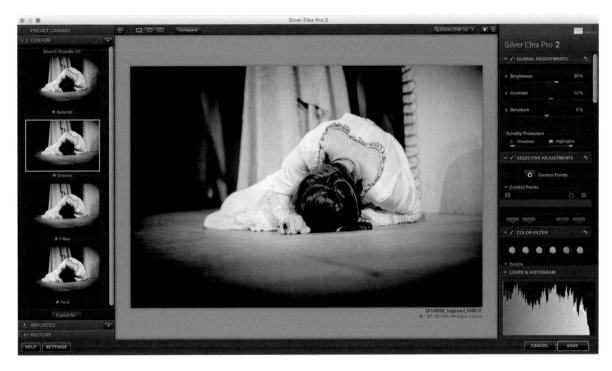

4. Edit your image, save it, and quit SilverEfex.

Capture One automatically imports the SilverEfex version of your image and displays it next to the raw original in the Browser. You don't have to know where the new copy is stored and you don't have to import it manually into the catalog.

Open With opens the raw original in your selected application. Because Capture One develop settings are proprietary, this means that none of your adjustments are handed over with the image file. Additionally, because Capture One doesn't know where your third-party application saves edited versions of the file, it cannot automatically reimport them into the catalog.

If Edit With is comparable to a round-trip, Open With is like emigrating to a foreign country.

> **QUICK TIP**
> The Open With command is useful only if you want to hand over your original raw files to your third-party application and only occasionally process the results in Capture One. This may be the case if you sometimes use a camera that isn't supported by Capture One but you still need to manage its raw and copy files in the catalog. Note that you can use Open With to send raw files to any application that's installed on your computer, whether FTP, mail, a database, or any other image-processing program. Using Open With is a quick and easy way to share raw files.

15.3 Using AppleScript

AppleScript is a powerful and practical tool, but it's too broad a subject to address in a single chapter of a book like this.

Scripting is a popular tool in agencies and photo studios where automation helps to prevent the unnecessary user errors that always creep in when humans perform repetitive tasks. Capture One is compatible with various versions of AppleScript, making it simple to script individual tasks or build its functionality into applets. For example, you can use a script to:

- Start Capture One.
- Open a session.
- Display the aperture and exposure time of a tethered camera.
- Create an automatically cropped copy of each capture.
- Save a copy of each cropped image in the session's Output folder.
- Close the session as soon as the camera is switched off.

15.6 *Using the OS X AppleScript Editor to write a Capture One script*

To embed Capture One in the OS X AppleScript environment:

1. Start the AppleScript Editor.
2. Use the Window > Library command to open the library.

3. Click the "+" button and add Capture One to your library.

Capture One's classes and commands will now be recognized by the AppleScript Editor and are available to all other applications in your scripting environment.

15.7 *Capture One's function library is extremely comprehensive but is almost exclusively designed for use in Session mode.*

You'll notice that the available classes and commands are largely related to Capture One's Session mode and tethered shooting (see chapter 14). It's easy to script how the program should behave before and after a capture or define which recipes to apply, whereas exposure evaluation (see section 5.2) and creative editing steps are more difficult to automate.

It's up to you to decide whether it's worth learning AppleScript for the task you have in mind, but if you're already familiar with the platform, a quick scroll through the available functions might just reveal a way to automate a task that you perform regularly.

If you do decide to use scripts, start small. Don't attempt to automate your entire workflow from the get-go. Instead, build up a library of short scripts and combine them later as necessary.

Whatever you do, don't experiment with scripts on important sessions or your "real" image archive. Create test collections and work carefully

and methodically. It would be a shame if one mistyped scripting command wrecked the integrity of your entire vacation collection or a client's images.

> **QUICK TIP**
>
> Because Capture One is historically based on AppleScript precepts, there is currently no scripting solution available for PC users. However, you can still use macros to automate processing tasks. Various freeware macro creation solutions are available (Nemex Studio's Mouse Recorder, for instance) as well as commercial applications such as N.R.S.'s Control. Whichever program you choose, you can only automate program functions. Macros cannot access more complex data such as a tethered camera's exposure parameters or the batch status of an image.

Appendix

A.1 The Workflow Pipeline

The following diagram shows the complete workflow pipeline in detail, with two exceptions:

1. Because they can be applied at any stage in the workflow, the Lens Correction tools are not included. They can be applied as necessary depending on the task at hand and the availability of appropriate lens or LCC profiles.
2. Metadata can also be assigned at any stage in the workflow—during image import, image processing, application of Styles, or shortly before output—which is why the Metadata tools are not included in this overview.

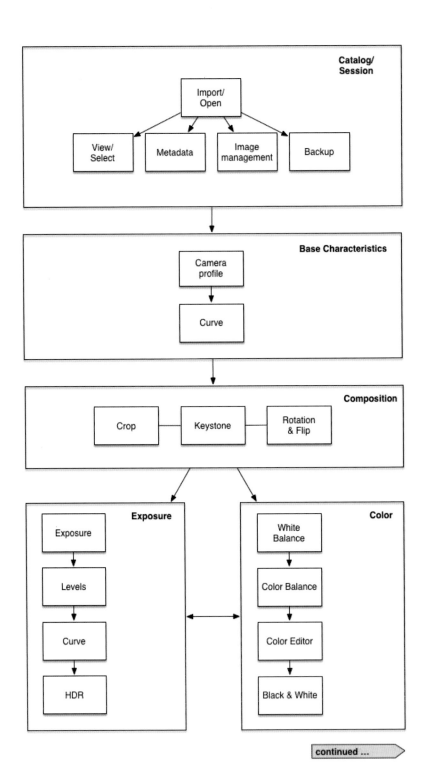

continued ...

... continued from

Local Adjustments

Clone Layers — Heal Layers — Adjustment Layers

Details

Clarity/Structure — Sharpening — Moiré

Denoising

Film Grain — Spot Removal

Output

Recipe

Batch/Output Location

A.2 Other Sources

There is relatively little dedicated information about Capture One available. The following are sources I have found helpful in the context of the topics discussed in this book.

www.phaseone.com

This is Capture One's online "mothership." The website contains new and legacy versions of the program for download, and the support area includes a knowledge base, a user-to-user forum, documentation, and other training and tutorial resources. This is also where you can open a support case. The forum is ideal for discussing techniques, bugs, and other issues with Capture One users. The blog (blog.phaseone.com) publishes tips from Phase One staff and real-world case studies written by working photographers.

www.captureintegration.com

Capture Integration provides consulting, sales, training, and support for high-end digital photographic applications, and the company's blog includes a wealth of tips and tricks for Capture One users. CI tests new Capture One releases with every imaginable combination of hard- and software, and offers advice on whether and how to update your installation.

AppleScript 1–2-3, **by Sal Soghoian and Bill Cheeseman**
(Peachpit Press, 2009)

This is the reference book in the official *Apple Training* series and is probably the most accessible book around for AppleScript beginners or experienced users. The text is easy to understand and goes into detail where necessary, but never loses sight of the real objectives or its sense of humor! Visit www.macosxautomation.com to review excerpts from the book and for more information on AppleScript in general.

The DAM Book: Digital Asset Management for Photographers,
2nd Edition, by Peter Krogh
(O'Reilly Media, 2009)

Peter Krogh is an Alpha Tester for Adobe and one of the world's leading experts on digital asset management and digital imaging in general. This book is regarded as a reference for building workflows around image databases and DAM systems. It is essential reading for anyone interested in DAM, image management, and metadata handling.

Index